THE SISTINE CHAPEL

THE SISTINE CHAPEL

HISTORY OF A MASTERPIECE

ANTONIO FORCELLINO

TRANSLATED BY LUCINDA BYATT

polity

Originally published in Italian as *La capella Sistina. Storia di un capolavoro*.
Copyright © 2020, Gius. Laterza & Figli, All rights reserved.

This English edition © Polity Press, 2022.
Paperback edition published in 2024 by Polity Press

The right of Lucinda Byatt to be identified as translator of this work has been asserted in
accordance with Section 77 of the Copyright, Designs and Patents Act 1988.

This book has been translated thanks to a translation grant awarded by the Italian
Ministry of Foreign Affairs and International Cooperation / Questo libro è stato tradotto
grazie a un contributo alla traduzione assegnato dal Ministero degli Affari Esteri e della
Cooperazione Internazionale italiano.

Polity Press
65 Bridge Street
Cambridge CB2 1UR, UK

Polity Press
111 River Street
Hoboken, NJ 07030, USA

ISBN-13: 978-1-5095-4923-8 (hb)
ISBN-13: 978-1-5095-6545-0 (pb)

A catalogue record for this book is available from the British Library.

Library of Congress Control Number: 2022930583

Typeset in 10.75 on 14 pt Janson Text
by Cheshire Typesetting Ltd, Cuddington, Cheshire
Printed and bound in Great Britain by TJ Books Ltd, Padstow, Cornwall

The publisher has used its best endeavours to ensure that the URLs for external websites
referred to in this book are correct and active at the time of going to press. However, the
publisher has no responsibility for the websites and can make no guarantee that a site will
remain live or that the content is or will remain appropriate.

Every effort has been made to trace all copyright holders, but if any have been
overlooked the publisher will be pleased to include any necessary credits in any
subsequent reprint or edition.

For further information on Polity, visit our website:
politybooks.com

CONTENTS

ILLUSTRATIONS

1. General view of the Sistine Chapel, Vatican City.
2. Pietro Perugino, *Baptism of Christ*, fresco. Vatican City, Sistine Chapel.
3. Domenico Ghirlandaio, *Vocation of the Apostles*, fresco. Vatican City, Sistine Chapel.
4. Sandro Botticelli, *Temptations of Christ*, fresco. Vatican City, Sistine Chapel.
5. Cosimo Rosselli, *The Sermon on the Mount*, fresco. Vatican City, Sistine Chapel.
6. Pietro Perugino, *The Delivery of the Keys to Saint Peter*, fresco. Vatican City, Sistine Chapel.
7. Pietro Perugino, *Circumcision of the Son of Moses*, fresco. Vatican City, Sistine Chapel.
8. Sandro Botticelli, *Punishment of Korah*, fresco. Vatican City, Sistine Chapel.
9. Sandro Botticelli, *Trials of Moses*, fresco. Vatican City, Sistine Chapel.
10. Domenico Ghirlandaio with Luca Signorelli, *Testament and Death of Moses*, fresco. Vatican City, Sistine Chapel.
11. Domenico Ghirlandaio with Biagio d'Antonio, *Crossing of the Red Sea*, fresco. Vatican City, Sistine Chapel.

PROLOGUE

TURKS IN THE PORT

A WAR BY OTHER MEANS

On 28 July 1480, some fishermen from Otranto who were preparing to go to sea at dawn spotted a shimmer of sails outlined on the horizon and heading towards the city. Anyone still lingering in bed was woken by the cries of people hurrying back from the port to bring news of the catastrophe many had been expecting for months.

The Ottoman galleys had left Valona, a city on the other side of the Adriatic that had been under Turkish control for decades. The Ottoman governor Gedik Pasha was in command of the fleet, which carried some fifteen thousand men, ready to land in Otranto and from there to invade Ferrante of Aragon's kingdom before moving north, to the Papal States and to the heart of Christendom.

As the Ottoman horses and cannons were disembarked at Alimini, a nearby beach, a pitifully small number of troops rallied under the command of captain Francesco Zurlo, in a desperate and impossible defence of the city. The residents of the outermost neighbourhoods clustered around the city walls hastily carried what they could inside the fortified enclosure, and soon enough some five thousand people had gathered there. Others, with more foresight, escaped to the countryside, putting as great a distance as possible between themselves and the doomed city.

In the early afternoon, a small gig with Gedik Pasha himself stand-
ing at the bow slipped quietly over the flat, green water that lapped
the city walls. Pasha was renowned for his intelligence and determina-
tion, although to many this looked more like cruelty. He was also one
of the most trusted commanders of Mehmed II, the great conqueror of
Constantinople, now confined to the capital as a result of an attack of
gout that had left him with a swollen and misshapen leg. Gedik was
coming to offer the residents of Otranto a chance to surrender to the
sultan of the Sublime Porte and become his subjects, as the Christian
citizens of Valona had done years earlier. Not only would their lives
be spared but they would also be able to keep their religious freedom,
providing that they paid the *gizya*, a tax levied from both Jews and
Christians in lieu of the charitable tithe paid by Muslims, as their reli-
gion required. It was an entirely reasonable offer, which might even
have improved the lives of many, since the king of Naples was neither
magnanimous nor efficient.

But captain Zurlo had been deeply affected by the propaganda circu-
lated by the popes and other Christian leaders, who saw the expansion
of the Ottoman Empire as a threat to their own territorial power even
more than to their religion. Although he had no chance of staving off
such an attack, relying on promises of help from Christian princes that
were never to materialize, Zurlo gave orders for a bombard to be loaded
and fired at the approaching gig. It was an instantaneous declaration of
war and violated the Ottoman diplomatic code, which regarded such
negotiations as sacrosanct.

Gedik Pasha's anger was made clear a few hours later, when the city
walls came under heavy bombardment that continued for many days,
alternating with the activities of the Ottoman sappers. Nonetheless,
the first skirmishes gave Zurlo the false impression that he could win
the battle, and this prompted him to order the violent deaths of the
first Turkish prisoners. Appalling atrocities such as impalement and
quartering would later be paid back to the population of Otranto with
a vengeance.

The siege of Otranto lasted two weeks, enough time for any Christian
army to be able to come to the city's aid. But these commanders and their
troops, including those of the heir of Saint Peter himself, Pope Sixtus IV
Della Rovere, were too busy fighting each other, notwithstanding that-

some were not far from Puglia. Lorenzo the Magnificent, the ruler of Florence, had abandoned his allegiance to the pope, whom he had never forgiven for backing an attempt to overthrow the Medici in the Pazzi conspiracy two years earlier. Having escaped assassination and resumed control of the city, Lorenzo had then formed an alliance with the king of Naples and, together, they were now warring against the pope's nephew, Girolamo Riario, lord of Imola. This had forced the pope to ally himself with Venice in order to face the combined attack of Florence and Naples. As a result, Venice was engaged in complex military campaigns not only throughout Italy but also across the Mediterranean, where its maritime trade was increasingly hampered by the Turkish expansion. With the political pragmatism that had allowed the Most Serene Republic to survive for five centuries, unlike many other states and republics, the Great Council had signed a general truce with the Sublime Porte in 1479, and in the days before the attack on Otranto it had ordered its ships out of this stretch of the Adriatic so as not to hinder Turkish naval manoeuvres. Having to choose between the friendship of Turks or Christians, Venice had prudently opted for the former. Nor was its pragmatism a secret. Friendship with the Christian rulers came at the price of rapidly changing alliances, and it was this that made the political geography of the Italian peninsula so unstable.

The Ottoman advance on the West had been underway for some thirty years or more, ever since Constantinople, the city known as 'the second Rome', had fallen to Mehmed II, who then proclaimed himself emperor and heir to the Romans. For thirty years, Christian rulers had put their own trifling dynastic affairs before the defence of Christendom and of the integrity of what, for a thousand years, had been the Holy Roman Empire. Crusades were announced and then immediately aborted through the conflicting interests of the various princes, who in the end had attempted to reach peace with the sultan in other ways. Venice itself, which was the Ottoman Empire's main rival in the Mediterranean, had entered what seemed to be an alliance with Mehmed II. Now Mehmed had sent his highest vassal, Gedik Pasha, to present the bill.

The residents of Otranto, taken in by the religious propaganda of the Christian rulers and then effectively left to themselves, were almost all slaughtered after the final assault on 11 August, which marked a point

of no return for the people of southern Italy. The Christians made their last stand in the sacristy, and then inside the cathedral itself. The bishop continued to recite the mass until his head was severed from the neck in one strike, with a sword, then displayed on a pike by the triumphant soldiers. The horrors that followed, once the inhabitants had refused conversion, were typical of any military defeat and any surrender, except that on this occasion it was the Turks who carried them out, in the very heart of Italy.

Understandably, when news arrived in Rome on 3 August, just five days after the siege had started, there was deep concern. Masses were celebrated, promises were made, and lastly a truce was announced between the Italian states, and especially between Sixtus IV and Lorenzo de' Medici, who had been at each other's throats. An alliance was needed to defend Italy's borders from the Turks, but above all the pope needed to claim his spiritual legacy from Mehmed II, because the sultan, a great lover of ancient history and driven by a desire for conquest that made him identify with Caesar and Alexander the Great, claimed not only the temporal but also the spiritual rule of the universal empire whose leadership he had taken when he conquered Constantinople – the second Rome, which over the centuries had been much more powerful and influential than that hamlet of monks and sheep that the ancient city lying between the Tiber and the hills had become.

In the meantime, while waiting to conquer the first Rome, too, and to ride on horseback into Saint Peter's, as his grandfather had dreamt of doing, Mehmed II made much of his claim to Rome's spiritual and cultural legacy, which had to legitimate his dream of a universal empire. To many European intellectuals, his claims seemed well founded, because they were underpinned by facts that were hard to dispute. The legitimate base of his claim had already been acknowledged twenty years earlier, when Pius II wrote a letter to Mehmed in which he declared his readiness to recognize the latter's imperial investiture, on condition that Mehmed converted to Christianity. Mehmed naturally refused. Albeit a tolerant sultan who guaranteed freedom of worship in his empire, he was convinced that his was the true religion and that it should become the leading religion in all the lands and nations that were steadily being added to his empire.

As if this were not enough, many in Italy regarded and continued to regard Mehmed II's claims as being rightful. An authoritative cultural tradition championed his requests, on the grounds that anyone who conquered the second Rome was entitled to call himself Caesar's heir. The pope of Rome, Sixtus IV himself, acknowledged that tradition and took the matter very seriously. If all European princes faced the problem of territorial threats, since they were required to defend their borders with armies, then he, the pope, was called to react to a much more insidious threat: one that threatened to render his spiritual leadership illegitimate.

Sixtus IV decided to respond to this threat with an artistic endeavour that became a sort of universal manifesto of Christian theology and papal legitimacy: the decoration of the Sistine Chapel, the most important chapel in Christendom, which he had just rebuilt and which, from 1481, he would entrust Italy's best artists to embellish.[1]

THE WAR OF THE PAINTERS

While the defence of Italy's and Europe's territorial integrity relied on the armies and finances of the five main states on the Italian peninsula – Rome, Venice, Florence, Milan, and Naples – which had battled one another for almost a century but now, after the siege of Otranto, undertook to react to the Ottoman expansion, only Rome and the vicar of Christ could defend the legitimacy of Christendom as heir to the civilization and therefore legality of Rome. The reigning pope, Sixtus IV, was the right man for the job.

Born to a family of very modest standing, the pope had an exceptionally lively mind and was regarded as a distinguished theologian. His ascent through the curial ranks owed much to the brilliant solution of several doctrinal matters, which in previous decades had led to heated disputes between the leading religious orders of Dominicans and Franciscans. Sixtus also had a political energy that had already attracted much criticism during his papacy. He had launched a major rebuilding programme and significant works aimed at restoring Rome's status and prestige after the years of neglect that followed the transfer of the papal seat to Avignon. A factor in the transfer to the French city had been the need to protect the papal court from the acts of arrogance

of local baronial families, the Colonna, the Orsini, and the Savelli, whose armies were running riot in the city, endangering even the pontifical palaces.

One of the main projects launched by this energetic pope from 1477 on was the restructuring of the Cappella Magna (the Great Chapel) in the Vatican Palace. The masonry structure had now been completed, but the wall decorations were still lacking. Only, for this next phase, the pope needed the services of superb painters; and at the time almost all of them were in Florence. It was only after the truce with the Tuscan city that Lorenzo de' Medici agreed to allow his best painters to leave for Rome. Sandro Botticelli, Domenico Ghirlandaio, and Cosimo Rosselli were joined by Pietro Perugino, who was Umbrian by birth and training but had a workshop in Florence, too, and had already been appreciated by the pope (he had painted the pope's funerary chapel in 1479).

These painters would contribute with their art to the crusade that the pope intended to organize against the Turks, although another century would pass before that took place. A fresco cycle would be created inside the chapel of the Vatican Palace, the holiest place in Christendom, to prove to the world that the pope was the one and only heir of the Roman Empire. Mehmed and his universalist claims had to be refuted and rebuked with every possible weapon, both those in molten bronze that were cast by ballistic experts and those of propaganda that were laid out in gold and lapis lazuli on the walls of the world's holiest chapel.

A visible affirmation of papal legitimacy was much needed, especially in Rome, where a current of thought sympathetic to Mehmed II's claims had made headway in the most refined and academic circles. It was known, moreover, that in the conquered Christian territories beyond the Adriatic Mehmed's government had shown itself to be more liberal and generous with the small people [il popolo minuto] than the Christian rulers had been. These intellectuals were deeply undermining the papacy's cultural and moral legitimacy; hence they, too, needed an answer that could not be military but had to be cultural.

On the back of such ambitious aims, the Sistine Chapel became the centre not only of Christian spirituality and papal legitimacy but also of modern art. Yet the succession of artists who made the chapel

memorable also tells another story, apart from that of the papacy's legitimate descent from the Roman Empire. It tells the story of how art broke away from fifteenth-century rules and entered its modern dimension as a product of genius. Art began to be recognized as a product of pure talent and freed itself from the medieval heritage, which was still founded on the precious nature of the materials and the repetition of formal codes. The infinite horizon of the creative genius would be first glimpsed right here, in this chapel, where it would affirm its greatness through the work of Michelangelo Buonarroti and Raffaello Sanzio.

To follow the development of the chapel's decoration over the course of two generations of artists is to follow a transition from the rules that governed the Renaissance workshop to the expression of a modern creative genius, which asserts its universality and greatness precisely in the breaking of that rule.

PART I

AFFIRMING PAPAL PRIMACY

1

REBUILDING THE SISTINE CHAPEL

A great chapel, *cappella magna*, had been built beside the Vatican Basilica when the first large palace was erected at the instigation of Pope Leo III (795–816). The site of this chapel, if not identical, must have been very close to the present-day one. The chapel was probably enlarged, and perhaps rebuilt under Innocent III (1198–1216).[1]

Under Nicholas III (1277–80), the Vatican Palaces were expanded and the Cappella Magna was also rebuilt or enlarged, as reported in a Latin inscription that is still visible in the Palazzo dei Conservatori: 'Pope Nicholas III ordered that the palace, the great hall and the chapel be built, and he enlarged the other old buildings in the first year of his pontificate.'[2] These buildings fell into decay during the Avignon papacy and were in part restored by Martin V (1417–31), but according to fifteenth-century sources and Vasari, it was Sixtus IV who rebuilt *ex novo*, from scratch, the chapel that we now see. Recent studies on the building show that, contrary to what Vasari wrote in his *Lives of the Artists*, the chapel was rebuilt on the foundations and in the area previously occupied by the Great Chapel. Therefore it was not so much a rebuilding as a renovation, which broadly speaking preserved the plan and the dimensions of the previous chapel.

Thanks to a curious event narrated by a chronicler of the time, Andrea of Trebizond, we know how ruinous this chapel had become. During

the 1378 conclave, the people of Rome laid siege to the assembly of car-
dinals, shouting that the new pope had to be a Roman no matter what.
'We want a Roman',[3] they cried, banging on the beams with sticks and
brooms as a warning that they would not tolerate a foreign pope who
might move the Holy See away from the Eternal City again. The episode
speaks not only of the precarious situation in which the Church of Rome
found itself and the urgent reasons that had prompted its transfer to
Avignon, but also of the degradation of the old Vatican buildings, which
were barely fit to house such ritual events. So the architect, Giovannino
de' Dolci, designed the new chapel in the guise of a fortified building,
because its first function was to safeguard the Vatican's governing body
from the overbearing behaviour of the Romans – barons and populace
alike. Its walls were massive and impenetrable, with high windows that
barred entry and made it safe for cardinals to hold meetings, protecting
them from the threatening incursions of the Roman barons, who would
not have hesitated to use force in order to sway the pope's election.

The measurements of the new chapel – 40.93 metres long, 13.41
metres wide, and 20.70 metres high (plate 1) – echoed those of the
medieval building, which in turn reflected the dimensions and simple
proportions of Solomon's temple: the length was three times the width,
and the height half the length. What Pope Sixtus IV had done was to
change the height of the chapel, but not its floor plan. It was a decision
based on the Scrovegni Chapel in Padua, a building that the pope had
perhaps visited as a young man.

The building work started in 1477 and was supervised by Giovannino
de' Dolci, and the architectural structure was largely dictated by the
fashion of the time. The side walls were divided into three horizontal
bands by large cornices. The upper one was wide enough, like a gallery,
for someone to walk along it and secure the maintenance of the win-
dows, while the vertical divisions were created by Corinthian pilasters,
which formed six bays and supported the corbels of the barrel-vaulted
ceiling. But it was in the roof that the building presented a highly origi-
nal solution. The wide chapel was spanned by a barrel vault supported
by pendentives and spandrels that, by linking to the vertical pilasters,
formed blind lunettes above the large windows in the north and south
walls of the building. Pier Matteo d'Amelia, a painter from the Umbrian
hinterlands north of Rome, had painted the vault as a starry sky, which

provided a strikingly practical solution to the difficult undertaking of decorating such a complex and intricate structure.

There remained the problem of decorating immense wall spaces, on which it was important to display the political and religious manifesto of the combative Sixtus IV and his nephew, Giuliano della Rovere, the future Pope Julius II. The latter had been prominently depicted in one of the most powerfully symbolic paintings of the Della Rovere papacy: *Sixtus IV Appoints Bartolomeo Platina Prefect of the Vatican Library*, painted by Melozzo da Forlì in 1477 for the new Vatican Library.[4] Such a dignified presence was intended to highlight Giuliano della Rovere's central role in the cultural policy of the papacy of his uncle, who did not seem that interested in art.

The structure of the chapel lends itself particularly well to a pictorial cycle, so much so that many scholars have dwelt on the question of its conception and have wondered whether a painter (perhaps Melozzo da Forlì) could have worked with Giovannino de' Dolci from the outset, to ensure that the architecture was suited to a clear pictorial narrative. But the division of the walls into three horizontal bands was a well-established custom in many large churches, both in Rome and across Italy; a similar decorative scheme had been used, for example, in the old basilica of Saint Peter's and in the basilica of Saint Paul Outside the Walls. Even the vertical sequence of painted hangings on the lowest level, narrative scenes in the second order, and gallery of popes' portraits in the top order was not new. Painted drapes below a narrative sequence could be found in Santa Maria Antiqua in the Roman forum, a model that had inspired the whole classicist revival in Rome, while slightly further away, in Sant'Urbano alla Caffarella, projecting vertical pilasters were used to divide the walls into bays. Modern, on the other hand, was the lexicon of decorative architectural features – the graceful Corinthian pilasters, ornamented with grotesque motifs and echoing those that Melozzo had used a few years earlier to frame his extraordinary fresco of Platina's appointment as librarian, which had instantly become a statement of the classicizing taste of the Della Rovere popes.

Once the ceiling decoration had been completed at the tail end of 1480, it was necessary to move on to the walls, and very quickly. The urgency of the situation dictated a rapid execution, but it was not easy to find a painter capable of completing such a task in a short a time.

2

A CONSORTIUM

The pope was in a hurry to finish the whole lower area of the new chapel as an affirmation of his political programme. Indeed, his haste was such that he decided to commission not one artist, or even two, but a consortium. Everything had to be ready within just one year. No proper contract was drawn up, but a very unusual series of conditions were applied. Four leading artists from central Italy were summoned, namely three from Florence and one from Umbria, and in any case the latter was familiar with Tuscan practices, having spent several years in the area during his training. The artists were Cosimo Rosselli (1439–1507), Domenico di Tommaso Curradi, known as Il Ghirlandaio (1449–94), Alessandro di Mariano, known as Botticelli (1445–1510), and Pietro di Cristoforo della Pieve, known as Perugino (1448–1523). They were commissioned to paint four large frescoes on the chapel walls, as well as the portraits of the popes above and the fictive drapes below. The four *quadroni* or large pictures were then assessed by a papal commission, whose report is dated 17 January 1482. The commission declared that the four paintings had been executed to a professional standard, but also that they could be valued at the relatively modest price of 250 ducats each, and this included not only the narrative scenes but also the papal portraits and the drapes of mock fabric:

The said masters are to receive from Our Holy Lord the Pope, for the said four stories together with the said drapes, the cornices, and pontifical portraits, for each and every story, two hundred and fifty cameral ducats at a rate of ten carlini for each ducat and for each story, as above.[5]

For almost two hundred years, scholars have debated the sequence of the two surviving documents relating to this undertaking. The first, dated 27 October 1481, records the commission received by the four painters to produce ten figurative scenes whose cost would be evaluated at a later stage:

> namely, work has started on ten stories from the Old and New Testaments, with drapes in the lower part [inferius], to be painted as faithfully and diligently as they can, by each of them and their workshops.

The second document, cited earlier, values the cost of the four paintings, which had been finished by January 1482, or were at least at a sufficiently advanced stage for an evaluation to be made. On the one hand, it seems unlikely that between October 1481 and the following January the artists could have completed such a large area of fresco. On the other, the mention of just ten paintings commissioned in October suggests the likelihood that the four paintings valued in January were commissioned earlier, given that fourteen were painted in all. These ambiguities have given rise to a wide range of hypotheses, all linked to the fundamental question of who acted as the leader of the group and who decided the sequencing of the scenes. Only by retracing the practical organization of the work and of the worksite – aspects that, oddly, have been completely overlooked until now – can we attempt to answer these questions.

By reconstructing the events related to the organization of the work, and especially the problems linked to the scaffolding (a pivotal aspect), we find good grounds for asserting that a first commission was given to the four painters already in the summer of 1481 and that in October of that year, according to the surviving document, they were asked to fresco a further ten *quadroni*. The value of the latter was established in

January, but is unlikely to have come as a surprise. Indeed, there was a well-established market for paintings and the prices moved within a very narrow range, being affected not by the quality of the painting but more by the quantities of precious materials used in the frescoes, as well as by the costs of labour and scaffolding. This sequencing corresponds to a description that indicates the operating procedure and a techno-logical world determined by the historical context. The four painters were responsible for the finest execution of a work that was, for the most part, conceived by others.

In short, the two documents should be read as follows: the initial commission to the four painters was given in the summer of 1481 and referred to four large fresco paintings. The second commission, for a further ten *quadroni*, was then awarded in October that year; and in January, when the first four were finished, the actual price was confirmed.

The main value of the commissioning document dated October 1481 – which is signed by both Giovannino de' Dolci, 'building supervisor', and the painters – lies in its description of the decorative theme of the chapel (ten stories from the Old and the New Testament) and in the commitment to finish the stories by 15 March the following year. This was an extraordinarily short time, considering that each painter would have had under four months to complete a painted area of one hundred square metres containing dozens of figures, each of which, even with a good dose of optimism, would have required at least four days.

This tight schedule reflects the exceptional haste, nothing short of a fury, that consumed Sixtus IV, pressing him to finish a work that was evidently at the forefront of his mind and of his nephew Giuliano's, who was already an active patron of the arts. The pope wanted to decorate the most important chapel in Christendom within the shortest possible time. He clearly felt the need to offer a visible testimony of the power of his theological arguments in this symbolic setting. Mehmed II's death in May 1481 had freed the church and Italy from the ever present threat of an invasion, but it also urged closing the ranks against any renewed advance of the Ottoman Empire.

The sequence of the documents also reveals another important detail, which is usually overlooked in the interpretation of the Sistine Chapel, namely that the haste was also linked to the presence of a huge

scaffolding, which had been used to build and decorate the ceiling and now needed to be put to use as rapidly as possible to paint the walls. The height of the building, some twenty metres from floor to ceiling, presented a series of problems that were not easy to solve when it came to the scaffolding, which had to allow a team of painters to work comfortably. Erecting such an imposing structure was more than a matter of days and, above all, would have required planks, beams, and good-quality ropes. All these materials were already present in the chapel but would have had to be reassembled, since the scaffolding used for the ceiling was different from that required for the walls. The scaffolding for the vault needed only a flat surface at the top, at a height of around eighteen metres. Instead, to paint the figurative scenes on the walls, flat working surfaces were required at a height of around 1.8 metres. The availability of such extensive scaffolding already on site must have prompted the pope to use not just one but four teams of painters, given that the scaffolding costs had already been amortised for the ceiling. If such a large-scale structure had not already been available, perhaps the history of the Sistine decoration would have been different. A structure might have been built that sufficed for one workshop, and the execution itself would also have been slower, offering a greater guarantee for the stylistic unity of the decoration.

3

THE STARRY CEILING

The presence of the scaffolding should also close another matter that is still debated in the literature, namely whether or not Pier Matteo d'Amelia had, in those final months, painted the vault with golden stars against a blue background. A drawing of this decoration survives in the Uffizi, and it is attributed to Giuliano da Sangallo; but a comment in the margin reads: 'The vault for Sixtus by Pier Matteo d'Amelia. This was no longer done.'[6] Although this comment has led many scholars to regard the drawing simply as a project, it is worth noting that it certainly does not give that impression but looks like the record of the outcome. In my opinion, it would have been inconceivable to start painting the walls if the ceiling had been unplastered and undecorated. Not only would the grey, unfinished state of the vault have detracted from and impoverished the decorations below it (which the pope wanted to be full of gold leaf and ultramarine blue), but painting the ceiling afterwards would have risked damaging the wall frescoes. We know of no examples where walls were painted before the ceiling: the fresco technique calls for coarse materials such as pozzolana, water, and pigments that would have risked smattering the paintings beneath.

All in all, given the immense scale of the undertaking, the practical steps and methods used in the construction and decoration of the

Sistine Chapel must be kept in mind, because artistic production is a complex process and cannot be reduced to a series of abstract problems exclusively confined to style, iconography, and iconology. It is important to try to imagine how the work was carried out also in terms of an economic logic, which is always pivotal to artistic projects. To take down the scaffolding without decorating the ceiling and to leave that for later would have entailed an enormous increase in costs. It would have been equally inconceivable to spend large sums of money to reinstall the scaffolding just for the sake of painting the walls, and they would have looked insignificant against a coarsely plastered ceiling. Therefore, when interpreting the style of the paintings by the four artists, too, it is important to remember that these narratives were intended to be seen under a star-spangled blue sky. The fact that the scaffolding structure was already in place would also have brought down the costs of manufacturing the paintings, and this explains the modest price calculated for the frescoes. If the painters had had to supply and install the scaffolding themselves, the cost would have been at least 30 per cent higher.

So the timing of the decoration was closely related to the progress of the building work. Moreover, the choice to award the commission to four painters was unusual, but not unprecedented in fifteenth-century Italy, and reflects a world, that of painting, which was still intimately linked to craftmanship. Above all, the work could rely on close supervision from someone who had an overview of the narratives, and this could be only the pope himself, helped by his nephew Giuliano, who was already renowned for his appreciation of art.

The painters were asked to complete in a very short time span a product whose material difficulties were regarded as much more challenging than its creative complexity. As was usual in those days, the calculation of expenses included the lime, the cost of scaffolding, and the pigments, especially the most expensive ones, such as lapis lazuli and gold leaf, which together might amount to 30–40 per cent of the work's value, unless the patron himself undertook to supply them – as was certainly the case here. Once the programme had been decided and the preparatory drawings accepted, the actual execution was not that different from that of a work in wood or a relatively complex building project. The painters were required to decorate the walls almost as if an

upholsterer had covered them in the finest fabrics, and only the wish to convey a theological and political programme urged the pope to choose one rather than the other. The value of these decorations by comparison to other kinds of decorations, purely material (fabric, leather, inlaid wood), was only just becoming evident, and this offered a notable propaganda advantage in the political battles of the day.

The four painters were invited to work *melius quo poterunt* ['better than they will be able to'], a contractual clause equivalent to the formula 'to the best of their ability', which still appears in craftmanship contracts. Furthermore, they had to do their best in a very short space of time. The aim was to decorate the Sistine Chapel using an overall design, and in a form that had to look as homogeneous as possible, as if it had been done by one man. The painters also had to use their skill to solve the breakdown of the narrative created by the bays along the walls. Vertically, the walls were divided into three levels and, starting from the lowest, these were filled with painted drapes of fictive fabric, then with the stories themselves, and, at the top, with the portraits of the popes. Horizontally, the walls were divided by pilasters, which were painted in the first two levels, and then projected at the third level: both the real and the fictive pilasters, with their colours, had to be absorbed into the narrative.

The names of the four painters and an analysis of their works certainly help us to understand why these particular ones were chosen, considering that they had to execute decorative work *melius quo poterunt* within a short time span. What did Rosselli, Ghirlandaio, Botticelli, and Perugino have in common to make them the right choice for such an important task?

First and foremost, they were all middle-aged. Almost all of them had been born before the mid-century, so they were around forty; they were in their prime, in that they had acquired extensive professional experience, yet were of an age at which they could still work directly with their own assistants and cope with the strain of working on the scaffolding, which was certainly not an easy place to be. This group of masters in their forties were ready to spend six months on the precarious wooden structure with their best pupils, and they could draw on a wealth of experience, both technically and creatively, to ensure that the results would be entirely predictable – as indeed they were.

The four painters had received a similar training in both technique and style. They had learned or perfected their art in the workshops of Florence. In the mid-fifteenth century, these were certainly the most technically advanced in the art of fresco, which was the type of painting best suited for monumental decorations, but also the one most difficult to execute, particularly in circumstances where the natural unevenness of the materials used could easily be aggravated, as in the Sistine Chapel, by each workshop's particular usage and by the methods of application. And yet even today, when we enter the Sistine Chapel, we have the impression of seeing the work of a single team, so uniform was the result.

The distribution of the work was not even, also because the fourteen stories could not be divided by four, and there are still doubts regarding the authorship of individual scenes whose attribution is not unanimous. Two more factors complicate the attribution. Two of the scenes, those behind the altar – the *Birth of Christ* and *Moses in the Bulrushes* – were destroyed in 1534, to make way for Michelangelo's *Last Judgement*, and it has proved impossible to identify the painters solely on the basis of surviving documentation. The second factor that makes the attribution of individual panels difficult is the presence of other famous artists apart from those named in the contract. According to Vasari, Luca Signorelli, Biagio d'Antonio, Pinturicchio, and others worked in the Sistine Chapel, too. Perhaps they were assistants to the other masters, or perhaps they were employed in a form of 'subcontracting' arrangement that gave them some autonomy. Whatever the case, we do not know exactly how the work was distributed. Yet by cross-referencing stylistic details (still a significant line of study for the analysis of paintings) with hypotheses regarding the methods of execution (an equally important point of reference), we can make educated guesses regarding the chronology and authorship of the works.

4

EVALUATING THE FOUR PANELS

Various hypotheses have been put forward regarding the progress of the work. Some are highly authoritative, yet this does not make them plausible. Ernst Steinmann, the greatest scholar of the Sistine Chapel, suggested that some panels were assigned to painters after the conclusion of certain important events for the papacy, so that they could be alluded to in a triumphalist key. Although not surprising in a late nineteenth-century scholar, such an interpretation, skewed as it is towards an idealistic reading of the work, takes no account of the practicalities that would instead become all-important to later scholars. For example, Steinmann deemed that the drowning of the pharaoh's armies in the Red Sea was painted only after the pope's victory against the duke of Calabria. But this suggestion does not seem viable, because the iconographical programme must have been established before the work started.

If we go back to the document of January 1482, we know with certainty that an evaluation was made of four paintings executed by individual masters. Common sense tells us that, on the basis of the economic criterion that underpins the analysis of works of art, these four paintings must have been close to one another and in sequence. We can hardly imagine that the pope would have installed four separate scaffoldings in four different areas of the chapel. All four panels must have been executed with the help of a single scaffolding structure

used by all four painters. The system of joists, uprights, and ladders twenty metres high could not be divided into smaller sections, nor could it be assembled to cover the entire chapel at once. Considering that each panel is five metres in length and all four add up to twenty metres, we can suppose that a scaffolding of that length and height was erected. The four masters mentioned in the contract – Perugino, Botticelli, Ghirlandaio, and Rosselli – must have worked alongside one another, down the length of the scaffolding. If we stop to analyse the layout of the paintings on the plan, we see immediately that there is only one place where this happens: the first four paintings on the north wall, starting at the altar end. Here there is a sequence running from Perugino's *Baptism of Christ* (plate 2), Botticelli's *Temptations of Christ* (plate 4), and Ghirlandaio's *Vocation of the Apostles* (plate 3) to *The Sermon on the Mount* by Cosimo Rosselli (plate 5). The position of the first panels in this area also coincides with the mention in the contract of an execution *in capite altari* ['starting at the altar end'].

While this east–west sequence on the north wall seems wholly convincing from a practical point of view – as it allows all four masters to work alongside one another on the same scaffold – another aspect also supports this hypothesis. No one seems to have noticed that these four paintings are the only ones to use successfully an illusionistic device that gives the viewer the impression of looking at a single scene. Each of these panels ends with a section of landscape that is repeated, in almost identical fashion, in the next scene, beyond the vertical division of the painted pilaster. The rocky crag at the right-hand side of Perugino's *Baptism of Christ* is repeated, with identical colours for the rock, in Botticelli's *Temptations of Christ*; this, in turn, offers, in the right-hand corner, a hilltop that we find again in Ghirlandaio's *Vocation of the Apostles* and, lastly, in Cosimo Rosselli's *Sermon on the Mount*. This uniform treatment of the landscape on either side of the pilaster helped to minimize any break in the narrative – no doubt a problem that needed to be solved in these 'story' cycles.

An extraordinary example of this optical narrative device was used in Florence, at around the same time, in the choir of Santa Maria Novella where Ghirlandaio, fresh from his experience in Rome, ended the scene of the visitation by Saint Elizabeth with a triumphal arch seen from above, whose fictive bas-reliefs were then matched precisely on

the other side of the painted pilaster that outlines the bay on the wall. This gives the viewer the impression of standing in a unified space, even if the scene is set on the one side in open landscape, and on the other in a city square. While Ghirlandaio's choice served to maximize this illusion and to create a continuity of place, it is no surprise that in the Sistine Chapel the painters started by imagining a single landscape, in which the discontinuity created by the vertical framing of the pilasters was perfectly absorbed by placing them on the same hilltop. This detail serves to gauge the level of creative unity among the Sistine 'consortium' – a level that, as we shall see, was also affirmed with other technical and stylistic tools.

Yet even after such an exceptional proof of creative and executional unity, there is no gainsaying that more striking discontinuities appeared in the other scenes; besides, other painters appeared too, which makes it difficult to identify the sequence of paintings. Something happened, although in the present state of research we are unable to say what it was, but the first four painters were flanked by other leading artists, like Luca Signorelli, Biagio d'Antonio, and Pinturicchio. Vasari goes as far as to attribute some of the painted scenes to them, even if at the time of painting they were not held responsible for those scenes.

Many scholars believe that Perugino received as many as five panels: the two at the altar that were later destroyed to make way for Michelangelo's painting and the three scenes from the life of Christ – *Baptism of Christ*, *The Delivery of the Keys to Saint Peter* (plate 6), and *Moses's Journey into Egypt and the Circumcision of the Son of Moses* (plate 7). Botticelli was assigned three: *Punishment of Korah* (plate 8), *Trials of Moses* (plate 9), and *Temptations of Christ*. Also three went to Ghirlandaio: the *Vocation of the Apostles*, the *Testament and Death of Moses* (plate 10), with Luca Signorelli, and the *Crossing of the Red Sea* (plate 11), with Biagio d'Antonio. And Rosselli received three as well: the *Adoration of the Golden Calf* (plate 12), *The Sermon on the Mount*, and *The Last Supper* (plate 13). Perugino's larger commission can be explained by the fact that he had already worked for Sixtus IV, who had occasion to appreciate the quality of his work, that his workshop was at the time the most organized in terms of production, and that he already had a base in Rome. On the contrary, the others had to transfer all their equipment from Florence to Rome.

5

THE FLORENTINE WORKSHOP IN THE MID-QUATTROCENTO AND THE FRESCO TECHNIQUE

For nearly a century Florence had been regarded as the most advanced centre of art on the peninsula, particularly when it came to the production of large fresco cycles, which were developed to an unprecedented level of perfection.

The presence of a rich merchant class in the city and the existence of a democratic system that fostered competition between the families that participated in public life prompted these kinship groups to communicate their status by commissioning works of art. The concentration of culture and wealth in such a limited area was unparalleled in Europe, and had given an extraordinary impetus to the craft workshops that produced statues, panel paintings, jewellery, and frescoes. Family chapels, private palaces, public façades, and council halls were decorated with frescoes – not to mention churches of various orders, almost all of which were present in the city.

The tradition of good Tuscan fresco had been established almost a century earlier by Giotto and his school: they were summoned to work throughout Italy, covering walls in coloured plaster on which human life was portrayed in an increasingly convincing fashion. Having reached its highest expression in the Scrovegni Chapel in Padua, Giotto's realism was taken to an even higher level a century later by Masaccio, in the Brancacci Chapel in Florence, which remained a point of reference up

until Michelangelo's generation. Large expanses and very low production costs (significantly lower than in panel painting) made fresco the perfect medium for fulfilling that desire for realism and monumentality that fascinated the Florentine ruling classes. The ability to portray life-size figures on the walls meant that bankers and merchants, in fact the entire social elite, could see their own likenesses purged of the vices and miseries that afflicted everyday life, and this gave them the impression of forming part of the supernatural and heroic world of 'History'. It is no coincidence that affluent Florentines were shown as spectators of the major sacred events narrated in the Gospels and could be recognized from their facial features and fine clothes. The fresco as a mirror of fifteenth-century society was a true innovation, and it drew on the narration of biblical stories that had decorated the walls of Italian churches for two centuries.

Fresco painting called for precision, speed, and perfect control of both the materials and the production cycle itself. A well-seasoned wall was initially coated with a layer of lime-based mortar made up of one part of lime putty [*grassello di calce*], which acted as a binder, and two parts of river sand, not the fine sort but of a gravelly consistency, to provide bulk. Onto this layer of coarse but structurally very strong plaster that was left rough, the painter then transferred the drawing of the image from the preparatory cartoon and fixed it using a simple red outline to form the sinopia (called so because this shade of red was made with pigment imported from Sinope, a port on the shore of the Black Sea). Once the underdrawing had been transferred to the wall, it was divided into sections; each section had to be completed in a single day, because the colour had to be applied to fresh plaster. As the water from the plaster evaporated, the action of carbon dioxide in the air caused the lime in the mixture to form a crust as it reverted to calcium carbonate in its hardened mineral state. The coloured pigment was incorporated into this crust, which gradually hardened from the outside inwards, forming a mineral encrustation highly resistant to the action of humidity. The process of carbonation of the outer layer usually took twenty-four hours, which is why each section of plaster had to be finished within that time interval.

Painting the pigment onto wet plaster was very difficult. If it was too wet, the colour floated off because of the excess water; if it was

not wet enough, on the contrary, too much pigment was absorbed, which altered the tone desired by the artist. We can well imagine how challenging it was to control the hygrometry of the plaster, given the changes in air temperature and humidity, parameters over which artists had no control. However, the impact of these variables could be mitigated through experience, simply by adjusting the components of the plaster mix or by changing the amount of water used to dissolve the pigments. In theory, to achieve a uniform result, the painter always had to paint onto plaster that was obtained by blending identical quantities of lime and sand, and he had to do so at the exact moment when the water evaporated, but before the surface had hardened, so as not to create uneven effects after the plaster had set. In practice, the decisive factor capable of assuring a uniform result in spite of constant changes in weather and in air temperature and humidity was the experience of the artist and of his workshop.

At Assisi, and then in the chapels of Santa Croce in Florence, Giotto had shown the miracles that could be achieved through the Tuscan method. The pigments used were trialled in this way to resist the alkaline action of the lime to perfection and, once dry, they preserved the same tonal nuances for centuries. Every morning the artist had to assess the overall weather conditions and to give his assistants precise instructions for the preparation of the mix, the application times, and the solutions of pigments. During the day he also kept a watchful eye to assess, before it was too late, whether another touch of colour was needed or the tone had to be lightened.

Lastly, there were those parts that needed to be painted on dry plaster [a secco], using a binder that kept the pigment apart from the wet plaster. This was the case with the precious lapis lazuli, the king of pigments, that ultramarine blue that conjured up the depths of the Mediterranean waters in which the civilizations of Italy, Greece, and the Orient reflected themselves: this one was able to yield a tone that neither the fabrics of Syria nor those dyed in Florence or Marrakech could match.

Lapis lazuli was made from precious stones mined in the mountains of Afghanistan that were then crushed using a mortar. This produced a pigment whose intense tone was perfect for the cloaks of Madonnas and for the Gospel's miraculous celestial skies. But it was far too expensive

to be used like other colours. Giotto had found the perfect way to optimize its use, namely by underpainting the fresco with a reddish brown colour called *morellone* and then adding a very light layer of lapis lazuli dissolved in a lime tempera whose effect was enhanced against a background previously saturated in colour. The large expanses of blue painted in this way gave uniformity to the skies across such monumental walls: indeed, the effects created in the Sistine Chapel would be decisive. On the other hand, using glue to apply ultramarine blue presented serious challenges, especially when it was hot, as Benozzo Gozzoli had commented in a letter to his patron, Piero di Cosimo, while working on the Chapel of the Magi in the Medici Palace, in July 1459:

> I would have come to talk to you, but I started on the blue this morning and cannot leave it. The heat is intense, and the glue suddenly went off. I believe I will have finished this part next week and I think you will want to see it before I take the trestles down.[7]

One encountered similar problems when applying gold leaf, a crucial addition that embellished the wall painting and made it more like a panel painting. Gold leaf was beaten until it was so thin that artists had to hold their breath so as not to blow it away when applying it to the wall. It was added to dry plaster, often in areas curved out in relief, such as haloes, or punched with a metal point and covered in a glue called *mordente*, made from varnishes and mastic; or it was applied onto a very thin layer of dense clay (the bolus). It was gold leaf that created a jewel-like effect in some parts of the wall.

Cennino Cennini was the first to record systematically all this experience, accumulated over centuries of practice and displayed by Florentine artists, by putting it in a book and giving it theoretical form. He was the pupil of one of Giotto's disciples, and he flaunted this descent as a guarantee that he was in a position to divulge secrets that had been first tried and tested by Giotto himself. But the research had not ended with Cennini: in Tuscany and Umbria, during the first half of the quattrocento, innovators such as Masaccio, Andrea del Castagno, Piero della Francesca, Fra Angelico, Ghiberti, and Donatello had advanced the technology of art, turning their workshops into veritable experimental laboratories where they made progress in metal casting, in the

production of hard metal rods for sculpture, and in the execution of large expanses of fresco painting. The fervour of this research and the virtuoso nature of the competition were enhanced by the city's modest size and by the exceptional wealth of its patrons, who were knowledgeable enough to make an informed selection of samples, rendering the output of the city's workshops very uniform in terms of both style and technology. The best results became common knowledge.

In the years before the commission for the Sistine Chapel, one of the most advanced artists' workshops in Florence was that of Andrea del Verrocchio, who can be seen as a real scientist in view of his artistic and technological exploits. He was asked to make the large, gilded copper sphere that topped Brunelleschi's lantern on Santa Maria del Fiore. He also cast the sculptural group *Christ and Saint Thomas* for one of the niches around the outside of Orsanmichele, a sort of window display for the city's most advanced sculptures, and at least two of the four artists involved in the Sistine project had passed through his workshop: Perugino and Botticelli. Ghirlandaio may also have spent time there. The three of them had passed through his workshop during a period when it was frequented by another painter, who chose a revolutionary path of his own making, far from Florence and Rome: Leonardo da Vinci. Leonardo put every crumb of Verrocchio's teaching to good use, even though he never acquiesced in the intense productivity required by the Tuscan art market.

So the group of artists chosen by Sixtus IV for his undertaking had in common the fact that they had attended the same 'school', possessed a standardized technique of fresco painting that could deploy the best Tuscan research in this area, and could execute large frescoes quickly and with great homogeneity, precisely through their technical and stylistic uniformity. Sixtus IV, and above all his nephew Giuliano della Rovere, knew Florence well enough to be aware of how the city had evolved in its artistic output, and this explains why they summoned the four painters to Rome. They took up the challenge; but how could they have refused it?

6

A SINGLE VISION

The scenes from the Old and the New Testament were set within a large architectural framework, divided by pilasters ornamented by gilded grotesques and topped by a deep cornice; and, as I mentioned earlier, the latter supported a corridor that gave access to the windows, set into the third and uppermost band. Between these windows were painted false niches that hosted the portraits of the popes.

This architectural framework, separated horizontally by fictive porphyry cornices, played an important part in fostering the overall vision and guaranteeing the homogeneity of the various scenes portrayed. It was an innovative illusionistic device, which imagined an external world seen through the great architectural gallery that framed the chapel walls and whose pilasters were sufficiently robust to make a visual impact and to modulate the space divided into rectangles and topped by the broad upper frieze.

The first ingenious decision that guaranteed the uniformity of this vision of the different biblical scenes was to align the horizon in all the frescoes. A visitor walking through the chapel is given the impression that beyond the classical gallery lies a single landscape, inhabited by Christians intent on reliving the stories that the pope's advisors had decided to draw to their attention. This unifying treatment, which was probably the idea of the architect who carried out the works, acquires

even greater credibility through the choice of colours and the scale and gestures of the figures portrayed in the scenes. It is as if all were obeying strict stage directions, moving with the same decorum and propriety along the edge of the scenic space that lies closest to the spectator. The figures are all depicted to the same scale, being just slightly larger than life, and they are almost the same in number throughout all the scenes.

Undoubtedly this sort of organization is, in part, the result of the economic rules used in the estimation of painting in the quattrocento: the value of a work was directly linked to the number of figures or 'heads' that the artist depicted in it (as well as to the amount of lapis lazuli and gold leaf he used, of course). The use of lapis lazuli for the sky achieves such an even result that it is easy to imagine how the artists in charge of the work agreed on the precise quantity of pigment needed per square metre and on the quality of pigment to be used for the clouds, so that in each panel the sky seems to be lit by the same vernal light that made the paintings of those decades so transparently seductive. Agreements were certainly reached on the pigments to be used for the flesh and for the foliage, as well as for the rocks and for the ancient ruins visible in the backgrounds. Such details are hardly surprising because the Florentine tradition – as summed up in Cennino Cennini's treatise – gave precise instructions for the pigments to be used for faces and bodies, for clothing, and for trees and the sky. Painting was like a shared language in the quattrocento, it had its own rules and grammar. But in this case, considering the number of artists at work and the enormous area to be decorated, the uniformity of the shades of colour presupposes a rationalization of the production process that could have been achieved only in Florence.

To understand how these artists worked, we could turn perhaps to the collective artistic experience that stands closest today to the one used in the Sistine: the execution of a monumental restoration project entrusted to different groups of restorers. During both the cleaning of a fresco and its reintegration, the various restorers tend to impose their own taste and to differentiate the image that undergoes restoration. But when they are asked to restore a fresco cycle whose underlying homogeneity must be preserved (as happened with the Scrovegni Chapel in Padua, whose restoration involved as many as eight different teams of restorers), they need to work closely together, verifying each time the

effect of a retouching or cleaning and deciding from the outset to use the same solvents and pigments.[8] This must have been the case with the painting of the Sistine Chapel: the detailed planning transformed the consortium into a single workshop, inspired by the practice of the workshops in Florence whose way of working was so standardized that even today it is hard to distinguish between the hands of individual artists.

7

THE DIFFERENCES

Within the ambit of this language, so uniform in material and style, each artist tried to complete the images as best he could, making the most of the stylistic features for which he had already received praise and a consolidated position in the market.

If we take Perugino's paintings, we see immediately that the recognizable quality of his art is, here too, in the sweetness of psychological insights, in the graceful poses he uses in order to group his figures, and in the clarity of colours, which always avoid any strong contrasts and their visually unrealistic effects. These stylistic features, which would also be commented on by contemporary critics (starting with Vasari), are the hallmark of an artist who moved within a language that was rigorously shared by an entire generation and that allowed only minor variations – expressions of the artist's individual sensitivity such as gracefulness, soft features, a particularly successful rhythm of the groupings, and – as mentioned earlier – a colour palette that was 'filtered' by the air to soften tonal contrasts. All the Sistine artists respected the value of complying with the rules that underpinned this language. To this generation – which, at various levels of skill, conveyed an identical expressive style by harmonizing the general features of the composition – modernity consisted in uniformity of language, namely in the willingness to stick to a stylistic fashion that shared colours, gestures, and realism in representation.

Unity of place was achieved by unifying the horizon and the sky on either side of the false architectural structure, while unity of time, which is likewise important for narrative impact, was found in the style of clothing and the landscape dotted with Roman ruins, a feature that also bolstered the pope's political strategy of forging close links between Rome, the seat of the papacy, and the historical, cultural, and theological patrimony of the Old and New Testament.

With its recognizable ancient and universal ruins, imperial Rome, as well as the city built by Sixtus IV, appeared as the ideal setting for the historical narrative. It was a clear message to the Ottomans and their Italian supporters. The affirmation of the visual centrality of Rome foiled Mehmed II's attempt to divert the imperial legacy of the Caesars to the Turks who had conquered Constantinople. It was a concept that would be underscored in the most important of the frescoes allocated to Perugino, the first to be seen by any visitor to the chapel: *The Delivery of the Keys to Saint Peter* (plate 6).

8

THE APOSTLES' WARDROBE

The robes worn by the protagonists in these biblical scenes had the styles that tradition and convention had assigned to the early Christians for some centuries: heavy, coloured cloaks made of cloth interwoven with gold and silver and worn over simple tunics of lighter material. The women were typically shown wearing transparent or embroidered veils, which symbolized pagan femininity. But alongside these 'meta-historical' styles, the product of an abstract and ideal construction, contemporary styles appeared too, in a visual syncretism that lacked any sense of discontinuity; they were duly described with sartorial precision, but were almost always used to dress the spectators, never the protagonists. The clothing on the walls of the Sistine Chapel constitutes an exemplary catalogue of the late fifteenth-century Italian wardrobe. The *lucco* (an ample and full-length robe made of heavy cloth), the *sbernia* (a cloak), the doublets, hose, and shoes, together with various styles of hats, helped to make the narrated events feel contemporary. Besides, the fact that artists should be invited to celebrate the beauty of fabrics was all too natural in a city like Florence, which owed its wealth to a cloth industry renowned throughout Europe.

In nearly every section, groups of spectators appear alongside the scene that makes the subject of the narrative action; and they wear contemporary clothing, depicted with marked realism. At the edges of

the main scenes, literally as if surrounding the stage, men and women in minutely detailed contemporary outfits attend the event, as if they formed an audience. Even in *The Last Supper* (plate 13), two witnesses in contemporary clothing stand in the foreground, beside the table where the Apostles are dramatically and solemnly seated, and introduce us to the ceremony destined to become the core of Catholic liturgy. In some depictions, such as *Baptism of Christ* (plate 2) by Perugino and *Vocation of the Apostles* (plate 3) by Ghirlandaio, the large number of contemporary spectators suggests that the story is being told through these groups.

In the *Baptism*, the group of older and young men present is described in a moving manner. Elegantly dressed men, and also boys – the one with crossed arms in the foreground is perhaps one of the most beautiful figures in the Sistine – look out at us with serious expressions and luminous gazes, which can be seen every day in the markets of Florence or in the narrow streets of Rome. They introduce us to the *Baptism* with the aim of making us feel part of that ceremony, of bringing it to the present and involving us. They have moved it right under our window!

As many have suggested, these are portraits of important people, but this was not the principal reason: both artists and patrons were all too aware that in the space of a generation or two the identity of these characters would be lost. The presence of contemporaries was motivated instead by an extremely sophisticated communication strategy. It consisted of locating the sacred event in the here and now and reappropriating it through one's own presence, so that no one could question the legitimacy of the sacred place.

At times the presence of these witnesses is really unsettling. Is it an aesthetic game? Or a subtle message of self-celebration? This seems to be the case with the two particularly handsome and elegantly dressed young men who stand on the left of Ghirlandaio's fresco *Vocation of the Apostles*. One of these adolescents, with blond hair and a green tunic, wears a garland of flowers on his head that, according to some scholars, might allude to the artist's name, Ghirlandaio, because garlands of this kind were highly prized in his workshop. But if that was the intention, why has the artist drawn an equally beautiful young man beside him, with a golden doublet and a red velvet hat on which a man is attaching a white feather held by a pearl brooch with an antique coin or cameo at

its centre? What was the purpose of these figures, if not to establish a direct link between the story in the Bible and people's lives in the late fifteenth century? It is worth underlining the psychological and intellectual daring of an Italian vision of society, in which human beings were so central that it was appropriate for them to be protagonists in the sacred event, which was a reappropriation and revitalization of history and tradition. It seems that we could see these bystanders as inviting contemporaries to play a part in the story.

The attention paid to fabrics was also typical of contemporary style, because the formal lexicon of the time called for a painstaking depiction of luxury cloth almost as if this were one of the main aims of artistic research. Together with architectural and spatial perspective and anatomical congruity, the ability to specify the fabric was indeed a central preoccupation for painters of the quattrocento. The ornamental patterns painted on fabrics represented an elaborate and almost unchanging repertoire, which competed with the actual fabrics, whether produced in Italy or imported, and especially with the damasks arrived from the eponymous Syrian city. The motifs used to embellish velvets and the embossed brocades on silks and linens were jealously guarded by each artist's workshop through cartoons and appeared time and again, in any painting – but with different background colours. In fact, through the variety and complexity of the fabrics on the walls of the Sistine Chapel, we can recognize the different artists' workshops, or at least identify the different working techniques used by workshops to depict the fabrics. Such techniques almost invariably involved using templates [*maschere*] with the outline of the floral or geometric decorations. These were transferred onto the wall with the help of cartoons and then gilded with gold leaf, before being cleverly shaded to look like a sample of real fabric. Indeed, as we have seen, the value of the painting was estimated according to the quantity of its gold embellishments, and gold could be used on fabrics without detracting from the naturalness of the image. That said, in these paintings the need to show the power and wealth of the papacy prompted the artists to add gold to the leaves on trees, to the clouds, and even to the grass, vaguely outlined in the distance.

The reproduction of these textiles and of their decorative patterns resulted in fierce competition between the workshops in central Italy,

each of which could be recognized by the special ornamental devices it used. A series of damasks decorated with a leafy thistle had appeared in Perugino's workshop precisely during the work on the Sistine paintings, and this helps us to identify the contribution of one of Perugino's most gifted pupils, Pinturicchio, who was to make the richness of fabrics and mastery in their depiction the trademark of his own pictorial style. These damasks were jealously guarded over the decades and reappeared unchanged twenty years later, in the frescoes on the Piccolomini Library in Siena. Once Pinturicchio graduated to master painter, he put all his refinement and excellence into the imitation of these precious fabrics. The exceptionally beautiful golden fabrics that adorn the figures on the left of the panel depicting the *Baptism of Christ* (plate 2) allow us even to guess the date of Pinturicchio's arrival in Perugino's workshop.

For the garment worked entirely in gold that clothes the third figure, Pinturicchio employs a technique that he would use again twenty years later in the Piccolomini Library, even down to the almost identical floral motif of the flowering thistle. This is perhaps the most splendid and imaginative example of a piece of cloth painted in the fifteenth century. The painter first applied a thin layer of gold over the entire area of the robe and then he started to transfer the traced outline of the geometrical pattern in dark brown, which was then shaded with lucid colours and finished with a brownish lacquer. This created the intensely lifelike effect of a brocade made entirely of gold on which the light rippled and refracted in elusive flashes – just like in a golden fabric. All that was needed to make it look almost perfectly realistic was to emphasize lightly the hang of the folds by adding transparent and brown shadows (in Siena the painter would use lacquer). This was very different from Botticelli's technique for imitating golden fabric. In the scene of *Temptations of Christ* (plate 4), to the left of the priest we see a group of figures whose precious robes are covered in a solid layer of gold applied over the drawing of decorations such as oakleaves and acorns, which allude to the heraldic emblem of the Della Rovere family and their patron.

Yet another method of application can be seen in the paintings of Luca Signorelli, who used gold to highlight the hems and other parts of the folded fabrics that caught the light. In this case the gold was

treated as a colour and applied in small touches directly on the paint-
ing, after having been mixed with a binder. During this process the gold
was placed in shells (those white scallops from the Adriatic also known
as 'pilgrim shells' [*conchiglie del pelegrino*], with marvellously smooth
inner surfaces), which is why this type of application was termed 'shell'
gold [*oro 'a conchiglia'*]. To simplify, one could say that here the gold
replaced the white or yellow ochre, which was generally used to deco-
rate the highlights of folds in the fabric. Signorelli used this technique
extensively in the scene of *Testament and Death of Moses* (plate 10), and
continued to use it throughout the rest of his career, including in the
splendid paintings for the Brizio Chapel in Orvieto. A technique can
identify an artist and his workshop with precision, and perhaps more
easily than a style of painting, which is much more complex to analyse.
And an artist will stay faithful to his techniques throughout his career.

 Shell gold is applied according to the same criterion, namely of
forming sparkling highlights, along the edges of the oakleaves in the
scenes of *Temptations of Christ* (plate 4) and *Trials of Moses* (plate 9),
both by Botticelli; this is in homage to the heraldic emblem of the Della
Rovere pope. Perugino used shell gold to highlight the armour worn
by minor figures in the background of *The Delivery of the Keys to Saint
Peter* (plate 6); he also used it on the tops of distant trees and would
continue to do so for the next thirty years, not only in frescoes but also
in his panel paintings.

 Only Ghirlandaio seems to have been unwilling to make excessive
use of gilding, which is somewhat paradoxical in an artist who had
embarked on his career as a goldsmith. Vasari's biography is helpful
in correcting this apparent contradiction. Having been initiated by his
father into a promising career as a goldsmith, the young Domenico had
an unquenchable passion for drawing (apparently he drew the portraits
of all the clients who entered the workshop where he did his appren-
ticeship). Even in middle age and in a context that exalted material
wealth, he was unable to escape his fascination with that intellectual
abstraction whereby, through the simple power of a line, he could cap-
ture the entire world around him.

 Vasari also helps us to understand Cosimo Rosselli's particular use
of gilding. He was a very mediocre painter, or at least this was his repu-
tation in Florence, where he had trained as an illuminator rather than

painter. When he was involved in the Sistine project, he soon under-
stood that the comparison with other masters would leave him cruelly
exposed, given his poor ability to draw and to use perspective. His pre-
vious work as an illuminator prompted him to embellish his paintings
with gold highlights instead of pale colours, not only in the definition
of clothing but also in the landscapes. Here is what Vasari wrote in his
Life of the painter:

> Cosimo, feeling himself weak in invention and draughtsmanship, had
> sought to conceal his shortcomings by covering his work with the
> finest ultramarine blues and other lively colours, and had illuminated
> his scenes with a plentiful amount of gold, so that there was no tree, or
> plant, or drapery, or cloud, that was not thus illuminated.[9]

The pope must have found the results very pleasing because, again
according to Vasari, he awarded Cosimo the prize for the most beauti-
ful painting, having little knowledge of colour and drawing. Leaving
aside Vasari's comments regarding Sixtus IV's lack of taste, there is no
doubt that the favour shown to Rosselli's work indicates that this medi-
eval taste for handcrafted painting [*pittura artigianale*] was still strong
at the end of the fifteenth century, when it was regarded as a precious
object, on a par with a reliquary or a tapestry embellished with silk and
gold.

The new taste that emerged in the Sistine Chapel is perhaps best
documented precisely by Ghirlandaio's painting, which was based
on the perfection of the underlying draughtsmanship. Ghirlandaio's
unwillingness to use gold can be explained by the centrality of ceremo-
nial draperies to his project and by his search for a coherent plasticity
of their folds, which should reveal the body behind them; Michelangelo
would later carry this trend to the extreme, as a result of the artistic
imprinting* he received in his workshop. This stylistic trait, which
marked Ghirlandaio out from other Tuscan painters, seems to have
stopped him from making abundant use of gold because that inter-
fered with the gradual shading with which he defined the draperies on
his figures. Notwithstanding illumination or shading with transpar-

* 'Imprinting' is in English in the original.

ent lacquers, gold represents a chromatic simplification by comparison with the infinite tones that can be obtained by blending pigments. Moreover, Ghirlandaio preferred to mould his draperies on the anatomies under them, and this is something that became more difficult if gold leaf was added.

Hence fabrics, with their embellishment and their woven consistency, formed part of a patrimony that was shared by Florentine workshops along with the clarity of landscapes and the graceful poses of figures, even if we have seen how each artist made a different use of the contemporary wardrobe, depending on his own visual sensibility.

9

THE IDEAL CITY

The representation of architecture plays an important role in the decoration of the Sistine Chapel. It could not have been otherwise, given that the pope intended to use the cycle to place the centre of the church's spiritual life in an ancient and idealized Rome: the scenes from the lives of Moses and Christ were set against this background. The use of architectural details in each panel was particularly important, because they emphasized a link with imperial Rome that was claimed by the papacy itself. An analysis of these architectural settings also reveals important clues for reconstructing the work within the chapel.

The classical buildings painted by Perugino are very different from those painted by Botticelli and by Ghirlandaio, even if all of them reinterpret the city of Rome to some extent. This marked difference in how ancient architecture was depicted might simply mean that there was no single designer of the paintings, no single artist who drafted preparatory sketches for all the panels, as many scholars continue to argue. And likewise, there was no central management of the work. The patron's role was limited to defining the topics for the paintings and to approving the preparatory sketches, but this left ample room for each workshop to develop them, albeit within the linguistic unity highlighted previously. If one artist, perhaps Perugino or Giovannino

de' Dolci, had been given overall responsibility, we would have had a uniform treatment of the classical monuments. But instead these buildings are very heterogeneous, and this stems from the widely varying knowledge of antiquity within each workshop. The building shown by Perugino in *The Delivery of the Keys to Saint Peter* (plate 6) reveals an in-depth study of classical architecture, and this is his attempt at a serious and evocative interpretation.

Botticelli offers a very different interpretation of Roman antiquity. While in *Punishment of Korah* (plate 8) two famous Roman monuments, the Septizonium and the Arch of Constantine, are depicted with antiquarian punctiliousness, in the fresco of the *Trials of Moses* (plate 9) a glimpse of Leon Battista Alberti's Rucellai Palace in Florence is sketchily evoked and made to appear to be, incongruously, no less classical than the Roman ruins. Moreover, Botticelli's naive lack of architectural knowledge is highlighted by his use of the wrong perspective for the pilasters on the building's façade. Yet it was Botticelli who in *Temptations of Christ* (plate 4) underscored the high esteem in which the new architecture was held in Rome. Here a perfect representation of the façade of the church of the Hospital of Santo Spirito in Sassia, commissioned by Pope Sixtus IV, appears in the background as an example of continuity with the formal language of ancient architecture. There could be no clearer and more coherent gesture, in a cycle designed to reinforce a celebrative identification of ancient Rome with modern Rome.

This need to emphasize the identity and centrality of ancient and modern Rome is pushed to the point of representing the *Baptism of Christ* (plate 2) as taking place (and this is certainly far-fetched) in the Tiber rather than in the River Jordan: the city visible in the background is Rome, recognizably and beyond doubt – not some Palestinian cityscape. The three most important monuments in ancient Rome can be easily made out: in the foreground, the Arch of Constantine, which looks like an icon of imperial Rome; then, by the city walls, the Pantheon with its pronaos and the dome behind it; and, to its left, the Colosseum. Again, Rome seems to be evoked by Domenico Ghirlandaio, much more vaguely, as the walled city in the background of *Vocation of the Apostles* (plate 3), where a column reminiscent of Roman sculpted columns stands out.

An even hazier knowledge of antiquity appears in the work of Biagio d'Antonio, who collaborated with Ghirlandaio on the *Crossing of the Red Sea* (plate 11). The city in the background has no special features, but it looks like medieval Florence rather than like the city of the pharaohs.

The marked difference between the workshops in their representations of imperial antiquity reveals not only the taste for antiquarian studies shown by individual artists or by the workshops where they trained, some more up to date than others, but also the decisive, creative freedom given to individual artists as they worked in the Sistine Chapel. If there had been a single point of reference – a hypothesis that many scholars have argued for on the grounds of the importance of the project – there would have been greater homogeneity regarding what was, from a Florentine perspective, the most 'exotic' aspect: the reconstruction of ancient Rome. In the Florentine workshops the reconstruction of Roman antiquities did not attract the same level of attention as the study of drapery and of the human body, for example; and this is why there were such blatant differences in this aspect of the decoration.

If Giovannino de' Dolci, the overseer of the Vatican buildings, had tried to provide a rigorous definition of the architectural details, the results would have been different. But this did not happen, and every artist was able to decide on his own cityscape, perhaps simply by submitting a sketch of the fresco to the papal authority or a representative.

10

THE DANCE

To finish this discussion of the unchanging elements that made the work of the consortium possible, we need to focus on the physical gestures, as these followed the unwritten code of a choreography known to all in the quattrocento.

The position of the figure in space, a recent achievement of the Florentine workshop, followed fixed rules that showed people from behind, in three quarters, and in profile, as well as from the front. Standing in these positions, the figures always adopt the same pose, and the position of the feet and the gestures of the arms are stiffly repeated. To understand this phenomenon, we need to realize that artists struggled to develop an innovative pose for a human figure in space and that the idea of anatomical foreshortening – the study that carefully appraised how the ratio of the limbs should be altered when the pose changed, to make the image credible – still lay in the future. This is a real anatomical perspective inside the body, and its conquest in the next generation would make the representation of the body in space even more credible; but this achievement had not yet been accomplished for the generation of the Sistine Chapel painters. According to the rules of foreshortening, for example, the right arm must be smaller than the left if the left side of the figure depicted is closer to the viewer; but it is easy to note that, in the Sistine frescoes, both arms are often identical

and sometimes, for iconographical reasons, the arm further away seems to be even longer than the one that is closest. A clear example appears in the figures of Moses in the scene of Pietro Perugino's *Circumcision* (plate 7). It was even harder to compose a scene that contained in the same space several figures in complex poses that called for a reciprocal dialogue of bodies and emotions. At the time of the first Sistine decorations, all this was still in the future.

Each workshop had its own archive of drawings, which corresponded to the most frequently used poses, and the cartoons were often turned over for the purpose of economizing on design and paper. In the scene of *The Delivery of the Keys to Saint Peter* (plate 6), on either side of Christ and Peter, two figures look like the mirror images of the same pose. The slanted right leg has a gently lifted foot, while the left leg, which bears the weight, rests firmly on the ground and turns the foot with the precision of a mirror. The torso is slightly slanted, as is the head. One arm is bent to support the heavy folds of the cloak, and the other is held in a slightly more complicated way. The left hand is lifted in a gracious halting gesture while the right touches the chest to indicate the emotion of the moment with a studied grace. The turned-out feet, the bent leg, and the slanted upper body and neck are repurposed, in almost identical form, in Christ's pose in *The Baptism* (plate 2). The faces are always composed, the eyes look straight ahead, and the mouth is rigorously shut. Even when engaged in a lively exchange of emotions, as in the small group to the right of Christ in *The Baptism*, all the men keep their mouths shut tight. This is just one example of a dance of gestures that can be found uniformly in almost all the chapel's frescoes, as well as in other contemporary paintings throughout central Italy.

The development of a pose was always an arduous task for an artist. By picking up every now and then poses used by earlier artists, painters could introduce minute changes, which would then be added to the workshop's pool of examples and put to constant use in each fresco cycle, even in the same scene. These poses, first studied in sketches and then enlarged in preparatory cartoons, represented one of the workshop's most valued possessions. Here in the Sistine, the reputation of Perugino's workshop was bolstered by his earlier development of a series of graceful poses that gave his narratives a sweetness and a solemnity much appreciated in the market of the time.

Closely linked to the pose was the facial expression, on which the decorum of the narrative depended. Mimicry and the appropriate decorum of the pose in relation to the historical scene were questions that Leon Battista Alberti had reflected on. So would Leonardo and, in the treatise on painting, which he began during this period, he prescribed what poses were best suited to the representation. The feelings expressed by these figures could vary in intensity, as in battle scenes or assassinations, but they also had to be defined within a narrow range of expressions that showed the gestures of the protagonists in a decorous manner. The four artists and their workshops moved within the constraints of this highly prescribed technical and stylistic language, and each brought a specific sensitivity to composing it and making it their own, recognizable but at the same time compliant.

The best result was achieved by Perugino, particularly in view of the fame that followed what was perhaps the high point of his own artistic expression in *The Delivery of the Keys to Saint Peter* (plate 6), a painting that was destined to be reproduced in the coming decades without great innovations. Perugino's specific approach to the representation of grace and composure is a minor miracle, one that marks the creative power of art in every age and its capacity to overcome all obstacles, even those imposed by a rigid social segregation such as that in fifteenth-century Italy.

This stout maestro from Umbria, whose lifelong appearance retained the signs of his peasant origins, came from the humblest social background by comparison with all the artists who worked in the Sistine Chapel. Born to a very poor peasant family in Città della Pieve, he had set his sights on starting a career as a painter, come what may. Realizing that Italian art was reaching vertiginous new heights in Florence, he left Perugia, where he was apprenticed to a mediocre painter, and travelled to Florence without a penny to his name. For months he slept in a crate, having no house where he could take shelter, before he finally joined the workshop of Andrea del Verrocchio; and there he learnt the essentials of techniques and current styles. It was he, then, who, born into a micro-world that had neither grace nor gentility and where elegance of manners was not at home either, nevertheless developed an ability to depict people in a 'sweet' style, which was almost disturbing in the gentleness of lineaments and gestures – a gentleness that would

later be surpassed only by Raffaello Sanzio. In the paintings for the Sistine Chapel, Perugino reached the summit of his art, bringing to his storytelling a supernatural atmosphere that exerted a greater charm than Cosimo Rosselli's glittering gold. The latter may have charmed the pope, but not his contemporaries, who awarded the victor's palm for the Sistine to Perugino and, a few years later, compared his work to Leonardo's marvellous art. Indeed, there is no escaping the fact that Perugino was the only artist to add his signature to a painting in the chapel, under the fresco of the *Baptism of Christ*.

11

THE ICONOGRAPHY OF THE CYCLE

The iconographical programme of the decoration took as its central focus the parallel narration, on opposite walls, of scenes from the life of Christ and from the life of Moses. It was a manifest assertion of the legitimacy of the Catholic doctrine as sole universal religion and heir to the Old Testament, from which Islam, too, descended. The religion of Muhammed was regarded by medieval and Renaissance theologians as no more than a form of heresy, one of many, and indeed some considered Islam to be the mother of all heresies. In his *Augsburg Confession* of 1530, Philip Melanchthon would include Muslims among those heretics who denied the Trinity, for example the Manichaeans, the Valentinians, the Arians, and the Eunomians.[10] Establishing this legitimate descent with a linearity that made it visible could be done only by comparing the life of both protagonists of the Christian scriptures. Moses, who symbolized law before Christ's advent, is shown as prefiguring Christ. Indeed, a theological tradition consolidated over the centuries made the New Testament comprehensible only in the light of the Old, so much so that many events in the former were held to be reflected in the latter. Saint Augustine had made the point that the New Testament was hidden in the Old and the Old became clear in the New.[11]

The significance of the mirroring stories in the scriptures is reinforced and clarified by the *tituli* painted in the cornice above the panels, in

which the Latin translation was used for emphasizing the paired nature of the scenes illustrated on opposite walls. The Latin titles impose New Testament terms, and therefore concepts, on Old Testament events. Their purpose is to suggest parallels that are in many cases artificial, 'constructed'. Jewish circumcision, for example, is conceived of as the ancient form of that 'regeneration' expressed in the Christian baptism, and the trials through which Moses realizes that he is a Jew called by God appear overall as a 'temptation', simply to be equated with the temptations of Christ.[12] Thus the two scenes facing each other on the north and south wall – the *Circumcision* and the *Baptism* – are respectively described in the *tituli* as *Observatio antiquae regenerationis a Moise per circoncisionem* ['Moses' observance of the ancient mode of regeneration through circumcision'] and *Institutio novae regenerationis a Christo in baptismo* ['Christ's founding of the new regeneration through baptism'] and the next two scenes on the same walls are described as *Temptatio Moisi legis scriptae latoris* ['The temptation of Moses, bearer of the written law'] and *Temptatio Jesu Christi latoris evangelicae legis* ['The temptation of Jesus Christ, the bearer of the evangelical law']. The visitor did not assimilate the historical–chronological sequence of the events but rather their mystical significance, namely that Christ existed before Moses and that his life fulfilled and gave meaning to that of the biblical lawgiver.

In iconographical terms, this was not easy because the representation of Christ's life drew on a copious iconographical tradition that for centuries had narrated the life of Jesus in images that could be understood, painted on church walls and on panels, and represented in the illuminated Gospels created in monasteries throughout Christendom, from Constantinople to Rhodes and Paris. The life of Moses had not seen the same type of widely shared iconographical tradition. There were occasional examples, above all in monastic incunabula, but little had been transferred onto walls or panels. Nonetheless, this absence offered a freedom of expression that could push towards a greater visual uniformity of the images, benefiting the ultimate purpose of the decoration: to demonstrate an indissoluble connection between the Gospels and the Old Testament.

Above the altar were the two initial scenes, *Moses in the Bulrushes* and the *Birth of Christ*. These two scenes, which marked the beginning

of each narrative, were destroyed by Michelangelo fifty years later, to make room for the painting of *The Last Judgement* behind the altar. This is a striking example of how artistic demands followed those of papal politics.

The two opposite walls of the chapel, south and north, started respectively with the painting of the *Circumcision of the Son of Moses* (plate 7) and the *Baptism of Christ* (plate 2), two scenes with an analogous meaning: the sacrament of consecration to God through the cutting of the foreskin (as described in the Old Testament) and the sprinkling of baptismal water. These were followed by *Trials of Moses* (plate 9) and *Temptations of Christ* (plate 4), *Crossing of the Red Sea* (plate 11) and *Vocation of the Apostles* (plate 3), which were perhaps paired by virtue of their watery setting rather than through any real textual connection. Then, moving towards the chapel entrance, we find the *Descent from Mount Sinai* (or *Adoration of the Golden Calf*, plate 12) and *The Sermon on the Mount*, the *Punishment of Korah* and *The Delivery of the Keys to Saint Peter*; and lastly, in the panels to each side of the doorway, the *Testament and Death of Moses* (plate 10) and *The Last Supper* (plate 13). The links between the parallel stories are very complex and were undoubtedly clearer to the fifteenth-century audience than they are to us today. But there is no doubt that the conceptual unity of the narrative carries conviction mainly, perhaps, because of its stylistic unity.

12

PROPAGANDA

There is among the panels one that seems to have fully achieved the purpose of the papal commission: *The Delivery of the Keys to Saint Peter* (plate 6). This was one of the most important scenes of the whole decoration, because Christ's act of handing the keys to Saint Peter legitimated not only the spiritual but also the temporal power of the papacy. Moreover, the scene was in the most visual part of the chapel and was the second one to be seen by laymen, who walked in from the doorway reserved for them at the eastern end. It dominated the area set aside for them; and this area was separated from that of the clergy by a chancel screen, which at the time was a little less than halfway down the chapel. The chancel screen was moved to its present position at a later date.

In this scene, Perugino blended the grand scale of ancient architecture – in the form of a marvellous central-plan temple flanked by two triumphal arches – with that fifteenth-century spatiality he created through the aerial quality of blue skies and receding hills, a feature that remained the hallmark of his painting style. Within this grandiose setting – which was at once urban and natural, and therefore psychologically alienating – Perugino condenses the action almost around the viewer and moves his protagonists with a solemn grace that strikes us with its balance and sense of completeness. The arrangement of the figures, the arrange-

ment of the buildings in the background, and, even more, the sky and the landscape all converge, through a delicate but inexorable perspective, towards that bunch of keys that a handsome young Christ holds out to Saint Peter, who is kneeling before him. The scene encompasses the core meaning of the Sistine decoration and capitalizes on the best of the artist's stylistic research, the rhythmical balance of the figures, their graceful gestures and gentle expressions. The whole is framed in a setting of moving grandiosity, in which nature seems to celebrate the sanctity of the ritual act and the human ingenuity that has envisioned such perfect and geometrically proportioned architecture. If the Italian Renaissance is understood as the collective search for a codified formal language, then this painting is its high point.

The other artists did what they could to follow Perugino, each one making the most of his own stylistic traits. But none drew even close to his perfect grace; and this has prompted many scholars to hypothesize that Perugino was entrusted with the general direction of the paintings. In the scenes attributable to Ghirlandaio and his assistants, we find landscape vistas that look as though they have stolen a march on Leonardo da Vinci's work in Florence by transposing it to Rome: mountains that slope towards distant waters, their colours gradually fading until they blend into the sky, and the minutely detailed depiction of the flora, another highpoint of Florentine painting, with a series of trees and flowers that had never been seen before in Rome except episodically.

If anything, the way the episodes are fragmented within a particular narrative hinders the successful outcome of the scenes painted by Ghirlandaio and Botticelli, as well as those painted by Cosimo Rosselli. All three artists disperse the viewer's attention by breaking the narrative into unrelated scenes. Perugino, on the other hand, even when narrating different moments of the same scene (as in *Circumcision of the Son of Moses* and *Baptism of Christ*), relegates the minor episodes to the background, without undermining the narrative solemnity and pathos of the main scene, which has an immediate impact on the viewer. These differences in composition also argue in favour of a commission that gave complete freedom to individual artists. If the narrative structure had been overseen by a single person, there would have been greater balance between all the compositions. On the contrary, only Perugino,

who worked entirely on his own, seems to have hit the mark in this monumental undertaking.

In the scene of the *Trials of Moses* (plate 9) painted by Botticelli and made up of episodes dotted across the open countryside, the merit of the composition lies in the trees and the drapes. The gilt-edged oak, which, as already mentioned, alludes to the heraldic emblem of the Della Rovere, looks as though it were taken from a textbook on botany, so precise are the leaves and so deep the colours. But it is not enough to give the painting narrative unity, clear exposition, and pathos; one should point to the garments as the real markers for identifying the figures in Botticelli's and Ghirlandaio's scenes. Jesus wears a red tunic and a sky-blue cloak, Moses a yellow tunic and a green cloak, and his garments stay the same colour even when the prophet's dark beard and hair turn ash-grey, in the last three scenes on the south wall. Jesus does not have the privilege of growing old, so his chestnut hair remains unchanged.

The attribution of some of the scenes is problematic, for example that of the *Crossing of the Red Sea* (plate 11). Here, too, the historical context looks vaguely related to antiquity, since the city in the background contains recognizable buildings from the countryside around Rome and the sea that engulfs the pharaoh's army is not particularly successful. Vasari, who is not always reliable, suggests that parts of this scene were painted by artists who were not named in the contract, just as happened with *The Last Supper* (plate 13). Was the work subcontracted? Did Ghirlandaio and Cosimo Rosselli resort to using collaborators because they were unable to do the work in person? The documents are not clear on this point. In the autumn of 1481 Domenico Ghirlandaio returned to Florence, of course, because his son had just been born, but this alone would not account for the intervention of new artists such as Signorelli, Bartolomeo della Gatta, and Pinturicchio, who are mentioned by Vasari. Pinturicchio's hand can be identified, it seems, on some of the fabrics in Perugino's paintings because the decorative motifs, the way of using gold embroidery, and even the same stiff poses appeared twenty years later in the Piccolomini Library in Siena. They are a sign of how long-lasting the formal code established in the Sistine Chapel would become. But it is certain that the decoration was completed, in line with the pope's wishes, by the end of 1482, when a solemn mass was held to inaugurate the chapel.

The decoration was both the apex and the most successful expression of an Italian artistic community capable of working flawlessly in concert. What was more, it conveyed to the world Sixtus IV's message that the popes' legitimate descent from the civilization of Rome was not to be disputed – not even by the armies of the sultan, whose death in the spring of 1481 was greeted with jubilation among Christians and left Europe's rulers with the illusion of having dodged a fatal danger.

13

NO RULES AT ALL

While the Florentine artists had proved that they could produce a collective, mature, and seductive language so successfully as to make it look like the work of a single person, there was at the time an artist who could not comply with any rule at all when it came to art. Three hundred miles away from Rome, he was demolishing the very language that was glorified through the mantles of cardinals assembled for inaugural celebrations, through the voices of the papal choir, and through the clerics' incense burners. That man belonged in every sense to the group of painters who had left for Rome to work in the Sistine Chapel; he had shared their training and perhaps had even lived in the same house during that training, but he believed that his destiny was different from theirs. His name was Leonardo da Vinci. He, too, had received an education in art in Florence during the same period as the Sistine painters and had frequented Andrea del Verrocchio's workshop, where Botticelli, Perugino, and perhaps even Ghirlandaio had trained for a short time; but he had benefited from it in different ways.

Just as the Florentine artists left to travel south, to Rome, Leonardo had chosen to go north, to Milan, and offer his services to Ludovico il Moro, who had seized control of the duchy. Once he put the legitimate duke, his nephew Gian Galeazzo Sforza, under guardianship, Ludovico started to plan boosting the prestige of the powerful, hard-working city

of Milan through the work of artists and intellectuals invited to move to his court.

During these years in Milan, Leonardo had painted a work that revolutionized contemporary painting: a Virgin with the Christ child, with a young John the Baptist, and with the angel Uriel. It is now preserved in the Louvre, in Paris, and we know it as *The Virgin of the Rocks*. He, too, had been employed on a contract of the medieval type: a price had been agreed and the materials decided, including lapis lazuli and gold leaf, although the latter was not used in the painting. For all this, when the painting was shown to the patrons and to the public of Milan, it was deemed extraordinary. There were secondary highlights that gave the figures softness and unheard of beauty. There were naturalistic descriptions of rocks, of flora, and of an atmosphere that had not been seen in Italy before. In short, this was a new world, one that Leonardo had first studied and then painted thanks to an exceptional artistic talent and an equally unique ability to observe. This perspicacity had enabled him to note, for example, how rays of light hit objects like a ball, bouncing off again once they have absorbed the colours of the object they illuminate.[13]

This perspicacity also allowed him to understand that there were two different kinds of rocks: the sharp-angled, hard ones formed with the hardening of magma erupted from volcanoes, and the ones deposited by debris successively under rain. He grasped this and painted it in his *Virgin of the Rocks*, causing widespread amazement and showing that painting was not a craft, as his friends in Florence thought, but a work of the mind, an intellectual art that required endless study and research. Yet science alone, the discovery of the world, was not enough to make a painting extraordinary. It also took manual talent, that imaginative capacity characteristic of the artist, the ability to shade colour and blend different and complementary tones; in short, a creative ability that owed its full expression not only to the teachings and prescriptions of handbooks but also to a process of introspection that only artists endowed with exceptional creativity could accomplish. Leonardo had too much of it, and indeed rarely succeeded in disciplining it and in containing it within the time constraints demanded by the market.

He was able to understand things that others could not see; he had an interest in optics, mathematics, mechanics, anatomy, and countless

other topics, which later on flowed magically into his painting. It was a conception of art very different from the one that his colleagues had represented in Rome. When they needed to finish a work in time, they called on other assistants, confident that these would conform to a common language, perfectly controlled by the rules of art making. Not Leonardo, who was following a path entirely of his making. To begin with, he had clashed with the material and formal rules of painting by demolishing the conventions regarding light, colour, the use of gold and perspective; and now he came into conflict with the economic and social rules that governed the production of art. Leonardo refused to hand over to the client, at the contracted price, that marvellous painting in which Mary and the angel needed neither beaten gold nor wings to reveal their divinity. This was unprecedented and would change the course of modern painting. Yes, there had been disagreements and questions about the estimated price of a painting, but in this case Leonardo had demanded twice the amount.

His rebellion against the art system materialized in a letter written to Ludovico il Moro in 1491, in which Leonardo and his partners affirmed that the sum agreed on for the painting did not match its value and that not everyone was fit to appraise that value. This was another radically revolutionary position, since it shifted the value of a painting away from the cost of gold and lapis lazuli towards an intrinsic value, based on qualities that were not objectively verifiable but could be appreciated only by persons educated in art. As Leonardo wrote in his entreaty to Ludovico il Moro, *cechus non iudicat de colore*, a blind person cannot make judgements on colour. Faced with an art that was increasingly complex and original, ordinary people were similarly blind if they were unaware of this rapid evolution. Instead of the initial estimate of 200 ducats, Leonardo asked for a payment of 300 or the option of selling the work to another purchaser, who would recognize its true value and with whom he had in fact already reached an agreement (many scholars believe that Ludovico il Moro himself was the new buyer):

> Notwithstanding that the said two works are worth 300 ducats, as stated on a list of the said supplicants given to the said scholars, and that the said supplicants have agreed with the said commissioners that they want to make the said estimate under oath, and also that they

do not want to do it without fairness, wishing to evaluate the said Madonna painted in oil by the said Florentine only 25 ducats when it is worth 200 ducats in value, as stated on a list by the said supplicants, and that the said price of 100 ducats has been offered by persons who wish to buy the said Madonna, for this reason they are obliged to have recourse to Your Lordship. Humbly entreating your favoured Lordship that, *premissis attentis* [once the preliminaries have been dealt with], the said scholars are not experts in the matter, and that a blind man cannot judge colour. If you deem it worthwhile, without further delay, that the said three commissioners examine the said two works under oath or that two assessors are appointed, one for each party.[14]

This falsely humble entreaty challenged the entire system of conventions that regulated the art market, and its wording brought Leonardo into collision with the market and the centuries of tradition that governed it. The number of figures ('heads'), the profusion of gold, and the precious lapis lazuli, all of which qualified the work of art as a purely material object, were no longer enough to evaluate the painting, because there were new values to which the artist appealed, namely his own artistic genius and creativity; but these had not yet found adequate means of modifying the market, as would happen quite shortly afterwards – thanks in no small part to this dispute.

There was no better artwork than Leonardo's to demonstrate the complexity of the new painting. Not only were the figures more beautiful than was possible, but the world he represented was founded on his in-depth studies of nature. The rocks behind the Virgin Mary were of two types: intrusive and extrusive. Leonardo – as I have already mentioned – had understood that rocks had different origins and formations and their appearance was affected also by the erosion produced by wind and rain. A treatise would be needed to explain the many observations he made since boyhood, as he explored the gorges of Vinci and, later, the Alps, but the representation of these processes in painting had already brought him considerable renown. The plants surrounding the scene were not only minutely detailed in line and colour, but they were correctly sited in damp, rocky, or dry ground and, above all, were flowering together at the right moment on a day in April. Lastly, the reflections of light that shone from the coloured fabrics in

turn coloured the shadows with their reverberations. It is impossible to gauge how much the duke of Milan understood those studies, but he certainly saw their consequences through Leonardo's brushstrokes. This was enough to decide the success of that eccentric, handsome young man in Milan, where, dressed in highly fashionable clothes, he also organized extravagant feasts in his spare time. We know for certain from a letter of 1485 that the unfortunate young duke, Gian Galeazzo, had suggested sending one of Leonardo's paintings as a diplomatic gift to Matthias Corvinus, king of Hungary. Artistic diplomacy was born – all thanks to an immigrant from Tuscany who was ready to bask in the admiration that came his way and to make a demand that would change the history of art.

The dispute continued for some time, but Leonardo must have won in the end, because the painting was not given to the monks of San Francesco. Indeed, twenty years later, he would decide to make for them another version of the painting, the one that is now at the National Gallery in London; but here Leonardo's contribution was very limited and much of the painting was executed by his collaborators.

The Renaissance system of art had started to show its first cracks under the pressure of a new man's self-awareness, a man who was ready to argue that painting was not a mechanical activity but a cerebral one and that as such it fell outside the simple calculation of its material elements (or so it should). The more the politicians grasped the potential of art as a tool for communication and propaganda, the more the artists recognized their own value. It was a complex process that within a few decades changed the rules of the game forever.

INTERMEZZO

LEONARDO'S IMPOSSIBLE PROJECT

The small revolution sparked by Leonardo's refusal to deliver the painting of *The Virgin of the Rocks* was caused by a sense of personal vendetta that turned into a struggle against the barriers that confined artists to a place at the bottom of the social hierarchy of the time. Born into a family of notaries but never recognized by his father, Ser Piero, Leonardo found his condition particularly odious. This condition of neglect prompted him to push beyond these constraints even more than other contemporary artists, and he quickly realized that his emancipation would come through primacy – or at least through excellence – in art. He achieved that primacy by surpassing the masters of the previous generation, which he often did in ruthless ways. Indeed, in the sixteenth-century literature on art, and especially in Vasari, one of the central narrative tropes is *superatio* ['conquest', 'overcoming'], whereby the pupil surpasses the master, manifesting his own artistic genius in the process. It was not coincidental that Leonardo started to think about surpassing his own master, Verrocchio, during the years when he was painting *The Virgin of the Rocks*. The success brought by that painting further convinced him that he could conquer primacy not only in painting, a status he already felt confident of having, but also in arts and sciences, a goal he was to pursue for his entire life.

In Leonardo's mind at the time, primacy also meant surpassing his master's most famous achievement: Verrocchio had cast extraordinary bronze statues (*Christ and Saint Thomas* for the loggia of Orsanmichele and the gilded copper ball above the lantern of the Florentine cathedral) and was about to complete the equestrian monument of Bartolomeo Colleoni in Venice. Around the same time Leonardo started to work on the equestrian monument to Ludovico's father, Francesco Sforza, which he had already mentioned in his introductory letter:

> In times of peace I believe that I merit comparison with all others in architecture, in the design of both public and private buildings, and in transporting water from one place to another. Also, I will undertake sculpture in marble, bronze and terracotta; likewise, in painting, I can do anything in comparison to any other work by anyone. Work will also start on the bronze horse that will bring immortal glory and eternal honour in happy memory of Your Lord's father and the honourable house of Sforza.[1]

Once *The Virgin of the Rocks* was finished, Leonardo turned his attention to the equestrian monument, in the conviction that his apprenticeship with Verrocchio would enable him to surpass his master, although the latter's reputation for casting was unrivalled throughout Italy. It was in Verrocchio's workshop that Leonardo understood that casting, if successfully done, could bring him immediate fame and lasting glory through its predominantly technical and scientific character and through the challenges it presented. But bronze casting was a complex process, and the ambitious young painter lacked the required technical skills (we know of Leonardo only as a painter at this date). Besides, Leonardo had in mind a much larger equestrian monument than his master's, one that, to judge from the surviving early drawings, would have been at least seven metres high. Moreover, the horse was in an extremely daring pose for a statue of this kind. It would have been difficult for the molten bronze to fill that hoof raised in the act of stepping forward, which gave solemnity to the whole monument.

But Leonardo had one skill that played to his advantage. He produced beautiful drawings in advance of the projects, and for a long time

these were convincing proof that he really could deliver a work of unrivalled quality. Nonetheless, even as early as 1489, serious doubts were voiced in Milan as to Leonardo's chances of casting the horse, and in a letter to Lorenzo de' Medici dated 22 July that year a request was made to send other master casters:

> Magnificent Lorenzo de Medici, lord of Florence. Lord Lodovico is thinking of making a worthy memorial for his father and has already ordered Leonardo da Vinci to make a model, namely a very large horse in bronze, on top of which Duke Francesco is seated in armour; and because His Lordship would like an object of superlative quality, he has requested that I write on his behalf to ask you to send one or two master casters, skilled in this work. And although he has commissioned Leonardo da Vinci to carry this out, I do not think he is very certain that he knows how to accomplish it.[2]

This full-blown crisis neither stopped the artist nor served to give the patrons second thoughts, and the enterprise continued with outcomes that in some respects would prove paradoxical. After a series of changes, the project gradually became more feasible, although still extraordinary, and in the early 1490s Leonardo finally created a clay model of the equestrian monument. It stood in the Corte Vecchia of the Sforza Castle in Milan, and was so impressive that talk of the horse spread throughout Italy. It is the first example of a work of art that brought fame to an artist before it was even made. Perhaps it was the beauty of his drawings and the accuracy with which he designed the casework and the casting mechanism, or perhaps it was simply that Leonardo had given concrete form in his terracotta model to an idea that was too grandiose for the times, but the fact is that the bronze horse was praised even before it was cast. On the cusp of the new century, a booklet was printed in Italy in which the bronze horse was celebrated as an endeavour that had never been attempted before:

> The ancients never made such a large statue, / nor imagined one like his model / that devoured the sky, nor was he fearful / of so dark a theme / Vinci has an immortal soul / because he holds Jupiter's victorious palm. Victory is the winner, Vinci you are the Victor / You win

with words a proper Cato / and with such pleasing drawing of sculpture
that bring you honour as a painter of metal.[3]

This is hard to explain without the skilful propaganda that Leonardo
was able to engineer for himself.

Somehow, even before he made the work, Leonardo managed
to achieve his goal of surpassing his own teacher, because in the
Renaissance, too, the story was more important than the facts. While
no one praised Verrocchio's work with sonnets and printed eulogies,
Leonardo's unmade work became a reality and surpassed the statue
physically cast by his teacher in Venice. Leonardo knew how to infuse
such propaganda value into his enterprise that the horse became extraor-
dinarily famous. He benefited more from the fame of this project than
from the paintings he had completed (only a few, as a matter of fact). To
take first place among the greatest artists in Italy, he only had to dem-
onstrate his intelligence and his genius through drawings and through
a grandiose idea. The time was ripe for genius alone, manifested in
whatever form, to make individuals famous. Even the treatise by Luca
Pacioli, which was printed in 1509 but written in 1497, celebrated the
enterprise of Leonardo's horse and spread the reputation of this artist–
scientist among Italy's most refined and highly educated readers. It was
a reputation that Leonardo had won simply on the strength of a grand
design.

No one cared about the facts of the matter, which came to sad end in
late 1499. When the French armies reached Lombardy, in response to a
summons from Ludovico il Moro himself, they turned on the duchy. In
consequence, the duke offered to Alfonso d'Este the metal that Leonardo
had accumulated in the Corte Vecchia; it was to be made into defensive
bombards. The war devoured the monument to war; and the dream that
Leonardo had pursued for two decades evaporated, but not before it
brought him sufficient fame. As for the huge terracotta model, it was used
for target practice by the French archers and destroyed in the process.

Only Michelangelo would not fall for the facile propaganda gener-
ated by Leonardo's project and would publicly accuse the older artist of
having failed to cast the horse. He reminded him that empty words and
unsubstantiated claims did not have the same impact in Florence as they
did in Milan and in the rest of Italy. When he confronted Leonardo in

front of a small circle of Florentine intellectuals, Michelangelo challenged him: 'Explain why you designed a horse to be cast and yet you did not manage to cast it in bronze . . . Do you take us for capons like the Milanese?'[4]

PART II

THE GIANT CLIMBS SKYWARDS

14

ADIEU TO THE STARRY CEILING

In the spring of 1504, as the year's first spell of warm weather dried the ground after the winter rain, the earth under the Sistine Chapel, which stood on uneven foundations built over a span of four centuries, shifted and moved. A thunderous roar was heard in the Vatican and fragments of the ceiling rained onto the precious floor, whose serpentine and antique yellow porphyry patterns traced the eternal hopes of liturgical celebrations. Fortunately no one was hurt.

Upon hearing the desperate cries of young clerics and of guards on duty in the corridors, the palace majordomo rushed to the chapel; and, looking up at Pier Matteo d'Amelia's starry ceiling, he noticed that it had been ruined by a long crack running across it, from wall to wall.[1] The heaven had opened as it would at the Last Judgement, some must have thought (or like a ripe pomegranate, in the words of the first architects called to inspect the damage). Most areas of the chapel were declared unsafe for worship, and the news was immediately passed to the new pope, who had been elected just seven months earlier. Giuliano della Rovere had become pope in September 1503, taking the name of Julius II, and as Sixtus IV's nephew, he held the chapel to be more important than almost anything else. He had witnessed its birth and in all probability had also overseen the works carried out during his uncle's pontificate.

Much more combative than Sixtus IV, Julius now found himself facing equally grave problems. But, unlike his uncle, he had an overriding political ambition: to rid the Papal States of the arrogant claims of minor Italian rulers who had occupied part of its territories. And although initially he called on the support of foreign princes to achieve this goal, he was far-sighted enough to plan a way to extricate himself from their influence and to set Italy free from the oppression of foreign troops, especially French and Spanish, which were staking a claim to the richest territories in the peninsula.

15

ART CELEBRATES THE TRIUMPH

Understanding the political context in which the plans to decorate the Sistine ceiling took shape can also help us to understand the revolutionary methods of its realization. The new pope cared for that chapel as much as he did for one of his own family palaces, but he cared even more for art as a means of celebrating his personal glory and that of the church.

Julius II had a taste in art and a level of culture that was unrivalled, and he also had a warrior-like energy never seen before in a pope. He fought his battles by leading the papal army himself, taking part in military actions and risking life and limb on the battlefield on several occasions. If his legitimacy was questioned, the challenge did not come from the Turks, who, at least for the time being, had turned their expansionist aims to far-off Hungary and the southern shores of the Mediterranean; it came from the faction of cardinals influenced by the French king, Louis XII, who wanted to remove the only truly powerful princely ruler in Italy able to curb his ambitions in the peninsula. Julius had to put up with the humiliation of a schismatic council convened in Pisa to depose him; and he had to fight an unending war, against foreign armies as well as against the criticisms of his own cardinals. In this vortex of political passions and military campaigns, he felt the need to emphasize the legitimacy of his own pontificate and to consign it to

history as the harbinger of a new era, the greatest ever, by embarking on a grand artistic enterprise. He poured into these great artistic projects the same energy and determination that he brought to his military campaigns, with the intention of changing the face of Rome and finally making it worthy of the heritage that was its destiny.

Julius was too cultured and refined not to have realized, since the 1480s, that the starry ceiling painted by Pier Matteo d'Amelia in the holiest chapel of Christendom looked too miserly and inadequate to celebrate the heroic idea of papacy he had in mind. Moreover, as an avid collector of statuary, and one sophisticated enough to buy the *Apollo Belvedere* and afterwards the *Laocoön*, he had been aware for some time that artistic language had undergone a veritable revolution in the past few decades and new forms of representation had appeared that made paintings executed only twenty years earlier look tired and outmoded. After the death of Lorenzo de' Medici, Julius became Italy's most intelligent patron of the arts, and proved it from the earliest days of his pontificate.

He had been seduced by the exceptional talent of a Florentine youngster who left two extraordinary statues in Rome: a *Bacchus* purchased from a cousin and a *Pietà* exhibited in Old Saint Peter's. Setting aside for the time being the worries caused by the large crack that had appeared in the sky over the Sistine Chapel, in 1505 the pope summoned Michelangelo Buonarroti to Rome, who was to build a marble tomb for him. After an initial burst of energy, which saw Michelangelo travel to Carrara to select the marble for this monument, the project for the tomb was set aside, perhaps for financial reasons, or perhaps because someone had whispered in the pope's ear that it was bad luck to build one's own tomb.

Julius resigned himself to abandoning the project, but not to letting Michelangelo go once he saw proof of his extraordinary talent. He ordered Michelangelo to follow him instead to Bologna, where he commissioned him to make a bronze statue that was to be set above the door of San Petronio, to watch over the city. From that moment on – from that warlike undertaking, as one could describe the casting of a statue of the conqueror for a conquered city – Julius decided that Michelangelo should become his leading general in the wider war he intended to wage on the powers that opposed the rebirth of a strong

and independent Papal State. Michelangelo would become an alter ego able to understand his passions and translate them into images, ushering in a new relationship between patron and artist that would give the latter a political role akin to that of minister. For earlier popes, artists had been little more than craftsmen able to produce the fine objects they needed from time to time. For Julius II, Michelangelo became an irreplaceable political ally.

16

THE CRACK

As Julius was able to ascertain as soon as he returned to Rome from the military campaign against Ferrara in 1507 (together, of course, with his trusted architect, Donato Bramante), the damage to the chapel ceiling was considerable, so that all liturgical functions in the chapel were paused until the following autumn. Julius gave instructions to 'chain' the ceiling with long iron bars, some of which can still be seen today. Having secured the ceiling, Julius put off further solutions; he did not mend the crack but only made it less visible from below.

That spring of 1504, a very warm one, we should imagine, Julius had plenty to think about. The last garrison of his worst enemy, Cesare Borgia, had relinquished the Romagna fortresses he had usurped from the church, while Cesare himself, now a prisoner, was transferred to Spain under the watch of Consalvo of Cordoba. It was the end of a duel that had lasted more than twenty years. Now the focus moved to Venice because La Serenissima had taken advantage of Borgia's downfall to occupy in turn some of the church territories. It was an important challenge, one that Julius could not ignore, and although he had been pope only for a year, his political programme was crystal clear: take back those territories usurped by the Italian princes, large and small, and return them to the church.

Venice was the largest adversary on the peninsula. The pope entered into complex negotiations with the foreign princes, and this led, on 22 September 1504, to the signing of the Treaty of Blois, which guaranteed the protection – or at least the non-hostility – of Emperor Maximilian, of his son Philip, archduke of Austria, and of the French king, Louis XII. Julius soon grew convinced that politics alone was not enough to achieve his end and that he would have to organize and personally lead a military campaign in order to reconquer the main ecclesiastical fiefs of central Italy, Perugia, and Bologna. The expedition began in August 1506 and would prove a resounding success, even though at the start it was greeted by ambassadors and by most cardinals as pure folly. Only after achieving his aims, or a part of what he claimed for the church, did Julius return to Rome, where he made a triumphal entry on 27 March 1507. As soon as he had recovered from the long and exhausting campaign, the pope turned to a subject even closer to his heart: the new decoration for the Sistine Chapel ceiling, which, in view of the outcome of the military campaign, was also intended to celebrate his policy and its successes.

It is to this period – between March 1507 and July 1508, when Michelangelo paid Pietro Rosselli to start working on the ceiling – that we can date the very rapid outline of the project that would change the face of Rome and of the Catholic Church forever.

From what Michelangelo himself would tell Vasari, it seems that for a little while the pope was pushed by Bramante to give the decoration of the Sistine Chapel ceiling to Raphael, a young and exceptionally talented painter who had made himself known for his Madonnas in Florence and whom Julius would summon to Rome to work on the decoration of the Stanze (papal apartments). Julius refused to sleep in the apartments used by his great rival Rodrigo Borgia; besides, Rodrigo had it decorated by one of the Sistine painters, Pinturicchio, whose work must have appeared wholly inadequate to the refined Julius II. But this version of events seems rather a clever self-celebratory manipulation devised by Michelangelo himself, to exalt his own stature. The archival documents tell a very different story. When Julius II decided to give Michelangelo the commission (and the artist did all he could to obtain it), poor Raphael had not even arrived in Rome.

17

AN ENTERPRISE WITHOUT A PLAN

From the very terms in which the commission was set, the Sistine project marked a radical departure from earlier practice. While in the case of the fifteenth-century painters a contract was drawn only after seeing the results of the samples painted on the walls by the four artists chosen for the undertaking, with Michelangelo something completely different occurred. Not a single copy of the contract has been preserved, only documents related to the payments that followed the progress of the work. Even the nature of the payments – vague amounts made at irregular intervals – makes one think more of a fee for service than of a transaction for a product, as it had been until then.

The decoration of the ceiling stemmed from the pope's desire to use Michelangelo's talent and to enrich the vault above the chapel rather than from a project defined and agreed upon in accordance with early sixteenth-century norms for decorative projects. This unusual procedure serves to gauge the revolution that took place in the Italian system of artistic production over the course of just a few years.

From what we know – namely information deduced from Michelangelo's skilfully manipulative account, and therefore itself not entirely reliable – the first requests made to the artist were for him to paint the twelve apostles and, of course, a decorative partitioning of the ceiling, which survives in sketches in some rare drawings

by Michelangelo.[2] As an update in the current fashion prescribed, Michelangelo presented the pope with a decorative project that divided the ceiling into geometric compartments of varying shape, after the model of some Roman ceilings found at the time during the excavations of Nero's Domus Aurea (plate 14).

In a very short time, perhaps in weeks, the project struck the pope and his painter as poor. Both were driven by a desire for the new, and this alone announced the start of a completely new climate in the artistic environment. The pope was enthralled by the painter's talent, recognized it, and gratified him. In turn Michelangelo, despite having virtually no experience of wall painting (all he had completed thus far was a youthful painting of the temptations of Saint Anthony, now lost, and the *Tondo Doni*, today in the Uffizi), convinced the pope that he could dare something that had never been attempted before: to decorate a curved surface, twenty metres above floor level, not with decorative partitions but with a real story, ingeniously developed between the architectonic partitions of a large painted marble frame that ran horizontally across the ceiling, from one pendentive to the other.

From discussions between these two great partners, the idea emerged of an unprecedented endeavour, one that would give the patron and the artist an unchallenged first place in painting, on account of its originality and the audacity of its execution. It had nothing in common with anything previously done in Rome or in Italy.

Having radically innovated papal policy in Italy and even the role of the pope, Julius II intended to put his stamp on this breakthrough by embarking on this artistic endeavour, and his great merit lies in having understood that only one man was sufficiently ambitious to follow him in that project: Michelangelo Buonarroti.

The idea of the new decoration – which was maturing in the pope's mind since the day in the spring of 1504 when he noticed that terrible crack in the ceiling, and which had already caused rivalry among Italy's artists in the immediately following years – took shape after his triumphal return to Rome in March 1507, when he was greeted like a victorious general by the population and the consistory. Speaking on behalf of all the cardinals, his cousin, Raffaello Riario Sansoni, congratulated him on his achievements: 'Your Holiness has wonderfully strengthened and expanded the standing of the church and your name

will be associated with immortal fame.'[3] It is not surprising that, in such a state of euphoria, the indomitable Giuliano della Rovere felt ready for endeavours as daring in art as those he had achieved in the political and military sphere.

18

THE CHOICE

For his part, the young and ambitious Michelangelo had, for years now, used every possible means to obtain the commission to decorate the Sistine Chapel ceiling. Encouraged by the warrior pope, he intended to make a radical break with contemporary painting.

Underlying Julius II's choice to assign the work to Michelangelo and not to Raphael was probably an awareness that the former was ready to revolutionize painting in Italy. Raphael had perfected the manner and colours of his generation, bringing to its highest expression a form of painting that had already been broadly delineated by the previous group of painters. The gentle Madonnas of his Florentine period and the graceful poses of his figures in the first examples of the Vatican Stanze were still closely linked to the language that had reached excellence in Perugino and Botticelli's Sistine cycle, a language renewed also thanks to Raffael's encounter with Leonardo in Florence between 1504 and 1508.

The pyramidal structure of Raphael's Florentine Madonnas and the sweetness of their features, reliant as it was on an expert use of sfumato, were indebted to the influence of some of Leonardo's large and innovative compositions that Raphael had seen in Florence, such as the Burlington Cartoon, the *Mona Lisa*, and *Saint Anne with the Virgin and Child*. The sfumato of his painting was more striking, the colours

were better mixed, and the light created a spatial perspective of which the artist was rightly proud and that was praised by the public. But we are in the realm of improvements to the language, not revolution. A comparison between Raphael's *Marriage of the Virgin* and Perugino's shows how Raphael worked, by improving and refining the aims of past and contemporary masters. The setting of the scene itself, including the architecture and the choreography of the steps, is the same, but he takes it to a more stylized level of refinement. The great merit of Julius II is to have understood that Raphael would have produced a more refined, more seductive reissue of the Sistine cycle, while Michelangelo could give him a revolution. This is why he commissioned him. We know from the archives that the pope's advisors, above all Bramante, expressed considerable resistance to the plan to entrust such an important painting to a sculptor who had almost no experience of painting and none of fresco.

But this was a risk that Julius II, the real architect of the golden period of the Italian Renaissance, needed to take because he always wanted revolutions and was more willing than anyone to take his chances with new solutions. He did so in politics, when he did not show signs of panic after the sack of Ravenna, although everyone expected the French to attack Rome; and he did so again when the schismatic council was called. Julius was a man of radical changes; and he needed Michelangelo to show these changes to the world. When Julius left Rome on his first military campaign, forcing the cardinals to follow suit and camping overnight in a modest but dilapidated house at Montefiascone, the Vatican court and the ambassadors thought he was mad. The same must have happened when he commissioned Michelangelo to paint the ceiling.

What was it that convinced him to take such a gamble? How did he counteract Bramante's well-founded objections, backed as they were by Raphael's marvellous frescoes in the Vatican Stanze (the *Dispute of the Sacrament* was certainly well underway in 1508–9, as work on the Sistine Chapel ceiling was about to start)? What convinced the pope was Michelangelo's drawings, which revealed the artist's total focus on the expressive poetics of the body, already evident in the cartoon for the *Battle of Cascina*. There, in that cartoon, lies the precedent that allowed Julius II to understand that Michelangelo, not Raphael, was the new man.

The narrative that Michelangelo offered the pope was a story of bodies that was very different from the theatrical story of the Sistine cycle. Here there were no landscapes, no architectural settings; just bodies, bodies that tell a story and excite and involve the viewer. This was revolutionary enough to please Julius. The samples that Raphael was completing in the Vatican Stanze at the end of 1508 seemed to be an extension of the Sistine cycle. After all, the *School of Athens* is only a monumentalized and more successful version of Perugino's *Delivery of the Keys to Saint Peter*. The architecture became perfectly classical (thanks to Bramante's input), but in essence it was an architecture that continued Perugino's setting: the scene could have been set on the steps of Perugino's marvellous temple, cleansed of the philological mishaps that Bramante had encountered. If Julius had given Raphael the commission, the result would have been not very different from the first Sistine cycle, as the frescoes in the papal apartments go to show.

With Michelangelo, the whole language changed; no room was left for architectural porticos, archeological references, and choreographed dances. With Michelangelo, the protagonist is instead a heroic man, perfectly represented through anatomical foreshortening and able to move on earth or even fly through the sky with a naturalness that no previous artist had as much as approached. The affirmation of a preeminent role for the human figure in the decorative scheme for the ceiling is clearly legible in the rapid evolution of the plans that Michelangelo submitted to Julius II within just a few months, from early 1508 to July that year, when the builders destroyed the plaster on which poor Pier Matteo d'Amelia had painted his blue starry sky. During this period, Michelangelo showed the pope a highly articulated decorative scheme (documented by one drawing in the British Library, London and by another at the Institute of Arts of Detroit, Inv. No. 27.2r). The scheme shows the decorative sections used for Roman ceilings, mainly those in the Domus Aureus, which at the time served as an example of the rebirth of classical taste. Inside this complicated structure, whose crossing frames formed coloured octagons at the centre, the figures are placed at the edge of the frame, right beside the walls. Already in the sketches, however, the figures are drawn with marvellous foreshortening and are perfectly credible in their spatial dimension; and

this must have convinced both the pope and the artist to expand the role played by the human figure further still.

Within the space of a few months, Michelangelo completely redefined the structure of the ceiling, reducing the architectural partitions to a simple organizing schema – rather than making it the central element of the painting, as it had been in the early drawings, in all its decorative superfluity – and giving more space to the human figures: they became the real protagonists of the painting, in a way that was completely new. It was a representation that, as we will see, offered a much more significant narrative than the one achieved by the masters of the previous generation on the walls below.

So a few sketches, produced in a few months, of this new role for human figures in the painting were enough for Julius to understand the lengths to which the ambitious Florentine could go. And that architectural framework, whose strong plasticity brilliantly solved the problem of the spatial congruity of the vault, also played a part by revealing Buonarroti's other talent, for architecture. This talent was destined to have an exceptional development subsequently, but its foundations are all here, in these illusionistic stone cornices that linked the two sides of the chapel, crossed the ceiling, and encompassed the particular shapes of the pendentives and lunettes into an organic whole.

Michelangelo imagined a structure that was the precursor of his architectural poetics, a language that would leave even deeper traces than the ones he left in painting and sculpture. To bring order to the barrel vault with lunettes, Michelangelo drew (and then painted in trompe-l'oeil) a marble cornice whose strength lay entirely in the plasticity of the trabeation embellished by marble bases; and on these bases he placed the seated Ignudi (naked figures), who hold festoons of oak leaves in honour of the patron. This, too, showed deviation from the directions in which Bramante and Raphael were moving. They sought harmony in the proportional balance between elements by trying to re-establish the entire classical vocabulary of ancient architecture; on the contrary, Michelangelo isolated a single element (in this case, a stone cornice and stone bases) and enlarged it until it became the expressive protagonist of the architecture – as he would do for the majestic capitals in Saint Peter's and for the aediculae above the bracketed plinths in the Laurentian Library. Where Raphael and Bramante used

a consistent lexicon of cornices and columns, function and decoration, Michelangelo proceeded differently. He took the architectural form of the individual element to an extreme level of expression, just as he did with the human body.

The most striking example of this anatomical exaggeration to which he subjected the human body in order to express the emotions that exalt it can be found in the statue of *Night*, where the ribcage is elongated to highlight the action of meditation. He enlarged the muscles of the *Prisoners* to give energy to their action but stopped before the effects became grotesque. And he did the same with the architectural framework of the ceiling. The rounded projections of the cornices are accentuated so as to create a strong sense of chiaroscuro, as if they, too, were a sculpture. The elements of the cornice are as expressive as an athlete's powerful body, but in stone. The same elements that become banal in the work of all other architects are exaggerated by Michelangelo through repetition, until they become the impressive protagonists of the narrative. By using this solution, Michelangelo brilliantly fulfils the illusionistic needs of this fictive architecture without betraying the impression of the ceiling's static and material continuity, and can insert his human narrative. The revolution was already present in the decorative structure that the artist began to apply to the plaster in July 1508, but the real novelty of his painting was the foreshortened figures that filled it.

Michelangelo had the perfect aid for mastering that type of representation, visible from below. He mastered perspectival foreshortening by using a method of drawing that showed the moving body and its inner perspective. This instrument was essential to solving the great problems related to enjoying the painting that had scared off all the other artists. Representing an action that would be seen from twenty metres away and painting it on a curved surface was truly a terrifying undertaking. The frontal view of the human body had dominated in the past fifty years through the very simple proportions of the limbs. Michelangelo overcame this simplified portrayal by showing the body as it appeared from a particular point of view. His method of studying foreshortening helps us to understand the principle on which this new depiction was based. Luckily, we have the very reliable testimony of the study through which Michelangelo had understood and mastered the

perspectival foreshortening of bodies in movement after he completed his study of the body, this prodigious machine of bones, tendons and muscles, thanks to the dissections he carried out at Santo Spirito hospital in Florence between 1492 and 1496.

19

BENVENUTO CELLINI AND OPTICAL PROJECTIONS

Benvenuto Cellini, a sculptor and an admirer of Michelangelo, tells us how the latter learnt to reproduce anatomical foreshortening in his drawings. Using a lantern, Michelangelo projected the shadow of a posing figure onto the wall behind, where he had attached white sheets of paper. The size of the silhouetted limbs was proportional to their distance from the light. The arm closest to the lantern was much thicker on the wall than the more distant arm. Its appearance was therefore proportional to the distance and at the same time it also diminished perspectivally according to the distance. The earlier generation of artists (as well as Michelangelo's own contemporaries) tended to show the two arms as being of equal size in space: this was incorrect. The optical projection accounted for it completely by giving objective evidence of the optical mechanism; and, once he discovered this naturalistic principle of vision, Michelangelo acquired great ability in foreshortening the body. This expertise made his figures appear fully convincing. Mastering the technique was essential when one painted at twenty metres above the ground and from a constantly changing point of view, like that of the viewer who walked across the Sistine Chapel floor. These were now the measures of decorative excellence – and no longer the gold leaf and lapis lazuli of the earlier generation.

In Milan, Leonardo had affirmed the new principle of visual congruity by controlling the reflected lights and the coloured shadows. In Rome Michelangelo affirmed it by controlling the foreshortening of the human figure. The Ignudi lying and seated on the pilasters of the ceiling offer convincing proof of this ability. All the rest is secondary.

Among the earliest drawings we have of the ceiling are the Ignudi and the Sibyls, bodies drawn with foreshortening and seen from below, and capable, all by themselves, of convincingly rendering the idea of a realistic representation. When he reached the end of the project, Michelangelo would provide an extreme, almost manneristic example, in the figure of Jonah, which tried to create the illusion of the wall crumbling under the backward pressure of the Prophet's shoulders.

By using this skill, Michelangelo would demonstrate how anatomical foreshortening alone could re-create the illusion of a completely realistic space, and could do so much better than perspective in the geometric construction of architecture and the landscape. This skill was also one of the fulcrums of the revolution sought or glimpsed by Julius II.

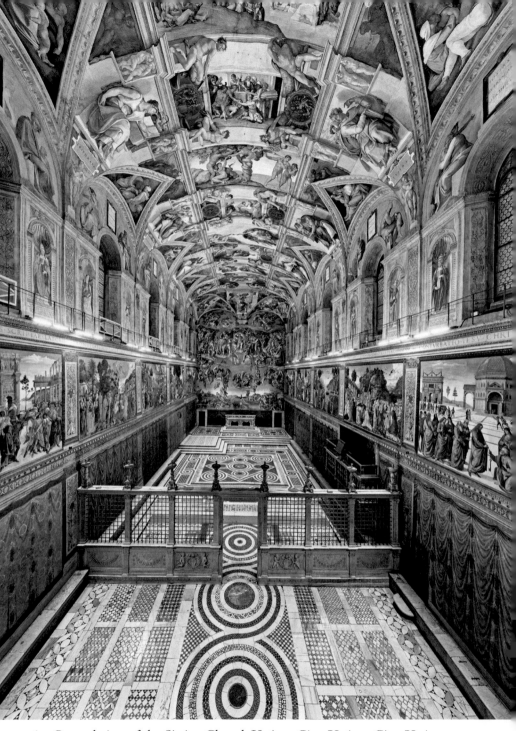

1 General view of the Sistine Chapel, Vatican City. Vatican City, Vatican Museum © Governatorato SCV – Direzione dei Musei

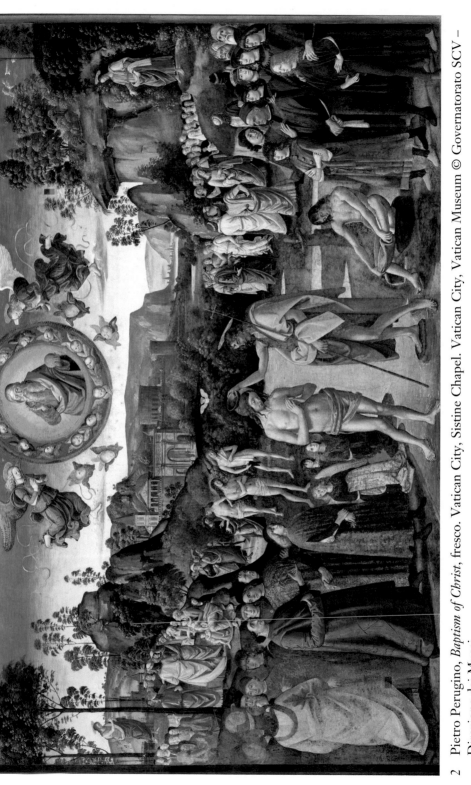

2 Pietro Perugino, *Baptism of Christ*, fresco. Vatican City, Sistine Chapel. Vatican City, Vatican Museum © Governatorato SCV – Direzione dei Musei

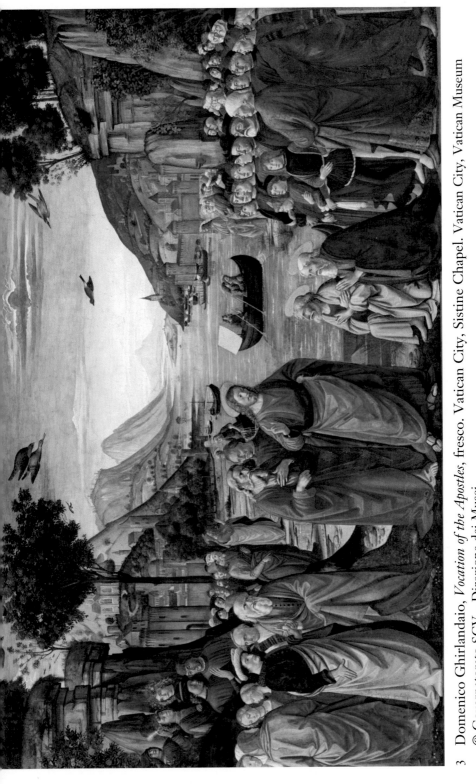

3 Domenico Ghirlandaio, *Vocation of the Apostles*, fresco. Vatican City, Sistine Chapel. Vatican City, Vatican Museum
© Governatorato SCV – Direzione dei Musei

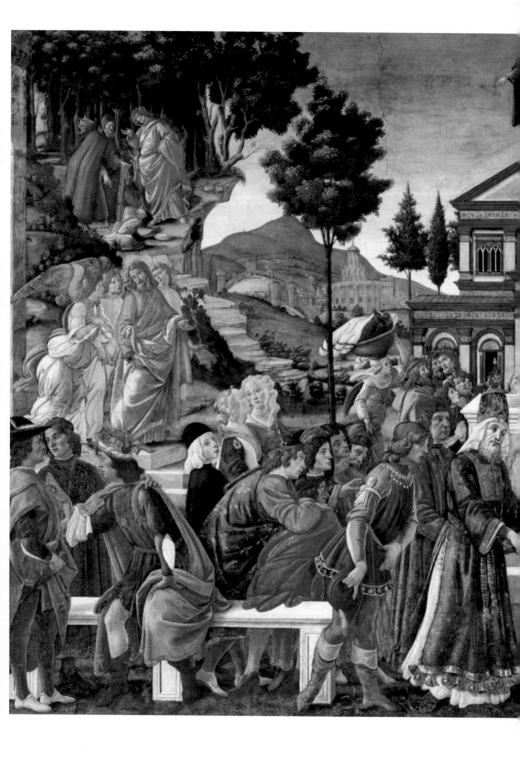

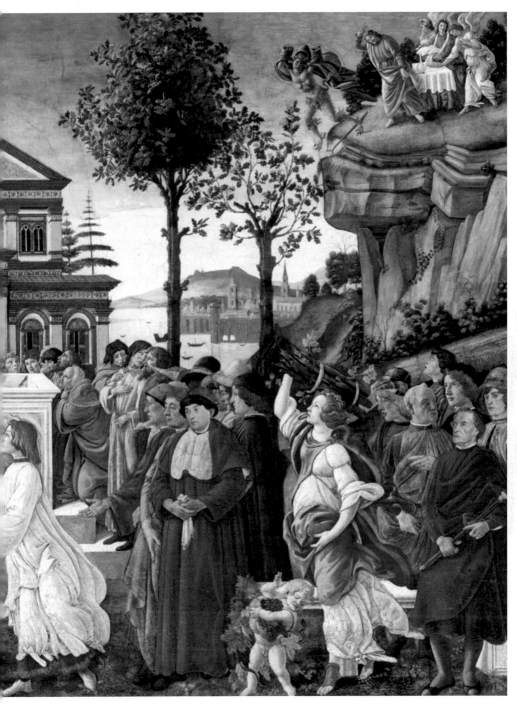

4 Sandro Botticelli, *Temptations of Christ*, fresco. Vatican City, Sistine
Chapel. Vatican City, Vatican Museum © Governatorato SCV –
Direzione dei Musei

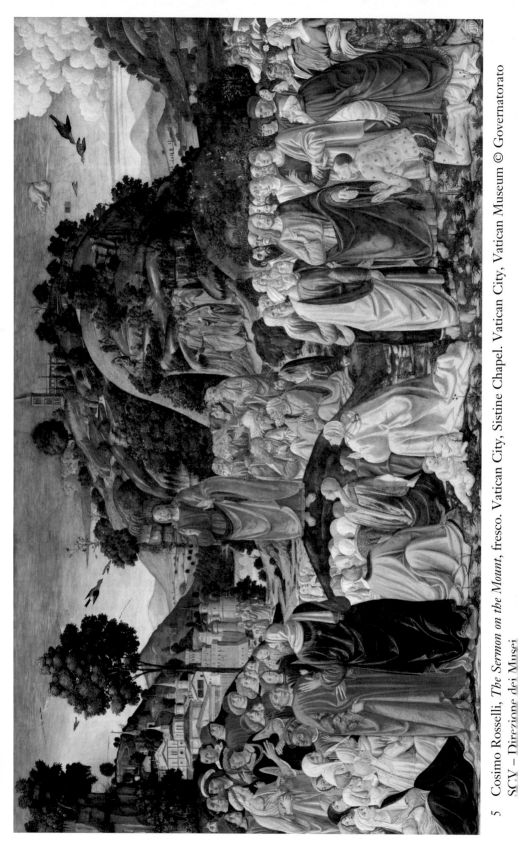

5 Cosimo Rosselli, *The Sermon on the Mount*, fresco. Vatican City, Sistine Chapel. Vatican City, Vatican Museum © Governatorato SCV – Direzione dei Musei

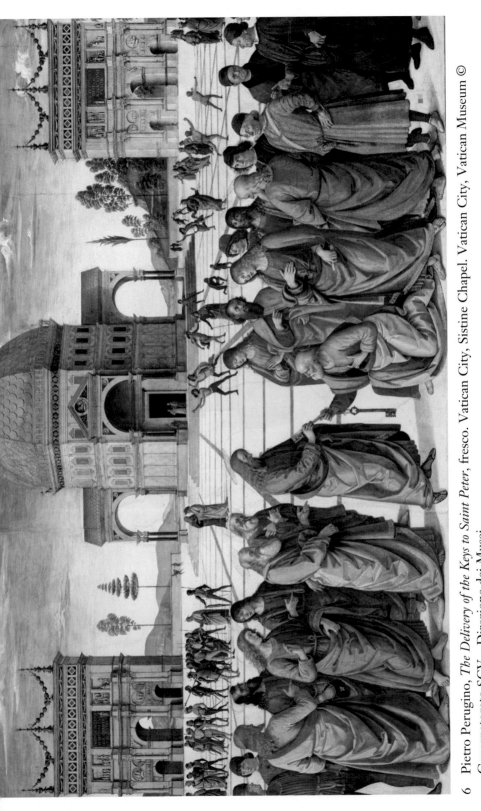

6 Pietro Perugino, *The Delivery of the Keys to Saint Peter*, fresco. Vatican City, Sistine Chapel. Vatican City, Vatican Museum © Governatorato SCV – Direzione dei Musei

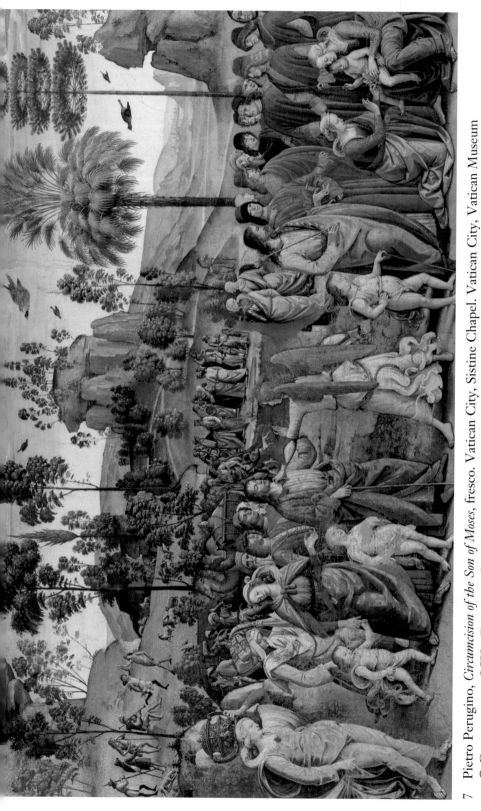

7 Pietro Perugino, *Circumcision of the Son of Moses*, fresco. Vatican City, Sistine Chapel. Vatican City, Vatican Museum
© Governatorato SCV – Direzione dei Musei

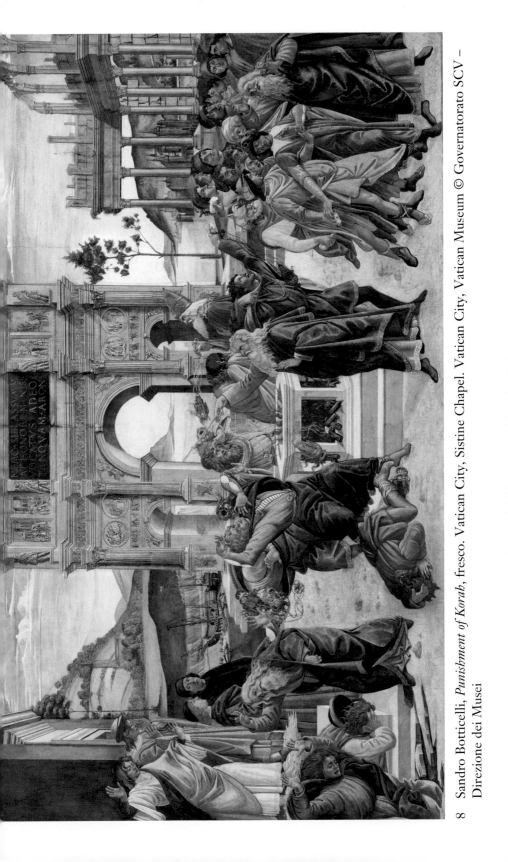

8 Sandro Botticelli, *Punishment of Korah*, fresco. Vatican City, Sistine Chapel. Vatican City, Vatican Museum © Governatorato SCV – Direzione dei Musei

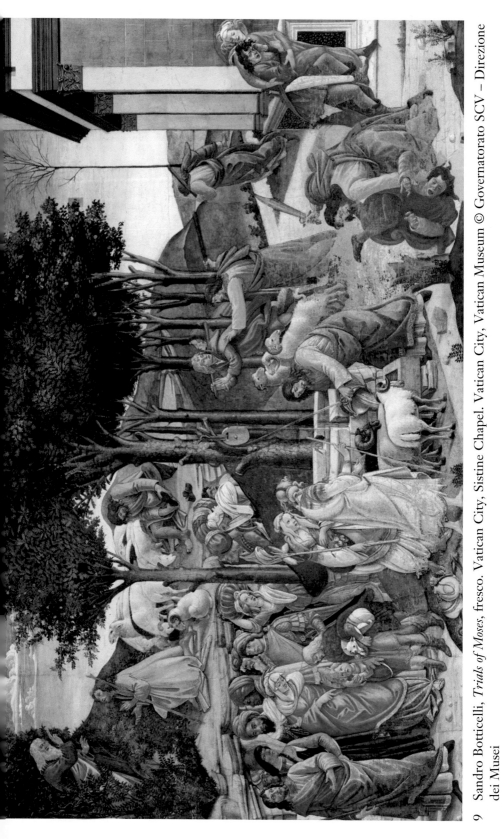

9 Sandro Botticelli, *Trials of Moses*, fresco. Vatican City, Sistine Chapel. Vatican City, Vatican Museum © Governatorato SCV – Direzione dei Musei

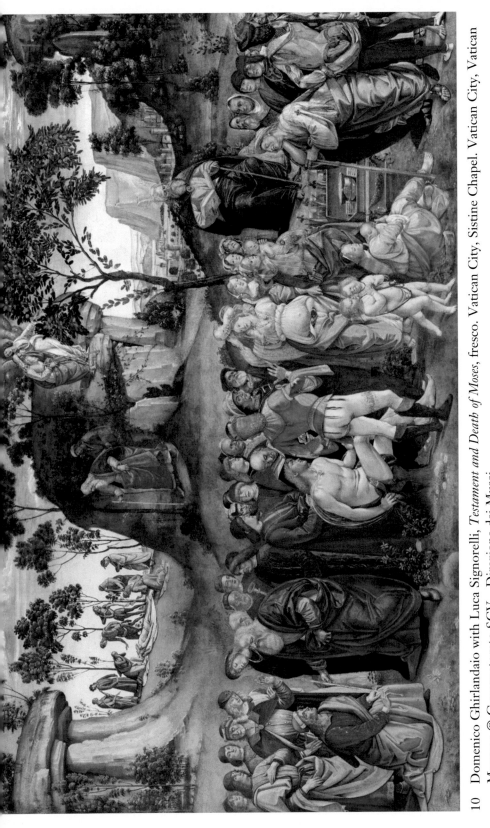

10 Domenico Ghirlandaio with Luca Signorelli, *Testament and Death of Moses*, fresco. Vatican City, Sistine Chapel. Vatican City, Vatican Museum © Governatorato SCV – Direzione dei Musei

11 Domenico Ghirlandaio with Biagio d'Antonio, *Crossing of the Red Sea*, fresco. Vatican City, Sistine Chapel. Vatican City, Vatican Museum © Governatorato SCV – Direzione dei Musei

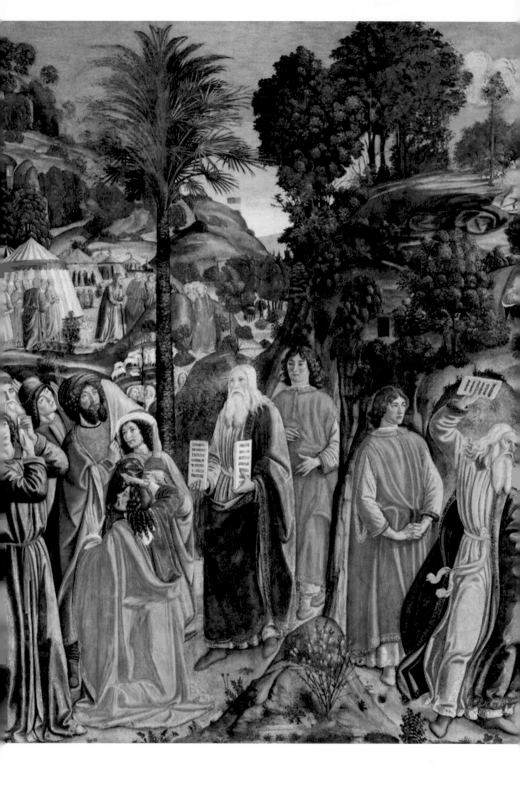

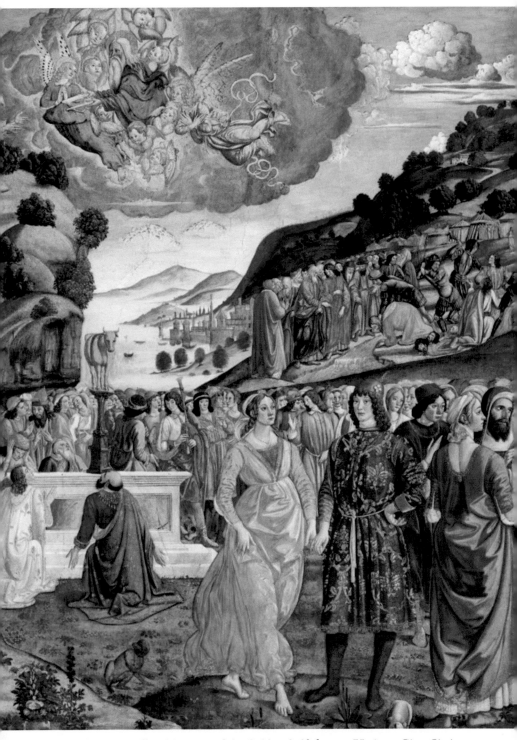

12 Cosimo Rosselli, *Adoration of the Golden Calf*, fresco. Vatican City, Sistine Chapel. Vatican City, Vatican Museum © Governatorato SCV – Direzione dei Musei

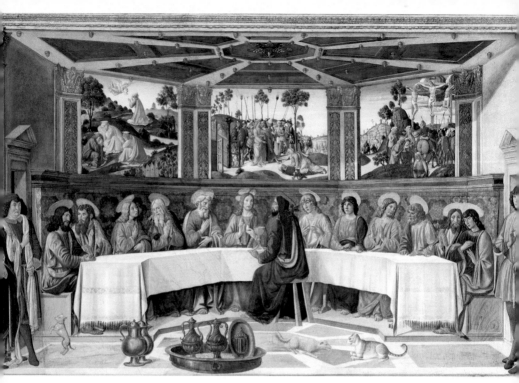

13 Cosimo Rosselli, *The Last Supper*, fresco. Vatican City, Sistine Chapel. Vatican City, Vatican Museum © Governatorato SCV – Direzione dei Musei

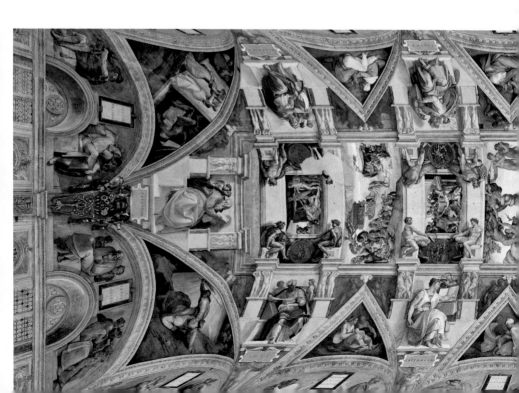

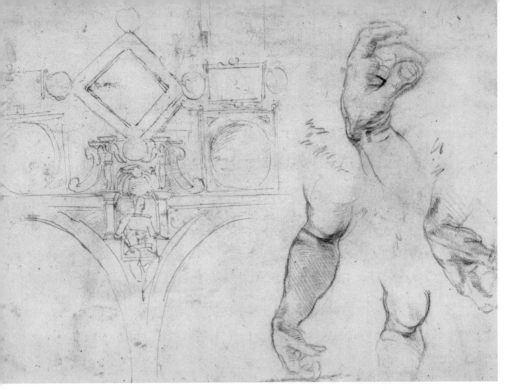

Michelangelo, Preparatory sketch for the Sistine ceiling, pen on metalpoint and pencil. London, British Museum © The Trustees of the British Museum

Overview of the paintings on the ceiling. Vatican City, Sistine Chapel. Vatican City, Vatican Museum © Governatorato SCV – Direzione dei Musei

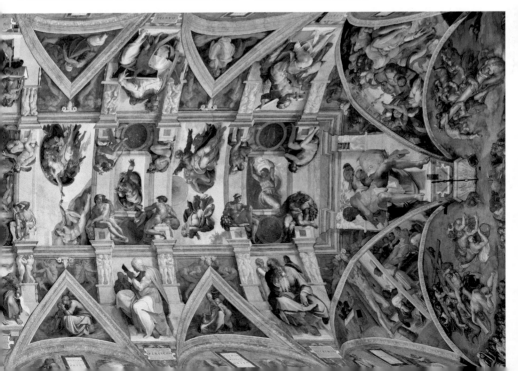

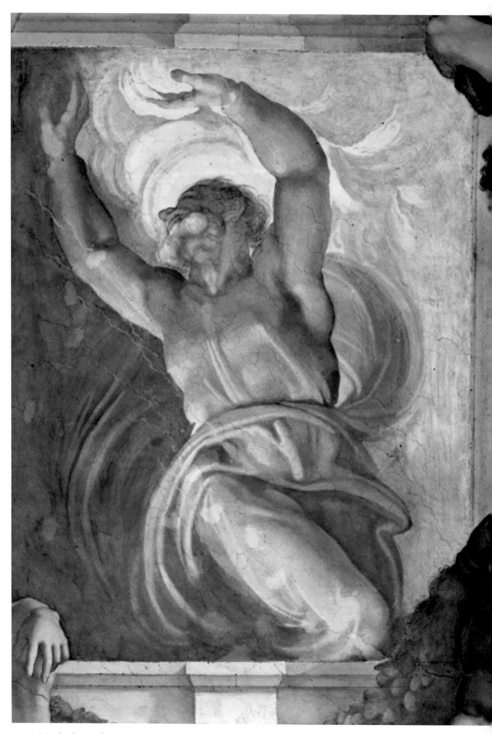

16 Michelangelo, *Separation of the Light from Darkness*, fresco. Vatican City, Sistine Chapel. Vatican City, Vatican Museum © Governatorato SCV – Direzione dei Musei

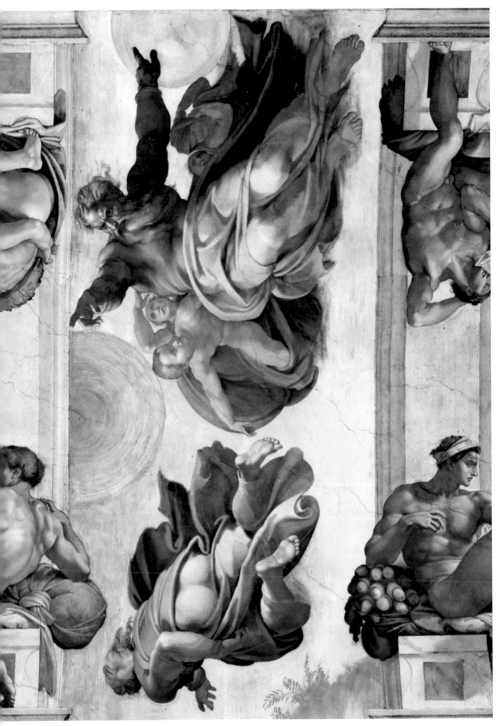

17 Michelangelo, *Creation of the Sun, Moon and Plants*, fresco. Vatican City,
Sistine Chapel. Vatican City, Vatican Museum © Governatorato SCV –
Direzione dei Musei

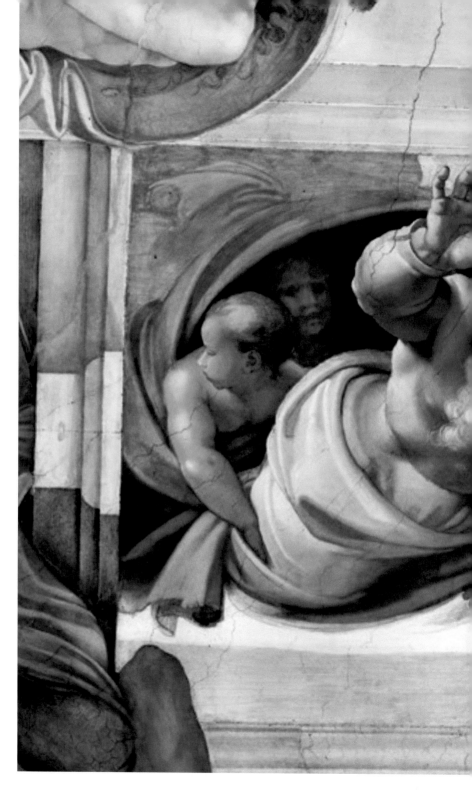

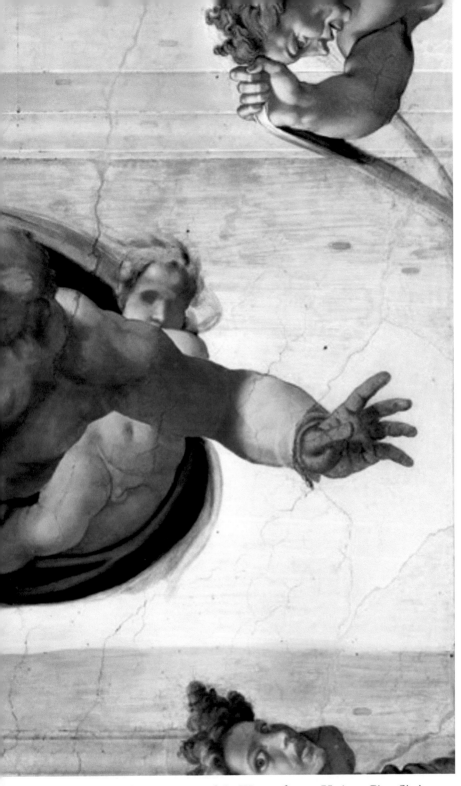

18 Michelangelo, *Separation of the Waters*, fresco. Vatican City, Sistine Chapel. Vatican City, Vatican Museum © Governatorato SCV – Direzione dei Musei

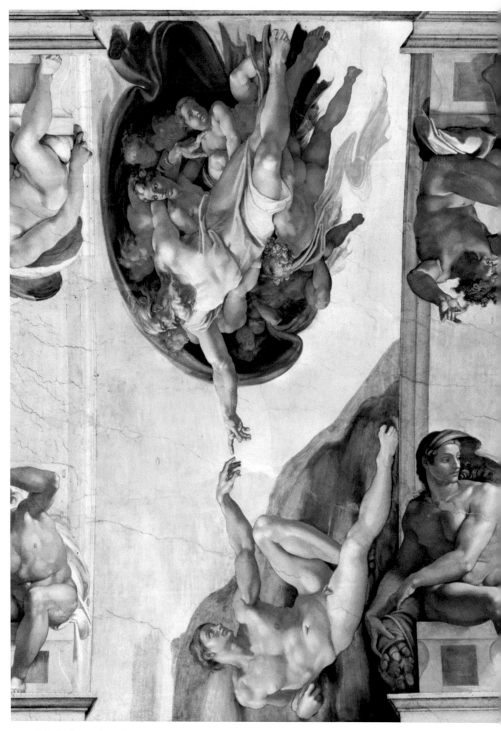

19 Michelangelo, *Creation of Adam*, fresco. Vatican City, Sistine Chapel. Vatican City, Vatican Museum © Governatorato SCV – Direzione dei Musei

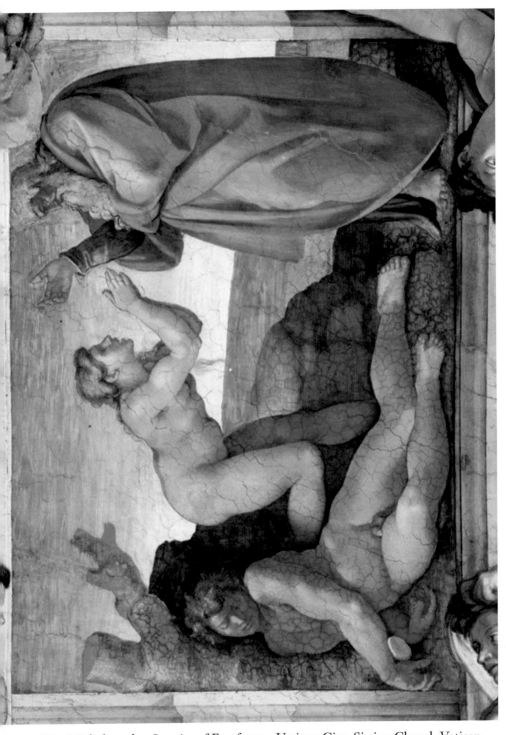

20 Michelangelo, *Creation of Eve*, fresco. Vatican City, Sistine Chapel. Vatican City, Vatican Museum © Governatorato SCV – Direzione dei Musei

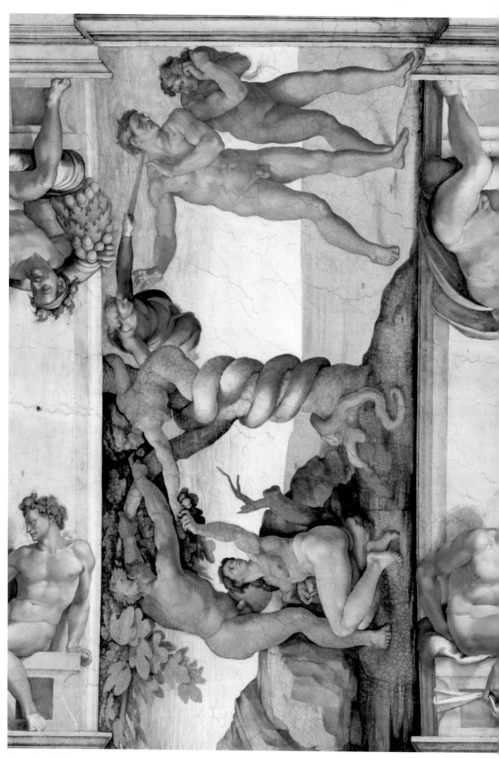

21 Michelangelo, *Temptation and Expulsion from Paradise*, fresco. Vatican City,
Sistine Chapel. Vatican City, Vatican Museum © Governatorato SCV –
Direzione dei Musei

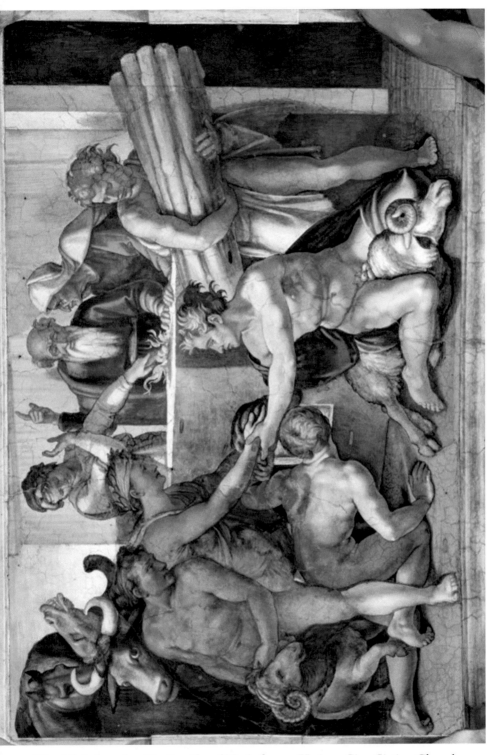

22 Michelangelo, *The Sacrifice of Noah*, fresco. Vatican City, Sistine Chapel.
Vatican City, Vatican Museum © Governatorato SCV – Direzione dei Musei

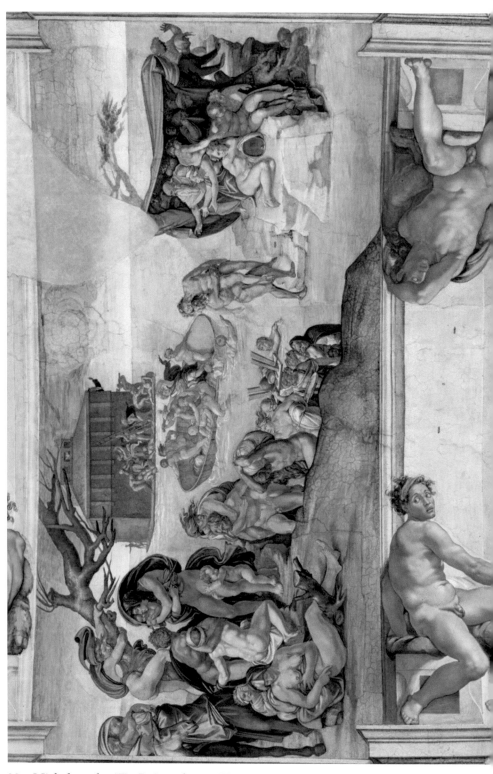

23 Michelangelo, *The Deluge*, fresco. Vatican City, Sistine Chapel. Vatican City,
Vatican Museum © Governatorato SCV – Direzione dei Musei

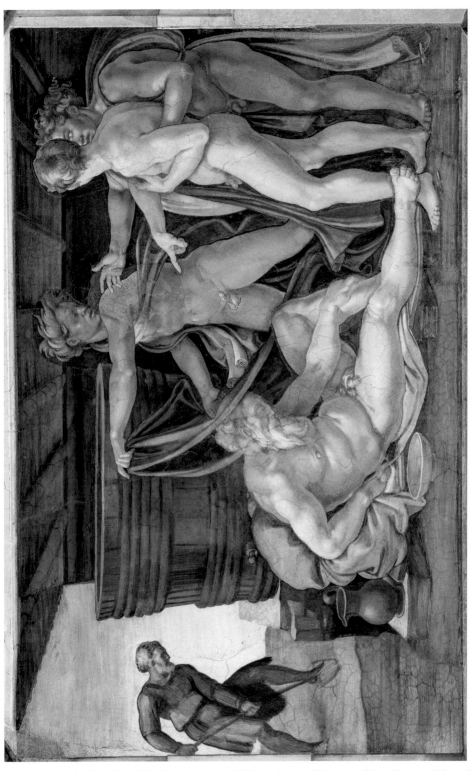

24 Michelangelo, *The Drunkenness of Noah*, fresco. Vatican City, Sistine Chapel.
Vatican City, Vatican Museum © Governatorato SCV – Direzione dei Musei

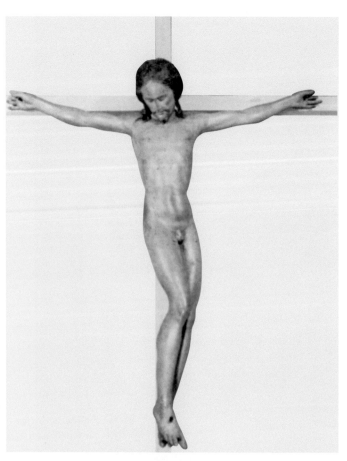

25 Anonymous Florentine
carver, *Crucifix*,
polychrome wood,
hemp, and plaster.
Florence, Basilica of
Santo Spirito

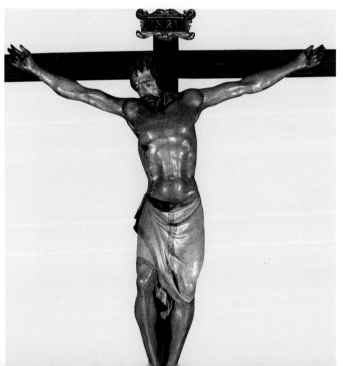

26 Donatello, *Crucifix*,
polychrome wood.
Florence, Basilica of
Santo Spirito

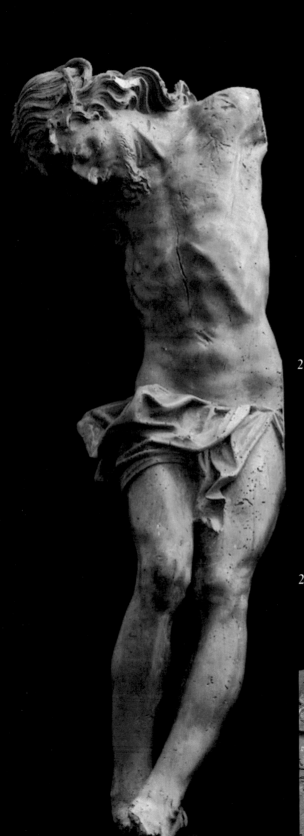

27 Michelangelo, *The Crucifix of Santo Spirito*, polychrome wood. Private collection

28 Michelangelo, *The Crucifix of Santo Spirito*, polychrome wood, detail of text carved on back. Private collection

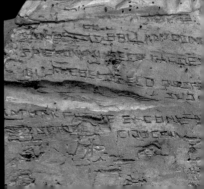

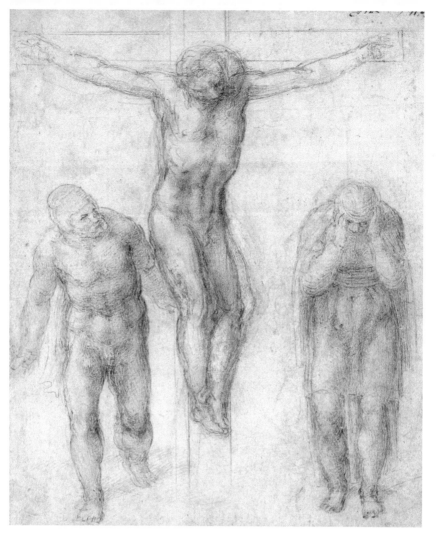

29 Michelangelo, *Study for Crucifixion*, drawing in highlighted charcoal. Oxford, Ashmolean Museum. © Ashmolean Museum, University of Oxford/Heritage Images

30 Giovanni Romano, Fifteenth-century ciborium with the stories of Peter and Paul, Octagon of Simon Mago. Vatican City, Saint Peter's Basilica. Fabbrica di San Pietro, Vatican

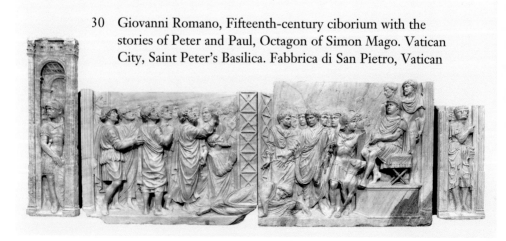

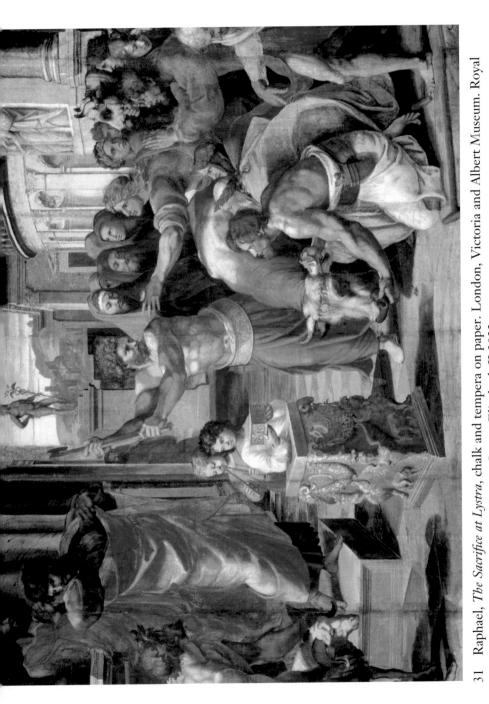

31 Raphael, *The Sacrifice at Lystra*, chalk and tempera on paper. London, Victoria and Albert Museum. Royal Collection Trust/© Her Majesty Queen Elizabeth II 2022

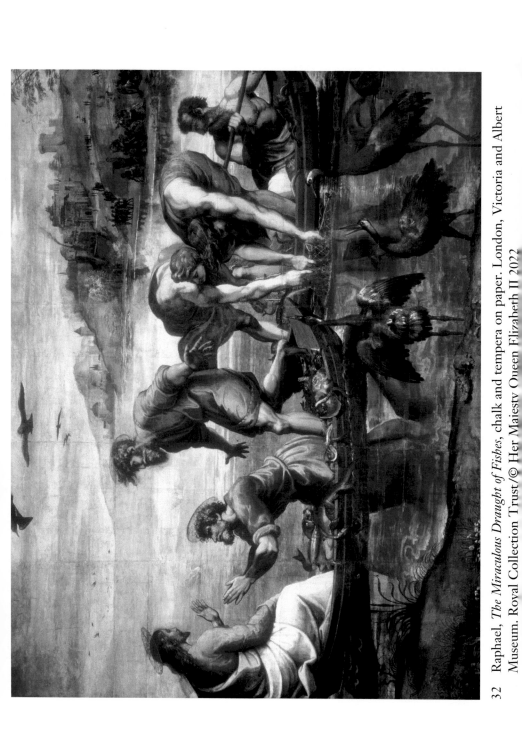

32 Raphael, *The Miraculous Draught of Fishes*, chalk and tempera on paper. London, Victoria and Albert Museum. Royal Collection Trust / © Her Majesty Queen Elizabeth II 2022

20

A PLATFORM SUSPENDED IN MID-AIR

While perspectival foreshortening could guarantee the success of this new vision of the world, it was equally important to solve the practical problems linked to decorating a twenty-metre high ceiling above a space that was so important that public worship could not be interrupted. The Sistine Chapel had to continue to host the main religious events while work on the ceiling advanced, however long that took.

The first problem to solve was a hanging scaffolding, which gave access to the ceiling but did not encumber the floor. It is no surprise that the practical issue of the scaffolding, which proved extremely difficult to resolve, has left significant documentary traces. It is not only that the huge scaffolding had to allow Michelangelo to work while leaving the chapel free to host the important cultural functions that took place there, but it also had to give the artist a good view of the curved ceiling and component parts, in order for him to control the effect of the figures that day after day went on to populate its surface – like a new and terrible humanity, resurrected from a past that everyone evoked but no one could imagine like the young Florentine.

The architectural framework housed crowds of putti, Ignudi, and Prophets in its corners and projections. The most important document concerning the problem of the scaffolding appears in Ascanio Condivi's *Life of Michelagnolo Buonarroti*, written in 1550 under Michelangelo's

direct supervision. Condivi presents the issue of the 'scaffold' ['*ponte*']
as follows:

> When Michelangelo was to paint the vault of the Sistine Chapel, the
> pope ordered Bramante to build the scaffold. For all that he was such
> an architect, he did not know how to proceed, and in several places
> on the vault he drilled holes from which he suspended ropes which
> were to hold the scaffold. When Michelangelo saw this, he laughed
> and asked Bramante what he was supposed to do when he got to those
> holes. Bramante, who had no defence, gave as his only answer that
> there was no other way of doing it. The matter was brought before the
> pope and, when Bramante gave the same answer, the pope turned to
> Michelangelo and said, 'Since this won't do, go and build it yourself.'
> Michelangelo dismantled the scaffold, and he recovered so many ropes
> from it that, when he gave them to a poor assistant of his, the proceeds
> enabled the man to marry off two of his daughters. Michelangelo built
> his scaffold without ropes in such a way, and so well fitted and joined,
> that the greater the weight upon it, the more secure it became.[4]

The story was repeated by Vasari in his *Lives*, with an additional detail
that is crucial for reconstructing the structure of this miracle of engi-
neering. After telling the story of the challenge, Vasari added: 'so
Michelangelo ordered scaffolding built on poles which did not touch
the wall, the method for fitting out vaults he later taught to Bramante
and others, and with which many fine works were executed.'[5]

Behind this story, which was certainly exaggerated by Condivi's and
Vasari's desire to celebrate the myth of Michelangelo, lies the unique
significance of this solution, namely Michelangelo's ability to overturn
the hierarchical relations that had until then regulated the production
of a work of art. The competition around the scaffold, which is what it
was, not only concerned a technical rivalry but represented an affirma-
tion of the power of the artist of genius to use his own creativity also
to solve problems that did not fall within his remit (or not until that
moment). Bramante was the pope's architect, in charge of building
Saint Peter's and the greatest building projects in Rome, and before
that he had acquired extensive experience in Milan. Michelangelo was
a young sculptor fighting to win a commission outside his sphere of

competence, so he would certainly not have been expected to resolve an engineering problem. But, as everyone began to understand from this moment on, his brilliance was not restricted to a particular area.

Michelangelo had grown up in a city that, owing to its limited space and excessive wealth, had made considerable use of projections or cantilevers to extend above the street the cubic capacity of houses while leaving the street itself free. These overhangs, faithfully recorded in many fifteenth-century paintings of Florence, were supported by a sloping beam or pole known locally as a *sorgozzone*, on account of its resemblance to a deadly upward blow to the chin in boxing. The *sorgozzone* is a large wooden bracket made of two parts: one horizontal, attached at one end to the wall, and the other sloping, which serves to discharge the strong vertical load invariably into the wall. As Condivi was at pains to stress, probably having had the function of this projecting structure explained to him by Michelangelo himself, the heavier the load on the pole, the more stable the structure was. Indeed, the sloping part of the load 'welds' the pole against the wall. Essentially this static cantilever allowed a reduction in the span covered by the aerial structure.[6]

The chapel is 13.41 metres wide. Spanning this distance with an aerial platform (which left the ground free) was very expensive, if not impossible to achieve, given that a 14-metre-long beam tends to flex and would have had to be supported by an arch that, as well as being costly, would create problems in the centre at the top of the king post. By constructing *sorgozzoni* anchored to the projecting underpart of the wall, Michelangelo reduced the aerial distance to just over six metres. This distance could then be spanned by a platform built with normal chestnut beams available from builders' merchants rather than with longer beams, which were much harder to come by, given the long seasoning process they needed.

Using his practical and visual experience, Michelangelo solved a problem that Bramante had struggled with; what was more, he himself had drawn Bramante's attention to the fact that, with the system of suspended platforms, he would find it difficult to close the holes – when he reached that point – from which the ropes hang. In order to do it, he would have had to build a very high, movable wooden tower placed on the ground. The operation would have been expensive and unlikely to

allow a uniform result – whereas Michelangelo was aware that the quality of a work of art also depended on the capacity to solve the practical problems linked to its execution.

Michelangelo's simple idea was a stroke of genius – perhaps with a contribution from Giuliano da Sangallo, also an engineer and a Florentine well accustomed to working with *sorgozzoni*; but his role was carefully edited out of the story told by Michelangelo to his biographers forty years later. It solved a problem that had seemed unsolvable, and this not only confirmed the pope's opinion that the youngster was truly prodigious but also hardened the opposition of Bramante, Michelangelo's real antagonist.

21

THE FIGHT FOR THE JOB

Michelangelo's victory over Bramante, which led to the construction of his scaffold and a sneering reception for the overcomplicated solution advanced by the most famous architect at the curia, was only the culmination of a battle begun three years earlier, a fight with no holds barred.

It is worth remembering that Bramante enjoyed the full confidence of the pope and the latter had entrusted him to rebuild the new basilica of Saint Peter in 1505, the largest and most costly undertaking in all Christendom. This competition, too, belonged in the new world that was taking shape in the Sistine Chapel in the summer of 1508, in the same place that – just over twenty years earlier – the four greatest masters of Italian painting had humbly agreed to collaborate on a collective project that demanded of them to adapt their individual professional qualities to a common goal.

A project of this kind that reunited Michelangelo and Raphael, Bramante, and, why not, also Leonardo – who had exiled himself to Milan in order not to have to compete with the two new boys on the block – would have been unimaginable. There are documents that testify to the ferocity of the competition. It is worth stating that two different types of document have survived to tell the tale of the fight: primary sources, in the form of letters written at that time that survived in the archives but have emerged from them only in the last decades;

and the story that Michelangelo told his biographers. This story was entirely biased in his favour, yet had the capacity to bolster over the centuries the myth that the artist himself had spun during his own lifetime.

The context in which the decoration of the Sistine occurred was completely new, and took its final shape in these years. It was most clearly defined by the battle to win the profitable work on the ceiling. The artist stopped being a refined craftsman who offered his creative and manual skills at current market prices and became instead an intellectual struggling to establish his own unique and irreplaceable role. This competition saw the involvement of all the artists who emerged between the late fifteenth and the early sixteenth centuries, and in Rome at least three of them were competing for work on the Sistine ceiling: Bramante, Raphael, and Michelangelo. According to Michelangelo, or rather according to what he wanted to make posterity believe – and unfortunately posterity was going to believe it, thanks to Vasari – Bramante, jealous of Michelangelo's fame (but this is already doubtful, because Bramante was a painter and an architect and could not have competed with a sculptor), had suggested to the pope that he should give him, Michelangelo, the task of decorating the Sistine ceiling – and this only in order to embarrass and oust him from favour, so as to share the pope's attention and purse with his pupil Raphael. Once again, the story relies on Condivi's account:

> When Michelangelo had finished this work, he came on to Rome where Pope Julius, still resolved not to do the tomb, was anxious to employ him. Then Bramante and other rivals of Michelangelo put it into the pope's head that he should have Michelangelo paint the vault of the chapel of Pope Sixtus IV, which is in the palace, raising hopes that in this he would accomplish miracles. And they were doing this service with malice, in order to distract the pope from projects of sculpture, and because they took it for certain that either he would turn the pope against him by not accepting such an undertaking or, if he accepted it, he would prove considerably inferior to Raphael of Urbino, whom they plied with every favour out of hatred for Michelangelo, because it was their opinion that Michelangelo's principal art was the making of statues (as indeed it was). Michelangelo, who had not yet used colours

and who realised that it was difficult to paint a vault, made every effort
to get out of it, proposing Raphael and pleading that this was not his
art and that he would not succeed; and he went on refusing to such
an extent that the pope almost lost his temper. But, when he saw that
the pope was determined, he embarked on that work which is to be
seen today, in the papal palace, to the admiration and amazement of
the world, and which brought him so great a reputation that it set him
above all envy.[7]

This is one of the cleverest manipulations in art history: a complete
reversal of events that was aimed at exalting Michelangelo's courage and
the wickedness of his enemies. In practice, as the archival documents
show, matters went quite differently. Bramante was rightly concerned
about Michelangelo's lack of experience and did all he could to try to
assign the work to another painter, but not necessarily to poor Raphael,
because at the time of the first clash over the commission of the ceiling,
in spring 1506, Raphael was not even in Rome. He was still in Florence,
studying the masters of that city and producing Madonnas for local
bankers, and as a novice [esordiente], as we would call him today, he was
attracting the attention of patrons but was far from being reputed as a
successful painter. At this early date Michelangelo, driven by his love of
a challenge or of money and not disconcerted by the inherent difficul-
ties of the project and of his own lack of experience in wall painting, did
everything he could to win the work for himself. The document that
tells us the truth of the situation is a letter written to Michelangelo in
Florence, on 10 May 1506, by Pietro Rosselli in Rome. Rosselli was
Michelangelo's partner and was striving to get the job for his friend, on
the promise that they would work together on the preparation of the
wall, removing the old plaster from the old ceiling and applying a fresh
render.

Rosselli was keeping Michelangelo up to date on what was being
decided and contracted in the Vatican:

My dearest almost brother . . . I inform you that Saturday evening,
while the pope was dining, I showed him some drawings and Bramante
and I commented on them. When the pope finished eating, I showed
them to him and he sent for Bramante and said: 'Let Sangallo go to

Florence tomorrow morning and bring Michelagnolo back with him.'
Bramante replied to the pope, saying: 'Holy Father, it will serve no
purpose because I have talked to Michelagnolo a lot and he has told
me over and over that he does not want to work on the chapel and that
you wanted to give him this work; and therefore you did not want him
to work on the tomb or on the painting.' And he said: 'Holy Father,
I think he lacks conviction, because he has not done much painting
and what is more the figures are tall and foreshortened and it would
be quite different from painting them on the ground.' Then the pope
replied and said: 'If he does not come, he will wrong me, because I
believe he will return at all costs.' Then I replied frankly and spoke
villainously, in the pope's presence. I told him what I believe you
would have said to him on my behalf, and he did not know whether to
respond, because he had spoken wrongly. I also said: 'Holy Father, he
never spoke to Michelagnolo, and if what he has just said is true, you
can chop off my head, because he never spoke to Michelagnolo about
it. Instead, I believe he will come back at all costs when Your Holiness
wishes.' And the conversation ended here. I have nothing more to
report. May God protect you from evil. If I can do anything, let me
know. I will do so willingly. Give my regards to Simone de Pollaiuolo.
Yours, Pietro Rosselli, in Rome.[8]

Pietro Rosselli's letter makes it quite clear how things went.
Michelangelo had been summoned to Rome by Julius II one year earlier,
to work on the pope's tomb in the new Saint Peter's, whose recon-
struction had recently begun under Bramante's supervision. Attracted,
seduced, pleased with the opportunity to carry out such an important
commission, the ambitious young sculptor walked out on the Signoria
of Florence, which had commissioned him to execute the large fresco
of the *Battle of Cascina* in the Palazzo Vecchio, in competition with
Leonardo, who had been given the subject of the *Battle of Anghiari*. Not
even the Signoria had dared to oppose the wishes of the terrifying new
pope; and the artist felt free to abandon the painting. On arriving in
Rome, Michelangelo had received enough money to quarry the marble
he needed in Carrara and had immediately left for the Apuan Alps, to
select the best pieces available in the quarries. Once he returned to
Rome in the winter of 1506, just before the dinner recorded by Rosselli,

Michelangelo had found an unwelcome surprise in store for him: the pope had changed his mind and no longer wished to build the mausoleum but was considering instead (as we learn from Rosselli's letter) the decoration of the vault damaged by the subsidence of two years earlier.

Michelangelo was so disappointed when the pope refused to see him during Holy Week 1506 that he committed an unpardonable affront: he left for Florence without seeking the pope's permission. So the dinner described by Rosselli occurred during a moment of serious disagreement between Michelangelo and Julius. The artist had left Rome without permission, yet the pope continued to entertain the possibility of giving him not only the construction of the tomb (if at a later date) but even the decoration of the Sistine ceiling. Rosselli's reassurances regarding Michelangelo's willingness and ability must have played an important part in convincing the pope to pardon the artist. This is documented in the extraordinary official letter, issued just two months later, on 8 July 1506, when the terrifying Julius, about to embark once more on a military campaign that would change the destiny of the church and Italy, wrote to the Florentine Signoria, asking it to send the rebellious Buonarroti back to him:

> Beloved sons, greetings and apostolic benediction. We hear that the sculptor Michelagnolo, who left us without reason and by caprice, now fears to return, although we bear no grudge because we know the natural disposition of men of his sort. However, to belay all suspicion, we call on the affection that you have for us and ask you to promise him, on our behalf, that if he returns, he will neither be touched nor insulted, and we will restore him to the same state of apostolic grace that he held before his departure. Rome, 8 July 1508, in the third year of our pontificate.[9]

In Italy that date, 8 July, marks a decisive change in the relations between artists and their patrons. The one between Julius II and Michelangelo does not resemble even remotely the relationship that the masters of the Sistine fresco cycle had had twenty years earlier, although they were regarded as the best artists in Italy. Michelangelo had challenged the pope, had dared to rebel against the greatest authority in Italy in an unprecedented manner; not even the Florentine

Signoria could afford to do such a thing. Yet the pope pardoned him
and even showed particular understanding for his genius. How else can
we interpret those words in the letter: 'we know the natural disposition
of men of his sort'? It was a way of recognizing the forbearance that was
due to artistic genius, to a quality that could not be assessed and evalu-
ated in a market modelled after the one for crafts.

Michelangelo and Julius both reasoned in a new way, revealing the
changing times and the new horizons that opened to the exploration
of an art that, from that moment, from those days, was no longer
the expert packaging of a product 'governed' by formal and material
rules – well-known rules that could be exactly appraised economically.
Michelangelo, aware of having verged on the border of insolence, pre-
pared to join the pope in Bologna, where in the following year he
was to cast for him a statue that will be placed above the doorway of
San Petronio. The statue would not be very successful: in the next
papal rebellion it would be turned into a heavy bombard and given the
name 'Giulia'. The terrifying hand that raised a sword to admonish
the people of Bologna would become a piece of artillery from whose
barrel the duke of Ferrara, Alfonso d'Este, would shoot deadly cannon
balls against anyone who dared to attack his state. But at that point
Michelangelo and Julius will already have embarked on a new story.

22

THE POWER OF OBSTINACY

Whatever the objections raised by Bramante and the other artists at the papal court against Michelangelo's demands, they were set aside. Perhaps this happened also thanks to the excellent proof that Michelangelo was able to offer the pope with the casting of the large statue for San Petronio. It had not been a straightforward job, because casting large bronze statues was still a highly complex process, challenging enough to have caused the failure and disgrace of Michelangelo's other major rival, Leonardo da Vinci, around the same time. Leonardo had been unable to cast the large equestrian statue to commemorate Francesco Maria Sforza and had been publicly humiliated by Michelangelo, who had been himself just one step away from failure, in Bologna.

The letters Michelangelo wrote, from Bologna, to update his father and brothers on the progress of the work during the spring of 1507 outline a desperate situation, from which few would have emerged victorious. Michelangelo was short, with a sinuous, wiry frame, his nose broken by a friend's fist; but in the picture of the forge at San Petronio that he conjured for his family he might have been Vulcan himself, crippled but stubborn, as he hammered fearsome weapons while Venus dallied in sensuous embrace with young Mars. Such pleasures were evoked by Michelangelo only on paper during those months, in sonnets

in which he imagined himself holding the waist of his young lover like the fortunate belt that held up his trousers: 'While the plain belt, knotted and encircling, says to me, "Here, I will always clasp". I ask, What would my arms do in its place?'[10]

From a letter sent to his brother Giovan Simone on 28 April 1507, we learn that the terracotta statue of the pope has been finished and the shell around it 'will be done in twenty or twenty-five days, and then I'll give the order for it to be cast'.[11] But things did not work out as planned, even though Michelangelo asked his father to pray for him. The first cast stopped halfway up the shell, as the young man announced in despair on 1 July: 'we have cast my figure and, to judge from the result, I will certainly have to do it again . . . Let's say that the result is bad'.[12] But he did not give up; with a stroke of genius, he cast the second part in a new casting without removing the first and the result was miraculous, even though the sculptor was obliged to spend months and months removing the burr with hammers and chisels. A job that he had hoped to finish by the start of autumn took him into the following spring, without a moment's pause, until March 1508, when, without stopping to gather his strength, he returned to Rome to get to grips with a new and even more challenging project. Leaving aside Michelangelo's demonstration of exceptional willpower and physical resilience on this occasion, it is hard to see how a sculptor was able to embark on the most arduous painting project of his day and what convinced the pope, who was no less stubborn than the artist, to give him the commission. Only if we bear in mind the titanic effort made by Michelangelo in the complicated casting of the bronze statue in Bologna can we understand why Julius II, whose recklessness knew no bounds, decided to agree to all his demands.

Having returned to Rome at the start of March 1508, alone in a city that he felt was hostile, Michelangelo drew up his battle plan for the two major projects. He obstinately refused help from the artists who were present in Rome. Trusting only Florentines, he asked his old friends from Ghirlandaio's workshop to recruit painters who should help him in the commission. His plan of action was rational and meticulous, and it took shape in a note dated 1 April 1508, in which he outlines the use of financial resources with the lucidity of one of the Medici bank managers:

For the tomb I will need four hundred ducats now, and then one hundred a month on the same account, as in the earlier agreements. As for the painting assistants to be brought from Florence, there will be five *garzoni* at twenty gold *ducati di camera* each.[13]

These were huge, demanding sums, quite foreign to a market that until that time had been subject to simple rules and restrained investments. Shortly afterwards, we find other documents that testify to the rapid progress of the work. On 13 May he wrote to a friar Jacopo in Florence to buy blue pigments for the painting. These were the most expensive ones, regardless of whether they came from mineral azurite or from the extremely rare lapis lazuli imported from far-off Afghanistan mainly by Jewish merchants and then often processed in monasteries with specialized workshops. Michelangelo's obsession with Florence was reaching levels of manic persecution. He did not trust anyone not linked to his home city. As the *garzoni* had to come from Florence, so did the colours. 'Fra Jacopo', he wrote, 'because I'm having some things painted here, or rather I will paint them, I'm writing to tell you that I'll need a certain quantity of beautiful blues, and if you can provide them now, it would be very convenient for me.'[14]

From a note on 10 May we learn that Michelangelo received an advance of 500 ducats for the ceiling and that an agreement had been signed.[15] Among the same documents – in which Michelangelo painstakingly recorded every expense, showing his apprehension about the accounting process that he was to face with such nonchalance – we find receipts for the cash paid to the loyal Pietro Rosselli to prepare the ceiling, or rather to demolish Pier Matteo d'Amelia's starry sky and apply a layer of rough plaster over which Michelangelo would then add, day by day, the areas of fine plaster onto which he would paint. Rosselli worked for three months, from 11 May to 27 July, moving along the scaffolding, which was suspended mid-air on poles anchored to the walls. For this he was paid 85 ducats, while Michelangelo had received an advance of five hundred from the pope. Considering the 20 ducats he paid for the timbers needed for the scaffolding, we can calculate that Michelangelo started work on 27 July with an advance that amounted to the fabulous sum of 395 ducats (give or take one or two). If we compare these figures to those paid to the painters of the first Sistine cycle, we

discover the groundbreaking revolution that was underway. The poor consortium of Botticelli, Perugino, Ghirlandaio, and Rosselli were paid for the paintings only 'after' completion, and even then, the sum was significantly smaller than the advance received by Michelangelo. For an entire bay comprising the painted drapes, the narratives, and the popes above it (in all, an area of about sixty square metres), each painter received 250 ducats. But Michelangelo received 395 ducats before he even started. No artist had ever secured such favourable terms in a contract and, ironically, for an undertaking whose outcome was very uncertain. It is worth noting, for instance, that Michelangelo signed every note or document about the ceiling as 'Michelangelo sculptor': this is what he felt he really was.

A month later he received a very large quantity of marble from Carrara for the tomb. Among the twenty loads [*carrate*] dispatched from the quarries was the block destined for the statue of the pope. 'To the said Merino eighteen ducats paid for three pieces, namely two figures of three *carrate* each, and the figure of His Holiness, and the rest you will pay sixteen carlini per *carrata*' (a *carrata* was the weight that two oxen could pull in one cart).[16] With a keen business sense, Michelangelo managed to save on the transport by roughing out the blocks in the quarry and bringing them as closely as possible to the final statues he had in mind. On this occasion, among the blocks sent to Rome, one was already identifiable as the figure of the pope. The work during these torrid months, the hottest in the Roman summer, was frenetic and it is hard to imagine how Michelangelo kept everything under control.

The five assistants worked on copying and enlarging the cartoons for the first scenes on the ceiling drawn by Michelangelo. Pietro Rosselli, with a team of builders, was at work on the scaffolding, demolishing the old painting by Pier Matteo d'Amelia. In the chapel, the noise and the clouds of dust and broken plaster prompted the people who served mass to complain to the pope, but nothing could stop the work. On the eve of Pentecost, the cardinals who filed into the chapel wearing their precious vestments to celebrate vespers were overcome by the confusion and the dust, but their protests were in vain. Julius agreed with Michelangelo: the work must go on. On 27 July the plaster on the first part of the vault was ready. Michelangelo took possession of

the scaffolding with his assistants and started to paint, oblivious to heat and fatigue. The work was underway, but it was not a good start and Michelangelo's decision to shun the Roman craftsmen would backfire spectacularly.

23

THE CRISIS

The plasters used for frescoes in Rome were normally made with pozzolana, not with river sand, and the Florentine artists were not accustomed to working with this material. As a volcanic species of sand, pozzolana behaves differently from the fluvial sand used in all other Italian cities because, apart from bonding with the lime, it develops a hydraulic chemical bond that is owed to its volcanic origins, and the mixtures are not easy to make.

During the recruitment phase, Michelangelo's loyal friend Francesco Granacci, who was even trusted to pay Rosselli – quite exceptionally, in view of Michelangelo's obsessive relationship with money – had found one of Pier Matteo d'Amelia's old assistants. The poor man had worked on the vault twenty years earlier and now he asked for at least the same stipend as he had received back then, but to Michelangelo, penny-pinching as ever, this seemed audacious, and the man was not recruited. It was a fatal mistake.[17] The document is worth mentioning because it confirms that the ceiling was indeed frescoed by Pier Matteo d'Amelia, as John Shearman first noted.[18] Michelangelo could have been shown the correct way to work with pozzolana; but this did not happen and the ensuing technical difficulties threw Michelangelo into a crisis of unprecedented despair, as he recounted in a letter to his father the following January.

As soon as Michelangelo finished working on a section, it grew mouldy and deteriorated day by day. To the young artist it seemed that his enemies had cursed the newly painted surfaces. Today we can surmise, with some good reason, that the 'mould' was nothing but salts dissolved in the sand or in the masonry that rose to the surface as the water evaporated. It is a process that has given many restorers sleepless nights. Michelangelo was in despair. For the first (and perhaps the last) time in his life, overwhelmed by ambition and presumption, he admitted his mistake and blamed himself mercilessly, in a letter to his father dated 27 January 1509:

I feel that I am still living a fantasy, because it's already been a year since I have not received a *grosso* [a silver coin] from the pope, and I dare not ask for one because my work is not progressing in a way that deserves pay. And this is the difficulty of the work, its not being my profession. And I'm still wasting time without results, God help me.[19]

The crisis was a devastating one that caused the whole organizational structure, human and creative, to grind to a halt. Michelangelo quarrelled with his assistants, who abandoned him one by one. He was left alone on the enormous scaffold to cry over his own mistakes. Even rumours of his death circulated among the large Florentine community in Rome. His father and brothers were extremely worried and supported him as best they could by exhorting him to preserve his health, because without good health all ambition is vain, let alone a grave sin.

But, worst of all, in those closing winter months of 1509, just a few hundred metres away, Raphael, the youngster who had arrived in Rome barely one year earlier, was finishing the first walls of the rooms in the pope's apartment. He gave proof of such excellence that the entire city did nothing but celebrate this educated, handsome young man whose charming manners had seduced the pope and the entire Vatican court. On the walls of the Stanza della Segnatura, Raphael had created figures of great sweetness, and their perfectly calibrated gestures were softened in nuanced and concerted colours, which made them alive and credible. Everyone thought that the ogre barricaded up on the intricate cat's-cradle of beams and ropes suspended high above the floor, isolated and unreachable as he was inside Christendom's holiest chapel, was headed

for a sad end. The proud irascible Florentine, who wandered around the city in rags and in poor health, seemed destined to be overshadowed and shamed by the newly rising star, whose own triumph was devised according to a completely opposite strategy. Raphael introduced a new style too, but he was good at forming relationships. He had managed both to co-opt the old masters at work in the apartments and to recruit new ones in Rome, without showing prejudice about their origins and without any sense of persecution. In contrast to Michelangelo, who had isolated himself completely through pride, Raphael had created an affable and collaborative atmosphere. It was just a question of time and the ambitious sculptor would have to abandon not only the scaffolding in the Sistine Chapel but also the Eternal City, which was getting ready for a radical renewal after a thousand years of decadence.

24

'I AM STILL ALIVE'

The first sign of a resurrection came with a letter to his father dated 30 April 1509:

> It has been said that I am dead. It's hardly that important because I am still alive, and in a month and a half I'll have money because I will have made very good use of what I've had.[20]

The letter has all the hallmarks of announcing a triumph – certainly the overcoming of the crisis that had taken him to the brink of self-destruction. Years later, Michelangelo himself would tell his biographers what had led to this rebirth. His loving protector, a Tuscan, of course, namely the old architect Giuliano da Sangallo, stepped in to solve the problems created by the pozzolana and taught Michelangelo the right dosage for mixing volcanic earth and lime putty: the mixture [*impasto*] needed no added water and had to be dissolved in one part of lime putty to three of pozzolana, calculated with great precision, so that in the hydration phase the frescoed plaster would remain compact and not become mouldy. In a very few weeks, Michelangelo managed to master the secret of this mixture and to use the pozzolana so expertly that he could add it to the colour range of the fresco, leaving some of the pigmented areas so transparent

that they exalted the grey and violet undertones of the underlying pozzolana.

This is how the painting of the Sistine Chapel's vault started, in the winter of 1509: by the hand of one single man, with the help of two assistants who prepared the cartoons by enlarging the drawings that had to be transferred to the plaster, and also of a builder who every morning applied onto the wall the right quantity of plaster for painting (plate 15). The fact that Michelangelo had not prepared a definitive drawing of each scene gives us a measure of the gulf between his work and the procedures used by the masters who had decorated the first band of frescoes on the walls below. In the three years he spent on the scaffolding he made changes that confirm that he had only a general idea about the sequence, together with the outline of the architectural frame, although this, too, was altered as the work progressed. This was a revolution of form and planning on a scale never seen before.

In the great Italian fresco cycles of the fourteenth and fifteenth centuries, for example those in the Basilica of Assisi, the Scrovegni Chapel, or the choir of Santa Maria Novella in Florence, the architectural schema was rigidly established at the start, as were the character of the composition, the figures that would appear in each scene, and their number and size. Not so for the Sistine ceiling. The thrones on which the Prophets sit and the nameplates held by the monochrome putti beneath them were changed during works. Michelangelo would have a creative idea, which took shape even as he worked on it and changed the very composition of a scene. The nine central panels to be decorated with stories from the Old Testament were dictated by the division of the vault generated by the four spandrels along each wall. It seems probable that the subjects were chosen in consultation with the pope and his theological advisor, Egidio of Viterbo, an intellectual of boundless learning who was the central protagonist in a project of cultural syncretism that aimed to merge pagan, Hebrew, and Christian traditions into a single corpus.

The series of scenes should be read starting from the altar, in an order that follows the one used twenty years earlier for the stories of Christ and Moses. On the ceiling, right above the altar, was the first act of Creation, the *Separation of the Light from Darkness* (plate 16); it was followed by the *Creation of the Sun, Moon and Plants* (plate 17) and

by the *Separation of the Waters* (plate 18). These three scenes define the terrestrial globe as a tangible physical place in which God would set his chosen creatures to start history. There followed the peopling of earth with the *Creation of Adam* (plate 19) and the *Creation of Eve* (plate 20), the inevitable premise to the *Temptation and Expulsion from Paradise* (plate 21): these marked the start of the dramatic story of God's people.

The tormented existence of the humans who lost the grace and happiness of Paradise is summed up in the three final scenes, *The Sacrifice of Noah* (plate 22), *The Deluge* (plate 23), and *The Drunkenness of Noah* (plate 24). Thus the vault represents the life of the world before the coming of Moses and Christ – a synthetic representation of the Bible and of history that is directly correlated with the stories narrated in the lower registers. It was the account of a long and essential path to grace that started on the vault, with the separation of the darkness, and ended on the walls below, with the crucifixion of Christ, the event through which God redeemed the people who celebrated Christian identity in that chapel.

The programme of the pope and his advisors was once again centred on a definition of Christian identity as the sole legitimate heir of history. But, unlike his uncle Sixtus IV, who was operating under the pressure of an Ottoman invasion, Julius II felt threatened less by the Turks and more by the cardinals who sat beside him in consistory. More precisely, criticisms of his way of interpreting papal authority had been circulated by some cardinals who opposed him, and the situation was such that a part of the college of cardinals was now planning, with the backing of the French king, to open a schismatic council and to depose him from the throne of Saint Peter.

This emphasis on the Old Testament and on western philosophical wisdom served to identify Christian legitimacy with papal legitimacy. Such legitimacy not only had recourse to the authority of the Gospels but also aspired to encompass and use the philosophical tradition of the Greek and Roman world itself, represented on the vault by the Sibyls, seated as they were on fictive thrones formed in the lower part of the spandrels. Here the Persian, Eritrean, Libyan, Cumaean, and Delphic Sibyls alternated with the Old Testament Prophets – Jonah, Isaiah, Ezekiel, Daniel, Zachariah, Joel, and Jeremiah. To underline the syncretic value of this representation of history, memory, and ritual, in

the lunettes between spandrels (on the only flat part of the vault) were painted the *Forebears of Christ*, ancestors of the man chosen by God to save those who had faith in him. The classicizing value of the vision was emphasized by the presence of the nude figures, the Ignudi, carrying huge garlands of oakleaves on their shoulders. Here they become an astonishing reinterpretation of the Greek and Roman celebratory glorifications represented by the spirits or *genii*, with or without wings, who carried the emblems of the persons glorified; and here their beauty makes them the protagonists of the scene. Such beautiful, happy young men had not been seen for thousands of years on the surviving monuments in Italy.

This elaborate narrative schema for the vault was integrated with the representations in the panels below, making the entire chapel the largest painted narrative in human and Christian history, a narrative that assimilated all the good and just that mankind had achieved since the Creation, in the known lands of the East and the West. Such a narrative had never been illustrated before.

Everything was integrated and assimilated, including the philosophy of the most learned minds that confirmed the only true religion and the greatness of the Church of Rome, which absorbed the legacy of the past in order to make it flourish in the new golden age ruled by Julius II, legitimate descendant of Peter through that gallery of papal portraits aligned directly under the lunettes that contained Christ's forebears. Such an ambitious programme had been entrusted to a man who nurtured an equally immense ambition for his own expressive abilities; a man who had promised the pope, with magnificent sketches, to astonish the world by changing the style and the form of the story. Together, the pope and his painter admitted no limits to their ambitions and found no obstacles to stop them in the cumbersome bureaucracy of the Eternal City, which in these years was undergoing one of its rare moments of revitalization.

25

THE NEW WORLD

Work on the ceiling started not at the altar, where the narrative started, but at the opposite end: at the south-east wall, where the lay public entered the chapel. The choice was probably a practical one: the platform suspended in mid-air had to assure the continuity of worship in the chapel, but needed to be tried out in practice. If there were drawbacks, these would not have affected the vital area around the altar and the presbytery, the area where the cardinals gathered for the most important services. When the ceiling was painted, this enclosure occupied a half of the chapel; but by the middle of the century it would be enlarged to its current position, or rather to the height of the fourth bay along the walls.

According to the clues gathered by restorers during a major twentieth-century restoration,[21] the first scene to be painted was *The Deluge* (plate 23), accomplished in thirty *giornate* or plaster segments (a *giornata* corresponded to a day's work) or plaster segments – a huge number of fragmented parts, which will never be reached again by the artist. The preparatory drawing was transferred in this case by using charcoal, which was a very accurate system but required more time than the so-called method *ad incisione* ['by engraving']. In the former, the drawing of the scene or part of it on the cartoon was pricked around all the significant lines with a thin point designed to create tiny dots through which

the charcoal could pass when a gauze bag filled with charcoal dust or black pigment was lightly pressed against it. The prepared cartoon was held against the wall and the bag was pounced over it. The small black spots that passed through the pricked holes were then joined up with a brush dipped into watery colour, until the drawing reappeared on the plaster. This method of transfer guaranteed greater fidelity to the drawing but took much longer to carry out, owing to the time required to delicately prick the edges of the sketch. The second system, which used incision, was more perfunctory. The preparatory cartoon was rested on the damp plaster and the lines were retraced with a pointed stylus so as to create an impression on the soft surface; then the artist emphasized it with brush and colour. This kind of transfer called for greater skill and practice and was used by Michelangelo only in the later scenes.

The use of charcoal was not the only sign that betrayed Michelangelo's hesitant start in the scene of *The Deluge*; his recourse to many dry layers did the same. 'Dry glazing' [*velature a secco*] was the term used for chromatic expanses applied when the plaster was already carbonated (when it had already hardened and a crust of calcium carbonate had formed) and on which the colour was thickened with a tempera, which could take the form of a dilute solution of milky lime or actual organic glues. The scene of *The Deluge* contains many of these dry layers, which in practice represented a delicate moment for the painting because the perfect execution of the fresco required only the use of pigment dissolved in water.

In all, the use of pouncing to transfer the preparatory sketch, the reduced area covered each day (the *giornate* for this panel corresponded to a very modest amount of work), and the use of dry layers of paint point to a timid start from the ambitious sculptor who turned his hand to painting – all the more as, for this scene, he could still rely on the help of the painters he had recruited in Florence. According to the diagnostic tests performed during restoration, there are significant quantities of pigments that were not suited to fresco, such as the red and the lacquers, which were used here precisely because Michelangelo had not yet developed a visual sensibility as a fresco painter but still had in his mind's eye the effect of the colours of his *Doni Tondo*, where the timbre remained very high, both in the reds and in the blues of the mantle.

Apart from these material details, which can be accounted for by the uncertainty of the start and the difficulties of mastering Roman rather than Florentine materials, the painted scene immediately appeared rev- olutionary in style and expression. Merciless in his criticism of the 'old manner', which he pronounced 'old' right here, Michelangelo erased the world created just a few metres below by the painters who had been his masters. There would be no archaeological references, no refined brocades, no gold to highlight the foliage of trees and precious gar- ments, no complacent imitation of the naturalistic details of plants, flowers, rocks, and flying clouds. Instead he resumed the language developed in the cartoon for the *Battle of Cascina*, the language that, in Julius II's eyes, guaranteed a narrative revolution (as mentioned earlier, the pope must have seen this cartoon to convince himself of the young man's talent). Here Michelangelo placed the human body centre stage, as it would be in his painting for the next fifty years: nude, athletic, expressive, and perfectly articulated in space.

The thundering language of the genius that brushed away the stuttering hesitancy of earlier generations is wholly centred on the expressiveness of the human body, its capacity to condense every nuance of emotion and history into gesture or, better, body posture, because history is sentiment and emotion. There is no need for emblems and symbols to read an action as it happens, everything is told through the different attitudes and poses of the body. Backed by his anatomi- cal studies and his studies of foreshortening, even in this first scene Michelangelo oversteps the realistic representation of the body in order to impose a psychological one, in which the body – every gesture, every limb – is rethought, modelled, exaggerated so as to reveal the inner emotion.

As if to make space, to leave room for this representation, Michelangelo performed a radical simplification and abstraction of the natural world. The water is a grey-blue expanse, barely streaked by the movement of the waves. Compared to this visionary immensity, the triangular waves of the sea painted by Ghirlandaio a few metres below, to represent the *Crossing of the Red Sea*, appear ridiculous (plate 11). The land where the wretches submerged by the waters seek refuge is a simple green field. In place of the painstakingly detailed, high- lighted, jagged trees that flourish in the painting below, here there is

just one majestic specimen, bare and essential, designed to recall the forests that covered the earth before the flood. The clothes undergo the same radical simplification, becoming just coloured blocks of primary tones (blue, yellow, green, red) in order to emphasize the movement of bodies and the fury of the wind. In this natural setting reduced to basics, what triumphs is the gestures and the sentiments that grab our attention at first glance, even though we, the spectators, stand twenty metres below. The protective embrace in which the woman at the top of the hill enfolds her child relies on the light that moulds the weighty arm with which she clasps the boy to her breast. The despair of those submerged is present in that single gesture, in the same way in which, a little further back, the mercy of these wretches is represented by the man who tries to hold up his wife's body as it droops over his shoulders or, halfway up the rise, by the man who carries his wife on his shoulders, her hair tossed in the wind. All around is the movement of despairing bodies, deformed by the unfolding disaster that manifests itself through their torment, so that it is the body, not the rain or the flood, that becomes the subject of the biblical catastrophe. The devastated and tormented bodies are always portrayed with perfect, believable realism. Even the ark in the background, where Noah takes refuge with his progeny, is reduced to its essential form and colour – a wooden shell that will house the escapees.

The scene that was painted next, *The Drunkenness of Noah* (plate 24), is even more radical. Here the sons find the old patriarch naked and inebriated beside a vat of wine. But the sons are naked too, and the virile member of the most merciful son, who draws a veil over his father's nudity, moves visibly in response to the movement of his leg. The monumental vat reveals no artisanal or decorative detail. The old patriarch is as majestic as the statue of an ancient river god: old, but at the same time handsome and with powerful, still active muscles. The two young men in the foreground, who repeat the gesture of the two figures in the background of the *Tondo Doni*, are an exercise in plastic virtuosity. Their nudity was crucial for Michelangelo to define the calibrated dance of their movements and to recount the surprise, the derision, and the mercy. Nor did it matter that their nudity lessened the impact that the nakedness of the patriarch was supposed to have on the observer, as in almost all earlier representations of this scene, from

the most recent, by Bellini, to archaic ones, such as the mosaic in Saint Mark's in Venice.

This departure from the iconography is important if we want to understand Michelangelo's urge to impose the style of a representation over its meaning. By showing Noah's sons naked too, Michelangelo questioned the iconographical tradition and the readability of the scene's meaning. Why be scandalized by their father's nudity if they themselves were naked? Yet Michelangelo had no option but to remain faithful to his own creative passion. If he had had to dress Noah's sons, all that emotional theatre – surprise, movement, amazement – would have been lessened, and therefore his expressive needs were also imposed on tradition, perhaps to the embarrassment of his patrons. His was a creative fury in action that accepted no compromises and released an almost superhuman strength. It would also take form in the next scene, that of *The Sacrifice of Noah* (plate 22).

26

FROM STORY TO SPIRITUAL RITUAL

In this scene there is an unpitying comparison with the other scenes of sacrifice in the lower band of paintings. In Botticelli's (plate 8), the ceremony is entirely rendered through the rich priestly vestments, the constrained movements of abstract ritual, and the evocative background of an archaeological 'antiquity' set historically in a world that still survived through the Roman ruins. Michelangelo's scene is a furious battle between the men, naked of course, who body-wrestle the animals to the ground before cutting them into pieces that other men throw onto the lit furnace. In the background, a Noah, unadorned with gold and embroidery, a true evocation of primitive antiquity, consecrates the sacrifice to the Lord. Once again, everything is reduced to essentials, and the action – excited, raw – is told by the bodies alone. The scene is set in an archaic, almost suprahistorical time, where neither the clothing nor the architecture qualify a specific period. But this timeless story reveals the primitive force of the sacrificial gesture reduced to the crude violence of obedience to God. Michelangelo transforms the story – to which all earlier painters had adhered in simplistic fashion – into a powerful dramatization of gestures in which references to precise architectural forms or elaborate displays of clothing would be a superfluous distraction from the core of the formal communication.

Beside these scenes, in the part immediately below, which connects the ceiling to the wall, Michelangelo painted seven Prophets and five Sibyls, which show a beauty and perfection never previously achieved by a fresco painter. The figures were painted in the final phase of work, after the central panels; the maturity and confidence achieved by the artist within a few months is evident not only from the beauty of the figures, their poses, and the naturalness of their flowing garments but also from the impeccable, extraordinary technique of the painting. Seated on stone thrones that seem barely to contain them, the Sibyls and the Prophets are clothed in bright colours whose pure timbres were achieved by not mixing the pigments, so that the contrasts are not only clearly visible from below but also consistent, this time, with their historical period. Indeed, these figures are set in a historical period. *Joel, Zachariah*, the *Delphic Sibyl*, the *Eritrean Sibyl* and the *Prophet Isaiah* are dressed in silk robes, the characteristic textile produced in the geographic areas where they lived. The fabrics shimmer with pure colours combined with their complementary tones: an acid yellow for a fabric exposed to the light, coupled with an intense, cold green for the shaded part of the same fabric; a purple that becomes green in the parts placed in the shade, in the *Prophet Jonah*. Such radical combinations would be absorbed in the next generation, which used them in every possible variation. The style of Salviati, Zuccari, and Cavalier d'Arpino is focused precisely on chromatic contrasts, which became a repetitive, mannerist language.

The gestures are conceived of in a foreshortening that gives life to the movement so realistically that a more convincing representation could not be imagined. While the fifteenth-century painters, Michelangelo's masters, had staged a dance rendered through an endless repetition of small gestures, Michelangelo positioned his Prophets and Sibyls in a way that it is original to each, as if they were moved by the torment of a relentless agony that does not detract from the grandeur of their postures. Each figure offers an opportunity to experiment another twist, a contraction or a lunge that give expressiveness to the figure (as in the *Libyan Sibyl*, who displays an unprecedented twist to her torso, creating an illusionary depth to the space within the niche). Each of these figures became part of the catalogue of sixteenth-century painters who would devote their best energies to the task of copying these poses and adapting them to their own stories.

The climax of beauty and power was attained in the Ignudi: they are seated on the marble frames and hold up garlands with acorns, in an allusion to the arms of the pope's family, the Della Rovere. These figures derive from the *genii* placed on Roman monuments and bearing festoons and other decorations; but here Michelangelo makes each one the carrier of a different psychological sentiment, through the position of their bodies. These exceptionally beautiful bodies will be used as an anatomy textbook throughout sixteenth- and seventeenth-century Europe and will be imitated well into the nineteenth century, when painters and sculptors like Rodin will draw inspiration from them for their own work.

The vault had reached such a point of perfection and beauty that Michelangelo feared no comparison, not even with the elegant young prince who, just metres away, was about to decorate a new *stanza* for the pope.

27

THE BREAK OF 1510

In the summer of 1510 the first part of the ceiling, the section that contains the three scenes of Noah's life and perhaps the *Temptation*, was certainly finished. The rapid alteration in the size of the figures showed that Michelangelo had not prepared an overall design for the entire decoration before starting work; but even if he had, it would not have been detailed enough to stop him from rethinking the entire narrative work by giving greater monumentality to the figures and by making them fill the available space in a completely new way.

Even the use of colours underwent changes: greater emphasis was placed on iridescent colours, to make the figures more prominent from below. The explosion of shimmering colour is most evident in the coils of the snake wound around the tree in the *Temptation* (plate 21). Brilliant orange, yellow, and green follow one another with surprising force, the manifesto of a new poetics of colour. But there is also another intuition, which led Michelangelo to an improved understanding of the narrative: the reduced use of colour in the stories. In the early scenes, small expanses of colour were used to define clothes, objects, landscape details, dispersing a full and immediate understanding of the narrative from below, through excessive visual fragmentation. Michelangelo decided to simplify the use of colours still further and, as well as introducing iridescent tones, he removed chromatic variations and reduced

their range to that of the variations used for flesh and to the few shades used for clothing (above all, the purple of God the Father's cloak), a light green for the landscape, and pale blue for the sky. This is extraordinarily effective and makes the whole much more readable and exciting. Michelangelo gradually improved his pictorial style. He regarded it as the product of a rapidly and constantly evolving thought, refuting the earlier tradition, which had used a standardized language reproduced in identical form, again and again, with few variations, as can be seen from a comparison with the lower panels.

The absence of a unitary and definitive design before the painting started was itself an epochal change in the history of Italian painting. But Michelangelo's confidence grew steadily, and on 7 September he wrote to his family in Florence to announce that he would take a break in the work, to reassemble the platform below the second half of the ceiling, and that there would be a possibility of his coming home:

> You should know that I am still owed by the pope 500 ducats that I have earned, and he owes me the same again for the scaffold and for continuing the other part of my work, but he has left and has not left me orders for anything.[22]

The pope's departure convinced Michelangelo that the time had come for him to leave Rome and delegate to his young assistants the task of continuing to enlarge the drawings that were to be used in the second phase of the work. However, a letter sent to him from Rome by his trusted Giovanni Michi[23] confirms that the drawings for the second part of the vault were not yet ready and that Michelangelo was developing the project in midstream. This work-in-progress style was the artist's true stroke of brilliance because it allowed him, once he had examined and carefully assessed the effect of a painting as seen from below, unobscured by the scaffolding, to make substantial changes to the next part of the composition. The figures in the last scenes would be enlarged to fill almost the entire space framed by the marble cornices. This improved their legibility from below and refined the composition, which became an even more essential trait – so essential that it approached the classic standard in terms of the solemnity of the characters and their positioning in space. We have no way of knowing what

the patron thought of this choice, but it is certain that Julius also trusted his artist with the proposal of making alterations to the ceiling after the removal of the first portion of the carpentry structure.

The symbiotic relationship that bound the pope to his artist is manifest precisely on this occasion, through the fact that Michelangelo's departure coincided with the pope's. It was only because the pope left Rome that the artist was able to visit his relatives in Florence. Michelangelo had been away for two years and there were urgent matters to settle. The most pressing one was to bring his brother Giovan Simone back into line, since he had repeatedly broken the family's code of conduct by insulting their father Ludovico. With the thousands of ducats received from the pope, Michelangelo had brought to his family a newfound affluence. Farms had been purchased and significant sums lodged with the bank of Santa Maria Nuova. He wanted to see for himself how the gold ducats earned at the cost of agonizing material sacrifices were being spent:

> Giovan Simone, it is said that if you do good to the good man you make him better, and if to the sad, you make him worse. I tried a few years ago, with good words and deeds, to persuade you to live well and in peace with your father and us others, and yet you grew worse. . . . Now I am certain that you are not my brother, because if you were, you wouldn't threaten my father. Instead you're a beast, and I'll treat you as one.[24]

No one who reads these words would think that they came from an artist whose mind is on his painting. For Michelangelo, art was a dramatic struggle with matter and with his own vital instinct, which demanded rest, nourishment, and happiness, while painting demanded the annihilation of any need that was not pure creativity.

Michelangelo's determination was superhuman, but perhaps it was also stimulated by the need to free himself from any kind of dependence, even that of his collaborators.

28

A NEW BATTLE

The reasons for Julius II's departure were very different. Obliging the entire college of cardinals to follow him, he left in order to reconquer Perugia and Bologna, which had been taken back by the Baglioni and the Bentivoglio. His plan was to take back the fortress of Mirandola and, above all, to oust Louis XII from the north of Italy by radically realigning the political allegiances he had built in the past few years. The military campaign started in September 1510 and the political action behind it were so extraordinary that this pope will always be remembered as one of the key protagonists in European history.

Having reached Bologna in December that year, Julius wanted to be present in person at the reconquest of Mirandola in the following January. Wading through snow up to his belt, sword in hand, and a sable mantle over his shoulders, Julius was heard to swear against 'that whore', Francesca Pico della Mirandola, the dowager countess who was defending the fortress. Three cannonballs from a bombard narrowly missed him in the temporary shelter where he waited, and all were later walled into the basilica of Loreto, which he erected to thank the Virgin for having escaped unhurt. After an initial victory over the French, Julius was then resoundingly defeated at Ravenna, where the confederate army of the church suffered huge losses. The pope returned to Rome seriously ill, to wait, along with the rest of the city's inhabitants,

for the French army to follow through; but, for reasons that have never been truly understood, the army was disbanded and did not dare to attack the Eternal City. Encouraged by his military success, King Louis XII urged the cardinals hostile to the pope to open a schismatic council in Pisa and depose him. It was one of the most serious affronts ever received by a pope of the Holy Roman Church.

But the French king had not taken into account the affection that the lower clergy and the people had for the pope. The schismatic cardinals' attempts to open a council on Italian territory were met with stones thrown by the people and with objections from the priests. Slowly, even the threat of a theological crisis faded and in 1512 Julius could regard himself as the absolute winner of the battle started in September 1510. It was a well-deserved triumph, and one supported by God – in the eyes of Italians, at least – because all Italy knew that Giuliano della Rovere was the only pope who had dared to draw up a political project not for his own family but for the church and for Italy. He was a military commander who had re-established the physical boundaries of the Papal States that had been eroded by the ambitions of earlier pontiffs, their families, and the overlords of minor local states.

Moreover – and this was something that the Romans regarded as even more deserving – Giuliano della Rovere had accumulated an extraordinary sum in the church's coffers (700,000 ducats, it was rumoured) to wage war against the Turks, as other popes had promised for the past fifty years but none succeeded. Julius, on the other hand, was a man of action and no one doubted that he would have kept his promises. He had solemnly declared in public, on several occasions, that his dream was to celebrate mass in the old Hagia Sophia in Istanbul, which Mehmed II had transformed into a mosque. All too aware of the revolutionary power of images, he had passed that vision – mass celebrated in the far-off and usurped Hagia Sophia – to the sorrowing imagination of Christians throughout Europe who for fifty years had dreamt of escaping the yoke under which the Ottomans had brought Eastern Europe and the Mediterranean.

Rome and Italy were at Julius' feet, but he knew that only one man had to be entrusted with his triumph. This was his rebel artist, who was as headstrong as he was – the only man in the whole world in whom the pope saw himself and found strength for his audacious projects.

29

REVOLUTION IN PARADISE

After the separation of September 1510, in early 1511 Michelangelo returned to Rome, where his loyal collaborators Bernardino Zacchetti and Gismondo had continued to prepare the cartoons for the second part of the ceiling. For this second phase, the scaffolding covered the section of the vault that starts a little more than halfway down the chapel and stretches to the altar. Here, in this second section, the revolution that Michelangelo had timidly begun two years earlier was perfected and embodied in all its force.

The artist's eagerness to innovate was such that even the decorative structure of the vault changed. The nameplates below the Prophets were made narrower and the putti at the sides of the thrones assumed different dimensions. Unconcerned by the visible break with the part painted earlier, Michelangelo sought to perfect the decorative details constantly. The painting acquired a preciousness and a perfection of execution that can be appreciated even from the chapel floor. The plasters were as compressed and smooth as stone surfaces, and the colour so pure and perfectly slackened with water that, when dry, the surface took on the consistency of inlaid enamel. At this stage Michelangelo had absolute control of the exact amount of pigment to dissolve in water, and this perfect mix saturated the surface of the plaster, leaving it shining and mirror-like. Neither his brush nor any excess water ruffled the

plaster surfaces, and the colour settled into the barely perceptible pores of the outer skin of the mixture.

The quality of the painting was supported not only by the perfectly proportioned mix of lime, pozzolana, and pigments but also by a pattern of brushstrokes so even that they look as if produced by a machine. After applying a first transparent layer of colour over the plaster, Michelangelo remodelled it through a very regular pattern of strokes, which recall the regular blows with which he struck the chisel on marble. Michelangelo used this densely woven chromatic finish in order to give a distinct form to the chiaroscuro and to the rounded bodies. Not satisfied with this perfect and luminous pictorial scan, in the second part of the ceiling Michelangelo insisted on experimenting with a new type of chromatic perspective or plastic sfumato. The figures in the foreground are defined in dense, compact colour, while those in the background are outlined with wide brushstrokes and strong contrasts, but have undefined edges.

This was a type of chiaroscuro perspective that no one before him had used so expressively. The figures that fade into shadow using a few broad strokes, often revealing the plaster beneath, give the impression of a real depth that belies the constraints of the architectural structure. But the original technical refinement yielded by these woven strokes and the highly polished plaster served only to highlight the real revolution achieved by Michelangelo in the radical change of the narrative structure. When the scaffolding was removed from the earlier part of the ceiling, Michelangelo could finally observe the real effects of the painting from below. At this point he convinced himself that the first panels had still followed a late fifteenth-century narrative format, with too many figures in the panels. This multiple presence, this crowd of onlookers, was probably due to the traditional calculations still used in drawing up fresco contracts. Paintings were mainly evaluated by the number of heads or figures that appeared in them. This also explains why, in the fifteenth-century narrative cycle, the number of figures in each panel is almost identical. In the first scenes of the ceiling – namely in *The Deluge* (plate 23), *The Drunkenness of Noah* (plate 24), and then *The Sacrifice of Noah* (plate 22) – Michelangelo painted many figures. But, seen from below, these panels lacked the expressive force that the artist sought, precisely because they were crowded. The action was lost

in an anecdotal narrative.

On the other hand, the bodies that were such a focus for Michelangelo seemed less monumental when seen from below. On resuming the work, the artist radically changed the type of composition in the new scenes. In *The Expulsion from Paradise*, which is associated with the *Temptation* (plate 21), Michelangelo drastically limited the number of people, in a compositive crescendo that, by simplifying each narrative detail, aimed to emphasize the human figure that filled the space with a powerful sense of monumentality.

In the *Creation of Eve* (plate 20), the new language was perfected. God is immobile, save for that forceful gesture that gives life to the female figure, which rises with perfect equilibrium from the side of a sleeping Adam. This respects the biblical tradition but gets rid of the naturalistic incongruence that Michelangelo hated. His painting is always highly credible on the plane of reality and the full-bodied, tangible, Junoesque Eva who rises, her hands joined before the Creator, does not emerge literally from Adam's flank, but instead rests her feet on the ground just behind his flank, as he lies with abandon on the ground, in a pose that exalts his athletic beauty. Michelangelo uses light to draw attention to Eve, making her feminine body gleam so that it becomes closer and is highlighted when seen from below. The scene uses very low, almost monochrome tonalities: slight variations of green, bluish grey, and purple (the ample cloak of the Creator), so that the pallor of Eve's flesh shines out and underlines the first woman's role as a protagonist.

30

THE MIRACLE OF CREATION

Only in the next scene, *Creation of Adam* (plate 19), did Michelangelo's new language attain the perfection of a miracle, through a rapid refinement of his pictorial techniques and creative vision. It is a miracle that still works today, five hundred years after the scene was painted. Adam fills the entire panel, resting on his side and stretching diagonally across the scene to show his perfect body, which gleams thanks to the compactness of the plaster and the freshness of the colour, barely shaded as it is by chiaroscuro; and the chiaroscuro, far from concealing, instead models every muscle, every nerve, every detail of that monumental body. From the opposite side of the panel, the figure of the Creator enters the scene with a dynamism highlighted by the movement of his violet mantle, which is supported by a group of angels who fade into the mantle through the technique described earlier, so that the mantle becomes a cloud, a magic shell. The Creator forms a plastic and chromatic counterpoint to the young man, and the two of them are shining whirlwinds surrounded by a dark halo that makes them stand out. Adam is almost encased in the green rock he rests on, and the rock is emphasized by a broad blue line on the horizon that forms both earth and sky. This was precisely the dilemma that Michelangelo had to resolve: the scene takes place on earth, where Adam lives, but the Creator is in the heavens, and therefore the sloping horizon restores an appropriate location to both figures.

The gigantic plastic and chromatic masses, crossed by the luminous bodies of Adam and his father (whose muscular body is evident through the lilac fabric that adheres closely to his frame), are separated by the white stripe of the sky or horizon. This separation, exalted by the glimmer of the luminous background, is miraculously broken by the contact of the fingers that barely touch, calming the movement of the two dynamic masses and transforming what might have been a collision into a fusion or generation (which is the same thing) of the two bodies and of the spirit that passes from father to son. Everything is made ready for that gesture – the colours, the abandon of Adam's body, passive object of the event, the movement of the Creator, who is the active agent; and it is a gesture that condenses the emotion of the creation as it had never been imagined before and never would be again. In this scene Michelangelo's poetics of expression reaches the pinnacle of perfection; and it still disturbs us today, because the male body alone can describe, in such an unexpected way and with such emotional power, the Creation, that most spectacular event in human tradition.

Looking up to the ceiling, the spectator sees the two moving masses, framed against a sky that is almost realistically bright, as they brush and are stilled in that fingertip gesture that only a genius could invent. So much beauty, such power had to have a meeting point that could only be evoked, because only an evocation could leave the beauty and power of these two opposing figures intact. The *Creation of Adam* alludes to an encounter between the unattainable divinity of God the Father and his most successful creation: this beautiful, docile man, who extends his hand into the immense space of heaven to brush that of the Creator. But just to brush it, aware that a real encounter between humans and their Creator can never occur.

In the painting, which is almost at the centre of the ceiling, Michelangelo reached the full maturity of a revolution that would change European art forever. The scale of the representation is perfect; the latter is conceived of in such a way as to be appreciated from twenty metres away. By choosing to eliminate all other details from the painting, Michelangelo made the two giants visible from below and created an absence around them, a silent vacuum that, as in a musical score, emphasized the solemnity of the event.

The next three scenes would be only a virtuoso exercise of this infinite compositional freedom, achieved by the artist in great measure thanks to an anguished, almost despairing search for a highly original executive technique, which he had refined during months of dejection: he had spent that time alone on the scaffolding, with his face constantly turned upwards and a goitre again troubling him in his chest, as he described in a famous sonnet:

> I've grown a goitre by dwelling in this den –
> Like cats from stagnant streams in Lombardy,
> Or in what other land they hap to be –
> Which drives the belly close beneath the chin.
> My beard turns up to heaven, my memory boxed in,
> My chest and breastbone like a harpy's
> Now resemble. A rich embroidery is
> My face from brush drops thick and thin.
> My loins into my paunch like levers grind,
> My buttock like a crupper bears my weight.
> My feet unguided wander to and fro,
> In front my skin grows loose and long, behind,
> By bending, it becomes more taut and straight.
> Crosswise, I strain me like a Syrian bow,
> Whence false and quaint, I know,
> Must be the fruit of squinting brain and eye;
> For ill can aim the gun that bends awry.
> Come then, Giovanni, try
> To succour my dead pictures and my fame;
> Since foul I fare, and painting is my shame.[25]

In the last scenes he even abandoned the detailed anatomical definition of bodies, simply playing with it through the transparencies of the fabrics, which showed spectators God's flying body even from the chapel floor. Now he seemed interested in defying gravity and in portraying the dream that no artist had ever managing to fix in paint: the naturalness of a body in flight and the consequent aerial movements of the Creator who, borne up by a cloud of angels, separates the light from the darkness, the waters from the land.

In these scenes he was not content to show the foreshortened body correctly but rather a body foreshortened in flight, around which he seems to see the air vibrating as he demolishes the barrier of the vault itself through fully credible gestures and lends viewers his own imagination, so that they may glimpse what has never been seen. In *The Creation of the Sun, Moon and Plants* (plate 17), the flying Creator seems energized, defying gravity with his wide, unconstrained gestures. To make the force of the aerial movement even more evident, Michelangelo radically simplified the surrounding background: God's robe is one single expanse of colour, which miraculously assumes the form of an athletic body under the thrust and effect of a wind that we can almost feel down here, on the floor – our vantage point for this powerful creative act in the first days of the world and of Creation.

31

THE TRIUMPH

The last scenes on the Sistine ceiling are the culmination of a creative quest fuelled by technical confidence, a desire to test limits and set new goals not only for painting but for human vision. That severe, gigantic Eternal Father, so beautiful in flight with his angels, shown with a gestural expressiveness that has almost nothing to do with the narrative (the sun, the moon, and the darkness are almost unrecognizable in their abstraction), became a sensational attraction long before the carpentry structure was taken down. This sentiment was driven by the enthusiasm that pervaded Rome in the summer months of 1512, when it was clear that Julius had triumphed over the French despite their victory at Ravenna in April.

The certainty and enthusiasm of a victory that had been in Julius' sights for years is summed up by Paris de Grassis [Paride de' Grassi], the loyal papal master of ceremonies who had brought him news of the crack eight years earlier and had followed every moment of the pope's life for the past ten. When news of the French withdrawal arrived on 22 June 1512 in a letter from Cardinal Schinner from Pavia, Julius embraced Paris, shouting: 'We have won, Paris, we have won.'[26] After the fear caused by the defeat at Pavia, the threat of a schismatic council, and even the serious illness that had almost killed the pope in the summer of 1511 and from which all Rome believed that he had made

a miraculous recovery, the city was now overcome by a sense of triumph, in some ways shrouded in a miraculous aura. Contemporaries could not explain why the French army was disbanded after it had overwhelmed the papal troops at Ravenna. Still less could they explain the pope's recovery after his physicians had declared him virtually moribund and ambassadors had hastily sent their princes dispatches to this effect. The popular legend that spread through the narrow streets of Rome, that was endlessly repeated by stallholders in Campo dei Fiori, and that even Pasquino failed to quash was that a dish of peaches had brought the dying pope back to life: all as normal as you please in the spiritual capital of western Christendom, on which the corrosive critical spirit of north European Lutheranism had not yet descended.

This climate of miracles cloaked the pope's victory in deeply emotional suggestions, and the two great artists who were working for him tried to translate into images and reinforce the climate of collective enthusiasm in which the Eternal City now basked, after centuries of decay and obscurity. Finding itself again at the cultural and political centre of the old world as well as of the new, Rome beautified itself, trying to deserve its regained status. In the pope's apartment, the great painting of *The School of Athens* that Raphael was finishing was not only a manifesto of perfect painting in the sweetness of its poses and the harmony of its colours, but also a testimony to the unbroken tradition of western knowledge that led exactly there: to the court of Julius II, heir to the wisdom of Greece, to Rome's strength, and to the theology of the Bible. The completion of the Sistine Chapel ceiling emphasized this climate and rejoiced in it.

In early summer, one of the pope's most indefatigable enemies, Alfonso d'Este, duke of Ferrara, went to Rome to ask for pardon. Accompanied by his small retinue, he climbed Michelangelo's scaffolding, to get a preview of that miraculous painting from up close. At the same time he refused to visit Raphael's frescoes, although during the same period his agents insistently demanded works by the artist's own hand. But Raphael was just an artist, albeit one of the greatest, while Michelangelo was no longer a human but a godlike figure who had changed painting forever.

Alfonso d'Este's extraordinary visit, which was immediately publi-

cized by the ambassadors, only fanned curiosity and anticipation around
the public opening of the ceiling:

> His Excellency heartily desired to see the ceiling in the great chapel
> which Michelangelo has painted and Signor Federico arranged
> through Mondovi to go and make a request on behalf of the pope, and
> his Lordship the duke went up to see the ceiling with several persons;
> at length each person came down, one by one, from the ceiling, and
> his Lordship the duke remained with Michelangelo and could not see
> enough of those figures, and he paid him all sorts of compliments for
> the reason that His Excellency desired that he should paint a picture
> for him and he made him talk and offered him money, and he promised
> to make him one. Signor Federico saw that his Excellency was taking a
> long time up at the ceiling, and thus he took his gentlemen to see the
> pope's apartments, those being painted by Raphael of Urbino.[27]

The event had to be carefully prepared and no one knew better
than Julius II how to make such a ceremony memorable. The chosen
date was the eve of All Saints, when one of the oldest rituals of the
Catholic tradition was celebrated in the Great Chapel. The pope led a
procession of thirty cardinals dressed in purple and gold. The fumes of
incense from the burners and the voices from the chapel choir dazed
those fortunate enough to be admitted to that miracle. The cardinals,
the laymen, and the young clerics who swang the censers in hypnotic
rhythms, spreading waves of perfumed essences from the distant
Orient, found it difficult to advance without taking their eyes off the
ceiling above them. Nor could they stop their gaze from darting – from
the terrible Eternal Father in flight, his purple cloak stirred by the
wind, to the breathtakingly beautiful Adam, who brushed the omnipo-
tent with his hand, full of courage and at the same time timid. The sky
of the Creation is limpid, the world in its first days is drawn in languid
detail, space is left for the protagonists of the story: men deified by
beauty and invented by Michelangelo Buonarroti, the small man who
found it hard to lower his gaze to the ground – and not out of shyness,
a sentiment he never knew, but because his neck had been deformed by
months and years of solitary work on the scaffolding. Although lightly
built and short, his body was a bundle of muscles and nerves. No one

had helped him in the hours of fatigue, and no one could second him at this moment of glory.

The first public celebration of that success reached the rest of Europe in a book that had just been published in Rome, *Mirabilia Urbis Romae*, which recorded how Michelangelo had surpassed all painters and, to welcome the pope's triumphal procession, had invented a new world on the imaginary marble projections that framed the ceiling. Handsome male nudes carrying crowns of oakleaves; Prophets and Sibyls seated on white thrones – twisting figures that solemnly leafed through the pages of their books of millenary knowledge and whose terrible beauty was terrifying; putti who obediently held those books on their shoulders, beside and below the thrones; and, recessed in enormous lunettes, the gallery of Christ's ancestors, dressed in silk and brocade. Through this new world, Rome, the centre of Christendom, reclaims the potent allusions of an imaginary whose tradition stretched back one thousand five hundred years and that now, from this ceiling, was getting ready to snatch the Orient back from the hands of the Turks – engaged as these were in covering their places of worship with geometric intarsias and bright colours, because their religion did not tolerate any representation of God. Hagia Sophia lay waiting beyond the mountains of Abruzzo, which were already covered in snow in November.

INTERMEZZO

The Crucifix of Santo Spirito

Michelangelo's work on the Sistine Chapel ceiling, considered almost superhuman by contemporaries, can be explained only by an overwhelming ambition, a determination to be the first, which drove him between 1508 and 1512. A brief look at his youth and his competitive strategies confirms that the boy had prepared during his entire life for this task. From his earliest attempts, Michelangelo was striving to surpass everything that had been done by those who could be deemed his masters. This direct competition with, and triumph over, the artists of the previous generation had already been a conscious strategy of self-affirmation during his apprenticeship phase.

The strategy was to choose a model and re-create it, in a way that kept it almost identical but completely renewed it. He had already accomplished this in full in the relief of the *Madonna della Scala*, which can be dated among his earliest projects in 1490–1, when he was just sixteen. The model in question was Donatello's, and Michelangelo approached it almost as a copyist, save for giving greater emphasis to the relief and impressing on the anatomical form that barely constrained energy that would become his unique stylistic trait. Vasari himself revealed the trick:

a bas-relief in marble of Our Lady executed by Michelangelo, a little more than an armlength's high; in this work Michelangelo, as a young

man at this same time who wanted to imitate Donatello's style, acquitted himself so well that it seems to have been done by Donatello himself, except that it contains more grace and a better sense of design.[1]

But it was in the *Crucifix* for the prior of Santo Spirito (created as the artist entered his twenties, between 1494 and 1496) that Michelangelo challenged all earlier sculptors, because at the time, in fifteenth-century Florence, the representation of the crucified Christ had become a benchmark for an artist's mastery of human anatomy. The attribution of this *Crucifix* is one of the still controversial questions in the catalogue of the artist's works. It disappeared from the church of Santo Spirito in the early eighteenth century, but in recent times attempts have been made to identify various Florentine wooden crucifixes as being by Michelangelo. Among these, the most successful was proposed by Margrit Lisner who, at the time of the fourth centenary of the artist's death in 1963, suggested that a statue present in the monastery could be recognized as the *Crucifix*, although it had not been recorded as such in many of the inventories compiled in the eighteenth and nineteenth centuries (plate 25). The success of this attribution seems to have owed more to the desire to celebrate the anniversary than to any serious stylistic evidence. One need only consider the elongated proportions of the legs and chest to rule out any connection to Michelangelo, given that in the *Battle of Centaurs*, which also dates from shortly after 1490, he had already established the proportions that would appear in all his subsequent works. The same is true of the really embarrassing anatomy of the *Lisner Crucifix*, where the chest is separated from the legs by an awkward twist that is wholly unnatural, so much so that these might be two separate pieces later joined together. There is no sign of that knowledge of anatomy that Michelangelo would have developed through a hands-on experience of dissection, one so intense that it would ruin his appetite; and it is impossible to insert the *Lisner Crucifix* into that strategy of competition with and triumph over earlier models that can be found in all the artist's early public sculptures. If Michelangelo had challenged Florentine tradition with a work like the one proposed by Lisner, he would certainly have failed.

When it comes to competition and challenge, a much more plausible case can be made for a wooden *Crucifix* that appeared on the Italian

market around 1965 and was proposed as a Michelangelo autograph by Mario Pinzuti, director of one of Vatican's institutes for scientific restoration. His attribution was based not only on stylistic evidence (which is always questionable on account of its subjectivity) but also on the basis of a very important document: an epigraph carved in the early eighteenth century on the back of the work (plate 28). The inscription is not fully legible, but what can be read is enough to secure a very solid attribution of this *Crucifix* to Michelangelo:

P.A.(. . .)ANCETUS BELLANI COINI S. HIERONYMI FECIT INCIDERE DI MICHELA(N)GELO QUESTO SUDETO DATUM F(LORENT)IE EX CONVENTU SA(NCTI) SPIRITU(S) M.D.CCII.[2]

The date, 1702, is particularly significant because at the time *The Crucifix of Santo Spirito* was still a public work, mentioned by several guidebooks over the centuries, and therefore there could be no confusion or mistaken identification of the work in Florence (plate 27). In 1965 there was no time to spread news of the attribution or to discuss the discovery scientifically because the work disappeared immediately after being presented, engulfed in a legal controversy that lasted twelve years. What was more, the Italian scientific community had just taken a positive view of the *Lisner Crucifix*, and it would have been highly embarrassing to retract such a resounding recognition.

I returned to this *Crucifix* and carried out a series of diagnostic tests that certified a dating between the late fifteenth and the early sixteenth century, but more than anything the stylistic and technical interpretation of the sculpture reinforces the documentary value of the inscription carved on the back.

In its present state the statue looks mutilated and spoiled by a coat of fake bronze that was applied after a series of disgraceful restorations in 1963. Only the loincloth, the shoulder, and parts of the hair still bear traces of the original polychrome. The statue is carved from a single block and uses the same technique as Donatello, Brunelleschi, and other Florentine artists of the fifteenth century, but, unlike all their crucifixes, this one has not only the loincloth and the hair carved in wood, but also – and this is extremely rare – the crown of thorns,

which is pierced at the temple with a virtuoso play with the relief. Here is the first affirmation of Michelangelo's superiority through technical execution, which sets him apart from all earlier creations, in particular Donatello's. Indeed, although Donatello, too, had carved the loin-cloth and the hair in wood, he had relegated the crown of thorns to ephemeral materials (plate 26) – and it was precisely Donatello whom Michelangelo set out to challenge with this sculpture.

Donatello had set up his wooden Christ by giving it a slight curve on the right side, thus forming a barely visible arc, which starts from the left foot and concludes with the head, itself lightly reclining to the right. The posture is faithfully copied in the *Crucifix* attributed by Pinzuti to Michelangelo, but in the latter the curve is more marked and the artist extends the left foot, superimposing it on the right, so as to make the pose more dynamic. By comparison to Donatello's pose, Michelangelo's introduced two important novelties, intended to reveal to the Florentines his superior talent and his better knowledge of male anatomy: the right flank is slightly twisted forward (an innovation that is perfectly executed), and the head droops towards the chest. It is as if Christ, in agony, retreated into his wounds in order to protect himself from pain before abandoning himself to death. The lolling head, which produces a slight rotation of the left shoulder, is another characteristic element of many of Michelangelo's drawings of the crucified Christ, especially the Oxford drawing (plate 29). The placing of the left foot over the right is another highly original feature that would reappear in several other drawings by Michelangelo.

The perfect reproduction of the chest shows that delicate bulge of the ribs below the spare muscles, their tops blurred and rounded. The barely modulated abdomen hints at the suffering caused by the long fast before martyrdom. Alongside this, and contrasting with such a realistic definition, we find a treatment of the hair that is typical of the simpli-fication of late fifteenth-century Florentine sculpture and the jagged folds of the loincloth that characterized the images of the time, be they painted or sculpted. It is precisely that loincloth, with its sinewy folds, that dates the statue stylistically to the late quattrocento. The sequence of folds (and it could not have been otherwise) is reminiscent of the folds in Christ's cloak on the statue *The Incredulity of Saint Thomas* by Verrocchio, the other master of his whom Michelangelo aimed

to surpass. The combination of such strongly innovative elements – the anatomical modelling and elements transposed from tradition – perfectly define this phase of young Michelangelo's development and his desire to surpass earlier examples.

No upper body in abandonment can match this one on the *Crucifix* – barring that of the Vatican *Pietà*. Even the wound along the line of the rib, the mere trace of the nipples, and the softness of the abdominal tissues are very similar in the two works, which suggests that the two figures can be readily identified as the same person, modelled against the cross in 1494 and laid on the Madonna's knees four years later, when the artist had attained a maturity of expression that was clearly announced in the early work.

The thigh muscles look more strained, and their attachment to the kneecap is perfectly defined, bringing the whole stylistically closer to the anatomic detail displayed in the figure of Saint Proculus, sculpted by Michelangelo for the Arca of San Domenico in Bologna around the same time. These were details of which the young artist could be proud, and he wanted to show them with pride to the prior of Santo Spirito. Their perfection would surpass the gnarled anatomies of the Sangallo brothers, of Donatello, and of Bertoldo and Benedetto da Maiano, because the lack of any definition of the chest and the leg muscles signalled how little they understood the workings of the body.

This *Crucifix* shows for the first time an element that will characterize Michelangelo's later output: some anatomical details are exaggerated to the limits of reality, to give the figure a pathos attainable only by forcing any resemblance to nature. The reclining neck has an exaggerated bend, which the artist would later repeat in the neck of the *Christ* in Santa Maria sopra Minerva, and then much later in the Christ of the *Bandini Pietà*. It was a deliberate exaggeration that clearly conveyed the suffering and abandon of the dying body.

To create the dynamically twisted pose, Michelangelo made the left foot come forward on the cross, a feature that was extremely rare in fifteenth-century iconography; no other artist so insistently depicted Christ on the Cross with the left foot in front. We do not know what pushed Michelangelo to make such an original iconographical choice. It may have been dictated by the prior's desire to conform to Savonarola's

teaching, which favoured this iconography, as can be seen from almost all the images that appeared in the incunabula printed in Florence between 1487 and 1497. It was a feature that so struck the young artist that he kept returning to it throughout his life.

Christ's forehead reveals the slightly curled hair parting with alternating locks that will reappear in an almost identical form in the Vatican *Pietà*. Even the beard shows an arrangement typical of the late fifteenth century; its small symmetrical tufts rise from the cheek, in which the sculptor cut small locks with a curved surface, as he will just a few years later, in Christ's beard in the Vatican *Pietà*. The crown of thorns, simplified into two intertwined stems, will also reappear in almost identical form, being held by angels in *The Last Judgement*.

Lastly, we learn from the fluttering loincloth – a highly innovative sculptural element – that the prodigious Florentine youngster was extending his challenge to sculptors from all over Europe, and especially to Flemish ones, whose engravings were invading the European market for Catholic devotion. The loincloth stirred by the wind was a feature of all late fifteenth-century Flemish painting and sculpture; it had been admired and studied by Michelangelo through the prints of Martin Schongauer and other northern artists. Yet that moving fabric, as self-conscious as any new conquest of motion, retained a rigidity in the angles that fold the fabric without ever swelling it or rounding it from within, as baroque drapes will do. The contrast between these stiff waves, with their pointed corners, and the more vibrantly fluttering edges that characterize seventeenth-century and later European depictions of the crucified Christ, marks a clear distinction between the two epochs and a changing awareness of space.

In Padua, Donatello had shown his receptivity to northern examples by making a flap flutter at the edge of the loincloth, and even in the string that held it in place – all thanks to the pliability of the metal he used. Now Michelangelo wanted to go further, and he slightly filled the fabric, lifting it to reveal the right flank before turning it inside and making it fall between Christ's legs. This movement of the folds is pivotal to our understanding of how far Michelangelo exceeded the northern European models, which made these fluttering folds of fabric, above all in sculpture, an element of self-gratifying technical virtuosity. Michelangelo reduced these models and their agitated dynamism to an

all Italian scale, more restrained, without losing their dramatic evoca-
tion of the wind that blew across the earth at the moment of Christ's
death.

On the other hand, the story of Christ on the Cross offers little
room for artistic invention, save for minute details that define the
image in form and in technique. Michelangelo demonstrated a perfect
understanding of the possible challenge and an ability to maximize the
potential of each of these details, thanks to his mastery of an extraordi-
nary technique, which folded wood as if it were clay.

This sculpture presents a detail that shows, even at this extremely
early stage in his career, the dramatic tension between artist and the
material, a tension that will accompany him throughout his whole life
and that remains partly incomprehensible to us even today. A portion
of the beard on the right side of the face is not carved but roughed
out, left at the stage of draft. Rationally there is no explanation – and
the same can be said of all the unfinished portions of Michelangelo's
sculptures and paintings (except perhaps the *Doni Tondo*, where the
shadows of the Virgin Mary's blouse seem left in a preparatory state).
And there is no explanation for it in a statue whose modelled form is so
perfect and so carefully finished that it allowed the artist not to use the
layer of stucco that, in Florentine sculptures of the time, completed and
improved the carving before the painted finish was applied. Here the
stucco is instead replaced by a light preparation of lead white, precisely
because the carving itself was already perfect. Over this, the artist then
applied the polychrome finish of the skin, which has now been lost.
Yet inexplicably – and it is right to use this adverb, with which we must
content ourselves for the time being – Michelangelo did not complete
the beard on the right cheek. Why leave a part of the carving unfin-
ished, when it would have taken just a few hours to complete? There is
no practical reason, to be sure. Perhaps we will never understand why
Michelangelo left his works unfinished (the same happened later to the
small paintings for Vittoria Colonna and Tommaso Cavalieri, which,
unlike all the replicas made by copyists, have small unfinished parts).
However, we can imagine that when he offered the prior of Santo
Spirito this imperfect gift, the nineteen-year-old was already aware
that in its imperfection the gift contained such wonders and such proof
of genius that he could make demands that would not be granted to

others. In this sense, the non-completion of that detail is the equivalent of an autograph on the sculpture.

Seen in this light, *The Crucifix of Santo Spirito* announces all Michelangelo's future challenges and his promise to transform Italian art in all its manifestations. This promise was resoundingly and definitively fulfilled in his decoration of the Sistine Chapel ceiling.

PART III

THE GOLDEN AGE

32

RAPHAEL'S HOUR

A few years would have been enough for Michelangelo to complete the other enormous project on which he never stopped working: the tomb of Julius II. But fate decided otherwise. Less than four months after the triumph of the Feast of All Saints, Giuliano della Rovere died, lovingly attended by his daughter Felice and by a Jewish doctor. This time no one could help him; there was no miraculous cure, and neither the peaches nor the gold he was given, dissolved in liqueur – in fact not even the mythical golden apples of the Hesperides – could have saved him from nervous exhaustion. The city wept and grieved as it had not done for centuries. Michelangelo wept more than the rest. If the death of a great patron was bad news, the name of his successor was a disaster. Giovanni de' Medici was crowned on the throne of Saint Peter on 19 March 1513, with a triumphal procession worthy of his name. The exorbitant cost of that triumph presaged the grandiosity of his papacy, but for Michelangelo it marked the start of difficult times.[1]

33

ANOTHER GENIUS IN THE CHAPEL

After the election of Lorenzo the Magnificent's son, whose ascent to the papacy owed much to the shrewd actions of a few younger cardinals rather than to his own theological or political merits, the artistic spotlight was destined to fall entirely on the other genius about to change Italian art and the way it was produced: Raffaello Sanzio of Urbino.

Son of Giovanni Santi – a painter and a refined intellectual at the Montefeltro court in Urbino and author, in 1486, of a rhyming chronicle on Italian painting as well as of a number of remarkable works of art – Raphael was very different from Michelangelo. He was endowed with an extraordinary talent as a painter, but most of all with an intellectual curiosity that enabled him to adopt and improve the proposals and studies of his contemporaries. We could say that Raphael's creativity was triggered by, and developed through, his relations with the world around him, while Michelangelo fuelled his own by cutting himself off from that world. Raphael's physical appearance reflected his gentle character in the way in which the beauty of some flowers is a prelude to their scent. His well-proportioned face, poised on a very long neck, was framed by heavy chestnut hair that curled lightly onto his shoulders. Above all, his large, chestnut brown eyes looked onto the world with a benevolence that enchanted anyone who met him. No document left by his contemporaries fails to recall his loving nature and his profound

loyalty. This natural gift of grace and gentility would be transmitted to his painting, a gift to the entire world, and will help him to win the admiration of all Europe within a very short time span.

Having moved to Florence around 1504 in order to benefit from Italy's wealthiest art market and study Leonardo da Vinci, whom he chose as his indisputable master, Raphael immediately understood the potential offered by Michelangelo's work. For example, he studied the latter's *Doni Tondo* with great attention before literally copying the audaciously twisted pose of Michelangelo's Madonna in his own *Deposition*, painted for the Baglioni family, where a gentler, improved version of the pose is used for one of the Marys, who supports Christ's unconscious mother. Julius II fully understood Raphael's genius and had summoned him to Rome to work on the decoration of the rooms in the papal apartments in 1508, but while the Della Rovere pope was alive the prime beneficiary of his favour was Michelangelo. Perhaps this primacy would not have been questioned by Giovanni de' Medici, the new pope, either, if he had not had accounts to settle with his unruly fellow citizen whom the whole world acclaimed.

For years, Giovanni de' Medici and Michelangelo had shared the same table, even the same house in Florence, since Giovanni's father, Lorenzo, aware of the boy's talent, had welcomed him to his home like a son. But when the Medici regime was overturned by the republicans driven by Savonarola in 1494, Michelangelo had unceremoniously abandoned the family and gone to work for the republican government of Pier Soderini. It was then that he sculpted the regime's proudest symbol, the marble *David*, a guardian of liberty placed beside the Palazzo della Signoria, the headquarters of the city's government. It was hardly surprising that the new pope had little sympathy for the artist and chose the young Raphael as the sole interpreter of his political self-celebration. Within one year, thanks to other circumstances, too, for instance Donato Bramante's death in 1514, Raphael became the sole arbiter of the Roman artistic scene, notwithstanding the arrival of Leonardo da Vinci. The latter was given lodgings in the Belvedere, as a guest of the pope and of his brother Giuliano, but was surrounded by an aura of disrepute, as a result of his inconclusiveness and many failures. Although Michelangelo had been celebrated as a divine artist throughout Italy in November 1512, barely six months later he had

all but vanished from the public stage, which was now dominated by Raphael.

Raphael received papal commissions for the greatest artistic projects, in rapid succession: the rebuilding of the new Saint Peter's, the completion of the decoration of the Vatican Stanze, the decoration of the loggias, the building of a family villa on Monte Mario (now Villa Madama), and other commissions for celebratory paintings to be dispatched around the world as ambassadors of the Medici's greatness and of the Medici papacy. The entire intellectual community of Rome saw in this exceptional young man, so affable and quick, the new light in Italian art. Raphael commenced work on the philological study of the ancient heritage, which would take him to the project of a reconstruction of the plan of ancient Rome – an endeavour warmly recommended by all the intellectuals in the city. Then, to cap it all, Rome's richest and most influential citizens, including the outstandingly wealthy banker Agostino Chigi, followed the pope's example and tried to obtain some work in Raphael's own hand, pushing his good fortune beyond any bounds.

Raphael's commitments to the Vatican became so onerous that even Chigi had to contend with the pope for the artist's services. No one artist could have met such a mass of requests without exhausting his output and his creative streak, but Raphael had opted to deploy his genius much more broadly. Unlike Leonardo and Michelangelo, who worked alone and carried out their own research in solitude, Raphael had the gift of finding and organizing other talented individuals and using them for his own professional projects. In this he was helped by a gentle and sociable nature, and even his handsome, graceful presence seemed to invite friendship. It was an ability that affected not only his artistic activity in a strict sense but also, more generally, an intellectual research that embraced many fields of contemporary knowledge.

Within a short time of his arrival in Rome, Raphael became the centre of an intellectual circle that contained some of the greatest minds of the day, such as Baldassarre Castiglione, Andrea Navagero, Agostino Beazzano, Pietro Bembo, Fabio Calvo, and many others committed to a project for the rebirth of ancient knowledge and culture, not only figuratively but also in a broader intellectual sense. Raphael's project soon merged with that of an extraordinarily advanced court

engaged in the revival of the mythical golden age, an era that would bring the triumph of peace, learning and beauty.

The project had been conceived of by Julius II who, back in 1508, had given Raphael the task to define it in a concrete manner, in the decoration of the Stanza della Segnatura and particularly in the painting of the so-called *School of Athens*. This was, neither more nor less, the visible manifesto of a tradition of knowledge that stretched, unbroken, from the founding fathers of modern philosophy, Aristotle and Plato, to figures of contemporary Rome, including Raphael and Michelangelo, Bramante, Fra Giocondo, and other protagonists of the day. Through their personal talent and knowledge, all testified to the fact that Christian Rome, governed by Julius and then by Leo, was the legitimate heir to this tradition.

While he was engaged in this ambitious project of intellectual rebirth, Raphael had reorganized his studio along completely modern lines, in part erasing and in part innovating the tradition of the Renaissance workshop. In Raphael's studio, the collaborators were no longer required simply to carry out preliminary tasks before the master executed the work himself. Instead, each collaborator was given the task most suited to his own talent – which Raphael took time to discover, then enhance, and finally promote by coordinating this collective approach. Raphael's productive intelligence was expressed in his ability to direct the work by setting aside any competitive restraint and by encouraging the individual gifts of his pupils. This ability derived from a confidence and an awareness of his own genius that earlier artists did not possess. Engaged in intellectual research with the finest minds of the period, Raphael was greatly stimulated and undertook new artistic challenges, which refined his way of working.

The real supervision of this collective work was accomplished by creating very accurate drawings, which served as a basis for the execution of the great pictorial cycles, but also of the painted altarpieces. Contrary to what was done in other Renaissance workshops and continued to be done in Leonardo's and Michelangelo's, Raphael's pupils had a role also in making the preparatory drawings: they contributed to developing the initial idea by working on drawings that would then be added to the final model, complete with shadows and minute details, ready to become paintings without any further changes. This would have been

unthinkable for Leonardo, who made significant alterations to his work up to the last minute, which excluded his assistants from participating in the conception; if anything, he confined them to making copies, and even these were subject to his direct intervention.

The preparatory drawing for the fresco of *The School of Athens* (which has survived in excellent condition, thanks to the fact that Raphael's drawings immediately became objects of veneration for contemporary collectors) shows us how Raphael developed a different way of working, allowing his pupils to express their talent and make a significant contribution to the collective enterprise. We know that Giovanni da Udine was given free rein to develop new ideas for the portrayal of animals and plants; Giulio Romano was asked to study the gestures and movements of figures as a whole, as would be evident in his later work; and Giovan Francesco Penni, another artist in the workshop who was much loved by the master, was given space to study the calmer and gentler poses, almost a continuation of the figurative legacy of the Florentine altarpieces of the quattrocentro.

With the backing of this formidable structure, which also translated into communal living quarters and a lifelong sharing of stable personal and affective relationships, Raphael took steps to change the face of Rome in less than ten years, not only through the material tasks he was entrusted with but also through his scientific studies of the plan of ancient Rome. The latter was a founding project for modern archaeology: we owe it the good conservation of Italy's archaeological patrimony, which through his intuition became a shared heritage, appreciated by successive generations.

Such intelligence and such creative talent could not fail to leave a mark on the Great Chapel, the place that celebrated the greatness of the modern papacy, and also the greatness of Christian civilization itself.

The space available for a new addition was almost exhausted by the time of Julius II, who had to order the demolition of Pier Matteo d'Amelia's starry ceiling in order to leave his own mark on the chapel. But his own family culture reminded the new Medici pope of an option that could resolve the issue of space. Having grown up among the Flemish tapestries that were his family's treasures – so valuable that his brother Piero had pawned them to finance his pitiful military battles

– Leo X had the idea of relying on Raphael to draw the preparatory cartoons for a series of ten tapestries designed to be woven in Flanders and displayed in the Sistine Chapel during major festivities; they were to hang below the wall frescoes and to cover the painted hangings, deemed too miserable for the sumptuousness that the pope had in mind. If papal majesty had been interpreted by Julius II as territorial integrity and as military and theological control, Giovanni de' Medici, a weak and worldly man, interpreted it as a display of extreme luxury and deployment of power. In the same vein, Leo would plunder the coffers that Julius II had replenished in order to ensure the autonomy of the church and attempt the reconquest of Constantinople: he would do it through over-ambitious military campaigns in favour of his heir, Lorenzo de' Medici. In the wake of the worst tradition of Italian nepotism and dynasty building, Giovanni de' Medici thought it more appropriate to spend the money accumulated for the crusade against the Turks on his attempts to acquire a kingdom (the duchy of Urbino) for his unworthy nephew. As for Florence, Leo took the control of the city for granted and assigned it to his brother Giuliano.

In the Great Chapel, the public projection of papal majesty, Leo imagined these splendid tapestries woven in gold, because it was gold – that of the cloth used in the sacred vestments he ordered, and that of the threads bound with silk in the Flemish workshops – that gratified his delusions of grandeur. A large chapel, embellished with all the shades of lapis lazuli and transformed along its lower perimeter into a golden casket, was the setting in which Lorenzo de' Medici's son, accustomed to splendour, wished to be seen.

Leo's decision also had a private, emotional side because it harked back to his father Lorenzo's decision, forty years earlier, to assign to Leonardo da Vinci a tapestry project. But now that Leonardo was at his complete disposition, having come almost in exile to Rome, he chose not to give the project to an artist reputed to be ineffectual, but rather to Raphael. It was a clear sign of the low esteem in which Leo held Leonardo.

The majesty conferred by the golden tapestries was typical of the established taste of princely courts throughout Europe, and a man like Leo was more familiar with elegance than with the true appreciation of art, in which he had never shown any interest. Indeed, after his election,

he had been obliged to invent artistic commissions, which he had never supported. Unlike Julius II, who was an extraordinary connoisseur, Leo had a greater sense of the worldly attraction of luxury and riches than of the subtle charms of the new art: this is why he felt more at home dealing with precious furnishings. The choice to give the commission for the tapestries to Raphael can be perfectly explained by Leo's particular worldly taste and family tradition, and above all by his desire to be part of the artistic history of the Great Chapel, on which the Della Rovere had left their indelible mark. These were the very Della Rovere whom the Medici pope, after receiving support of various kinds and even hospitality during his exile from Florence, was now attacking in an attempt to conquer the Duchy of Urbino for his nephew Lorenzo, whose only claim to fame was his mediocrity.

Although lacking taste, Leo was intelligent enough to understand that he had to enter the chapel alongside the artist now hailed as the new star in the Italian panoply, destined – in the pope's plans – to humiliate that unfaithful and ungrateful Michelangelo, holed up in a modest house not far from Trajan's Column, where he was carving the statues for the tomb of Julius II. Even on his deathbed, Julius had made plans for Michelangelo, the only man in the world who could understand him.

34

RAPHAEL'S TAPESTRIES

The subject matter that would conclude the great story of Christianity narrated across the walls and ceiling of the chapel was the Acts of the Apostles Peter and Paul. They were the figures closest to the popes, and it was they who started the mission of teaching by spreading Christ's word, so dear to the Church of Rome.[2] In many ways, this was the project that recorded the great changes in Italian society that had taken place over the past forty years and that manifested themselves so clearly in this highly symbolic location.

Thirty-five years earlier, Pope Sixtus IV had asked artists to create a narrative in a process that resembled the commissioning of an artisanal product, albeit a highly refined one. The artists were engaged in crafting decorations that had very similar formal and material elements, as they represented a modality of working and creating common throughout Italy, not to say all Christian Europe. Botticelli, Perugino, Rosselli, Ghirlandaio, and the other collaborators had not only produced the preparatory drawings but also executed every detail in person, applying the lapis lazuli, the gold leaf, and the varieties of textile ornamentation that, together with the graceful but repetitive poses, formed the essential features of art at the time. In the years that followed, the figure of the artist had evolved and changed so much that Raphael was asked to produce in effect a concept, an idea that others (in this case the Flemish

tapestry workers) would realize. This transition marked the definitive recognition that the artist's role was creative and not artisanal, as it had been one generation earlier.

By inventing images and by conceptualizing form (whether architectural, pictorial, or sculptural), the artist assumed a new role in society and in politics. The role had shifted slowly from execution to ideation, from the precious nature of pigments and gold to the creative capacity as a purely intellectual rather than material feature of the artist. Of course, the execution retained a fundamental value, especially in the case of painting, because it entailed manual skills, a gestural art, and a creative way of operating that still set the master's work apart from that of his collaborators, although precisely in the case of Raphael this distinction became extremely problematic for contemporaries. Perhaps it was only a coincidence or a sign of the times, but the passage from Julius II's pontificate to that of Leo X marked a decline in the appetite for the artist's direct execution of the works that came from his workshop. This can be seen in the painting of the Vatican Stanze. While Julius II was alive, Raphael had made shrewd use of assistants. Until the Stanza of Heliodorus we can talk of painting being done entirely by Raphael, and *The Liberation of Saint Peter* represents one of painting's high points of all time, in execution as well as in conception. But Julius was someone who paid attention to the artistic value of execution, perhaps because he was a man of the fifteenth century who could not help but feel passionate about the refinement of manual execution – or perhaps simply because he was a collector who loved the figurative art of his day.

Quite another matter was Leo's relationship with art, his understanding and his awareness. As soon as Leo took Julius' place, and exactly during the execution of the Sala di Constantino,[3] there is a strong sense of the presence of Raphael's pupils, especially Giulio Romano, and the master's hand almost disappears. Raphael left to them not only the execution but also the ideas for the decorations, perhaps because he had too much else to do, but he was certainly emboldened by Leo's indifference. It is entirely legitimate to suppose that Julius II would never have tolerated such a spurious execution of the frescoes, as Leo did. At all events, this transition, also one of taste, encouraged a new use of Raphael's genius, which was increasingly expected to supervise events rather than contribute to their manual realization.

We do not know to what extent this transition, apparent in the commission of the tapestries, stemmed from an awareness of new openings for the artist's inventive talent or, more simply, was only the outcome of the numerous commissions that the artist accepted after 1514 and that forced the pope to opt for a solution that required Raphael's limited involvement. Leaving aside his passion for gold and silk, Leo's choice might have been either to commission the tapestries and the preparatory cartoons to send to Flanders, or to ask Raphael to paint actual frescoes that could replace the painted hangings. It has to be said that the commission of a 'movable' object such as the tapestries, whose material form and value relied in the first place on the exceptional skill of the Flemish weavers and on the gold and silk threads intwined on their looms, seems especially made to exalt the new creative dimension that Raphael had organized with his school.

By this time the team that would assist and follow him over the (very few) years leading up to his death was almost complete. Giulio Romano, Giovanni da Udine, and Giovan Francesco Penni were already at work in his studio and played a significant role in creating the cartoons to send to Pieter van Aelst's workshop in Brussels, where the tapestries would be woven on his extraordinary looms.

35

THE IMAGE REVERSED

Before looking at the details of the commission, it is worth saying that the work presented several major technical problems: the preparatory cartoons had to be made using very liquid tempera, so as not to ruin the backing, and they had to be designed for 'mirrored' weaving. The workers wove the tapestries from the back, and the final image was a mirror image of the one created by the artist. This was just one of the problems, and not even the most serious. However skilled, the Flemish weavers could never hope to equal the shadings [*sfumature*] achieved by mixing coloured oil pigments, because they had to combine silk threads that were already dyed and available in a limited range of colours, while the painter, mixing his colours on the palette, could obtain an almost unlimited range of nuances. The image had to be simplified in some way and go partly against the stylistic code of Raphael himself, who, thanks to Leonardo's example, had elaborated a very delicate sfumato, able to give the impression of figures breathing at ease in a natural atmosphere. Here Raphael had to simplify the condensing of shadow and light, necessarily flattening the figures and limiting background depth.

The use of silk instead of oil colour risked being a regression from Raphael's use of oils, with which he had achieved extraordinary effects by perfecting the sfumato technique. However precious the materi-

als, the tapestry technique set radical limits on the suitability of the images precisely in a context like that of the Sistine Chapel, where Michelangelo's immense vault seemed to have no artifice and the figures moved in a completely natural way. The tapestries would be hung at the level closest to viewers, and any incongruence would be immediately visible. For the young artist Raphael, this was an exceptional challenge, particularly at a time when he was overburdened with other commitments.

The first payment for the cartoons is dated to June 1516, which presupposes that the conception phase of the work started in 1514–15, when the artist was involved in the decoration of the Stanze, his study of the plan of Rome, the rebuilding of Saint Peter's, and the design for Villa Madama. He needed a design that allowed him to overcome the material and stylistic obstacles inherent in the task. It was a challenge that seemed tailor-made for an artist as versatile as Raphael, whose talents ranged from painting to architecture, from theatre to archaeology, and even to poetry. With Raphael, this universal dimension of knowledge and creativity became a model of modernity.

36

THE MONUMENTAL STYLE

As Raphael's friends did not fail to stress at the time, his art seemed to be a perfect imitation of nature, and his paintings were so real that many regarded them as exceeding nature itself. His figures seemed created by God, not by a human being. Commenting on the portrait of Antonio Tebaldeo, Pietro Bembo had written that the painting resembled Tebaldeo more than Tebaldeo resembled himself: 'He has painted our Thebaldeo so lifelike that he looks not so much like himself as like the painting.'[4] It is a critical gloss fundamental to understanding Raphael's art. Unlike Michelangelo, who represented his figures as being driven by an irrepressible energy, in the act of carrying out or attempting an action that engaged them dramatically, Raphael had the gift of showing them in the harmony of a gratified stillness. If Michelangelo's beauty was always sublime and terrifying, Raphael's was always contented, as he himself must have felt surrounded by the affection and gratitude of an entire court.

Raphael's figures do not fight for their own destiny, because they have already fulfilled their life's aspirations. No drama is apparent in the graceful poses of Raphael's Madonnas; they radiate the satisfied benevolence of an appeased world. The same sentiment of tranquillity, of the attainment of harmony, transpires from his historical narratives, for example *The School of Athens*, where all participate in the achieve-

ment of a shared knowledge that brings happiness. Even in the fresco of *The Mass at Bolsena*, the last room painted on the eve of Julius II's death, the dramatic event of the miracle of the bleeding host on the altar is presented with a calm sentiment that radiates from the characters, not in the least disturbed by what they see happening before their eyes.

There is no doubt that this aspiration to show a happy world, which exuded a profound peace and a beauty in itself reassuring, was present in the artist's earliest works and led to his success already in the first decade of the century, at the time of the Florentine altarpieces and of *The Marriage of the Virgin*, which is now in the Brera. His meeting with Leonardo fuelled this aspiration to emotional balance still further, focusing his research on the harmony of colour and on the light and the sfumato, instruments that would enable Raphael (as well as Leonardo) to explore the psychological depths of the characters and even the reassuring sweetness of the landscape. The lesson learnt from Leonardo in Florence is fully visible in Rome, in the painting of *Galatea* (plate 44), done in 1513 for Agostino Chigi: there Raphael, although starting almost literally from Leonardo's invention, *Leda*, gave the nymph a dynamism, a transience of movement and affections that leave the original model far behind.

Raphael's surpassing of Leonardo's model was the result of his encounter with classical art, an experience that transfixed the young artist from Umbria as soon as he arrived in Rome. For decades, perhaps centuries, the ancient statuary had inspired Italian artists; but the effect on Raphael was quite different. He was among the first people in the world who managed to isolate and identify a stylistic evolution in classical art, thanks to his own observations and systematic surveys of the ruins, but also thanks to the contribution of intellectuals engaged in the philological study of classical literature – for example Fabio Calvo, who translated Vitruvius from Latin for him and discussed styles and iconographical compositions, correlating the written sources with the evidence that emerged from the archaeological excavations carried out in the city. What had been an indistinct legacy of images until the previous generation of artists became a corpus of works arranged in a precise historical chronology. This systemic knowledge of antiquity would be the key to resolving the difficult question of the tapestries made for the Sistine Chapel.

At precisely the time when the tapestries were being worked on, Raphael deepened his study of the differentiation between classical styles, identifying in the reliefs of the Augustan and Trajan era that pinnacle of balance and solemnity that was subsequently lost. Prompted by the need to simplify the style on the basis of a technique that limited expression, yet to recover monumentality and decorum so as to come on top in a confrontation with Michelangelo's painting, Raphael creatively reinterpreted the classical repertoire found on the bas-reliefs from the imperial age. The explicit reference to these iconographical sources led to a rapid evolution of the celebratory language of the Leonine court, which attempted to legitimize itself as the heir of antiquity by adopting the imperial stye as its official language. On the other hand, these bas-reliefs from the reigns of Augustus and Trajan had developed a language whose measured gestures and naturally decorous poses had attained a monumentality that was also rich in emotional pathos. Ever since the initial procession after the pope's coronation, and also from the festivities held in Campidoglio in September 1513, when honorary Roman citizenship was granted to the pope's brother, Giuliano de' Medici, it had become clear that Leo X and his circle wished to recognize themselves in Augustan-style solemnity. On that occasion, an ephemeral theatre had been erected in Campidoglio. It was thoroughly classical in appearance and the plays performed in it had all been heavily influenced by ancient culture.[5]

A very important step in this direction had already been taken during the reign of Sixtus IV, when the choir in the old Constantinian basilica of Saint Peter's was built (plate 30). This monumental enclosure of carved marble erected over the saint's tomb was later demolished and transferred to what is now the Archivio Storico della Fabbrica di San Pietro (Historical Archive of the Fabric of Saint Peter) when Borromini's Baldachin was built, but Shearman, in his valuable study of Raphael's cartoons for the tapestries, was the first one to point to this model as the precise source of inspiration for many of Raphael's images.[6]

Very little has been written about the choir because it is now almost invisible to the public at large, but it represents a fundamental transition in the creation of a Christian classical style that the church adopted in representing its own worth [dignitas], which was presented as a direct

descendant of imperial *dignitas*. The reliefs decorating the enclosure around the most sacred part of Christianity, the tomb of the apostle Peter, portray some of the stories of the saint's life in perfectly classical form. It is not surprising that Raphael referred to this monument when he came to work in another area of the Vatican, which in solemnity and dignity stood comparison with the choir of Saint Peter's: the Sistine Chapel. Because technical reasons forced him to simplify his language, Raphael drew extensively on these bas-reliefs from Trajan's era, sometimes referring to them literally, as in *The Sacrifice at Lystra* (plate 31) and surpassing the model, in some respects still immature, used in the choir by Paolo Romano. At the same time, by invoking this recent but authoritative iconographical tradition, Raphael distanced himself from Michelangelo's style, which seemed unattainable also because it followed different paths.

This phase of classical sculpture had seen a process of simplification of the number of gestures and shadows that was designed to make the narrative solemn and regal but could now prove useful for the preparation of the tapestries. Once again, Raphael's critical ability became the driving force of his creativity and genius. The figures that tell the stories of the two apostles who laid the foundations of the Church of Rome, Peter and Paul, move with the naturalness of the figures carved on Trajan's triumphal arches on his column in the Forum (AD 106–13), and on many other reliefs that were being acquired by Roman collectors during those years. Moreover, Raphael successfully placed the apostles in their own historical era, as both developed their teaching in the first century after Christ, when this classical style was reaching its high point in Rome.

The process of stylistic transformation or change is very clear if we compare the wall paintings in the rooms that Raphael painted in around 1515, and especially *The Battle of Constantine*, with the cartoons for the tapestries. The difference between the two kinds of composition stands out and points to Raphael's new role, which is to control the expressive style and to finalize it for the most successful narration of the story. While on the wall his pupils could take risks with their painting, in the preparatory cartoons for the tapestries the astonishing movement and the originality of colours was suddenly quietened. Here the figures act solemnly, with measured gestures, and the colours are simplified to the

utmost – to the delight of Flemish weavers. But while the reference to the choir of Saint Peter's is evident and unmistakeable, the comparison with those sculptural reliefs also reveals how the almost naive citation of classical sculpture made by Paolo Romano nearly forty years earlier had been bettered.

The comparison between the reliefs and the tapestries shows the different ways of working used by the artists of an earlier generation and by Raphael. Paolo Romano and his collaborators had isolated, extrapolated, and reproduced, with ostentatious fidelity, some motifs, some gestures of the ancient reliefs. The figures from Trajan's reliefs were isolated and reproduced as copies in the choir enclosure in order to give a smattering of solemnity to the figuration, but the narration remains unrefined because the groups of figures and the space within them are still fifteenth-century in style, and the proportional ratios are often simplified in an almost grotesque manner. Raphael offered instead a completely different interpretation of the reliefs, catching the essence of the narrative in its spatial congruity and in the balanced and ordered story. Only within a fully concluded and mature narrative discourse can the gestures and citations from the reliefs be recognized. It was a wholly new way of working, which demonstrated full control over a classical style that had been adopted only by those late fifteenth-century artists who were seduced by a pose, by the realism of a dog or a horse, but were incapable of grasping the clarity and balance of the whole discourse.

37

THE ACTS OF THE APOSTLES
The End of a Long Story

The Sistine Chapel, where the first solemn rites of the new Medici pope were celebrated, is in reality the story of Christianity, a mirror of Michelangelo's revolutionary art, but also a showcase of the power of the Della Rovere. This family's arms are all over its walls, from the festoons held up by Michelangelo's Ignudi to the leaves of the trees painted in the Sistine cycle; it is even in the embroidered garments of many protagonists, and lastly, at head height, in the fictive hangings of the lowest register. Giovanni de' Medici's problem was how to make his mark on the holiest chapel in Christendom and continue to tell the story started thirty-five years earlier by the four master painters from central Italy. Raphael was the right person to achieve this goal.

In terms of the iconographical narrative, deciding to portray the Acts of the Apostles was a natural choice for an able theologian like Giovanni de' Medici. The urgent question he had to answer after the schismatic council summoned by a group of cardinals against Julius II concerned the legitimacy of the Roman Church and its leader. The roots of this legitimacy went back to the foundation of the church by the two apostles Peter and Paul, who had been tasked respectively with the conversion of the Hebrews and of the Gentiles. What was needed was to restore visibility and emphasis to an age-old tradition that stood at the heart of any coronation ceremony: in order to underline the

pope's descent from both apostles, the newly elected pontiff sat successively on two porphyry thrones in the Lateran that symbolized the seat of Peter, 'prince of the Apostles', and the seat of Paul, *doctor gentium* (teacher of the gentiles). The pope's legitimacy was therefore founded on this dual ancestry that no other church in the Christian tradition could claim.

So the stories to be celebrated in the tapestries were those of the two apostles and, when one had to choose from the stories a limited number of episodes, it was important to select those that transmitted with greater force and simplicity the sanctity of the apostles and reflected the benefit of legitimacy and faith on the pope himself. Numerous sources were available, thanks to a long medieval tradition of exegesis of the Acts; and Leo's court hosted theologians of exceptional scholarship, such as Egidio of Viterbo, who had already played a role in the realization of Michelangelo's ceiling.

The narrative that Raphael was commissioned to design can now be reconstructed only through circumstantial evidence because, within a decade after delivery, which was presumably complete by 1519, the tapestries became part of the booty stolen when the Vatican was sacked, first by the Colonna and then by the Landsknechts. The looted tapestries were then sold to various princes (one was purchased by Isabella d'Este) and were never fully replaced *in situ*, especially since these movable artworks were hung on the walls only for specific festivities. As a result of the sack and of this dispersion, which happened so soon after completion, no source has survived to document the order and succession of the tapestries, and thus the sequence of the narrative. However, the different measurements of the tapestries were used to outline an appropriate sequence in 1983, when, to mark the fifth centenary of Raphael's birth, the tapestries were once again hung in the lowest register of the Sistine Chapel. Scholars were able to agree at the time on this hypothesis, and it is still used for reference today.

According to this hypothesis, the narrative sequence started on the wall behind the altar, a wall that, at that date (1514/1516), was not yet filled by the lower part of Michelangelo's *Last Judgement* (painted between 1534 and 1541) but presented instead, in the upper register, two scenes from the Sistine cycle that formed a continuous sequence running along the side walls. These were *The Birth of Christ* and *Moses in*

the Bulrushes, both demolished later, to make room for Michelangelo's fresco. The tapestries hanging behind the altar were *The Miraculous Draught of Fishes* (plate 32) and *The Stoning of Saint Stephen* (plate 33). The former hung on the right side, looking at the altar, and marked the start of the Petrine cycle, which ended immediately after the railings that divided the space reserved for the clergy from that reserved for the laity (originally this was situated just a little more than halfway down the chapel). On the left hung *The Stoning of Saint Stephen*, which started the Pauline cycle and whose significance was to highlight the cruelty of Saul, persecutor of Christians before he had his calling and conversion; and these were shown in the next tapestry, which hung in the first bay of the left-hand wall. The stories of Paul continued with episodes that exalted his skill as an orator and evangelizer: *The Conversion of the Proconsul* (plate 34); *The Sacrifice at Lystra* (plate 31), where the apostle was mistaken for Mercury, divine patron of the city; and, finally, *Paul Preaching at Athens* (plate 35), a highly significant episode in the apostle's evangelical journey. It is not only that that sermon remained an unattainable high point of Christian oratory and theology, but in the popular imagination it was precisely in Athens, the cradle of pagan civilization, that Paul proved his ability to vanquish the most deep-rooted superstition.

In line with the different role given to Peter as Christ's successor and as someone invested with the power of intercession, the tapestries continue on the right wall with *Christ's Charge to Peter* (plate 36), which shows the delivery of the keys, an episode that, by virtue of underlining the power of Rome, was too important not to be repeated in this cycle as well, even though Perugino had already represented it among the frescoes in the middle register. There followed *The Healing of the Lame Man* (plate 37) and *The Death of Ananias* (plate 38), the Christian put to death by Peter for having stolen money from the alms destined for the needy.

Although this reconstruction is by no means certain, the sequence is more than convincing, also in view of the links with the narrative in the middle register, which at times it echoes and reinforces. Perugino had already painted *The Delivery of the Keys* and Raphael changed the structure of his representation to highlight the figure of Christ pointing at the flock entrusted to Peter, who grasps the keys as a symbol of the

kingdom he has been given. The same is true of *Vocation of the Apostles*, painted by Ghirlandaio in the middle register but completely renewed in the representation of Raphael's figures – so much so that it is perhaps the most successful invention of the tapestries. In Ghirlandaio's version (plate 3), the action is set on a crowded lakeside, where Christ addresses the apostles while a boat appears in the background, alluding to Peter's status as a fisherman, in what is a rather traditional iconography for the scene. Instead, Raphael gives a wholly innovative focus to the action (plate 32) by bringing two boats into the foreground, in a highly sim-plified landscape, reminiscent of the landscapes that concede little to descriptive detail, recently painted by Michelangelo on the ceiling (in particular in *The Deluge*). Christ is seated in the bow and Peter kneels in the narrow vessel that is almost sinking under the miraculous draught of fishes just brought on board.

With his usual ability to absorb the best of other artists' research, particularly that of Michelangelo, Raphael created an episode that is wholly centred on the strength of the gestures expressed by the moving bodies, a characteristic of Michelangelo's poetics, too. The viewer's gaze is drawn to the raised left hand of the majestic figure of the seated Christ, while in the other boat, on the horizon, the bare, muscular arms of the fishermen hauling in the nets reveal bodies in tension. As in Michelangelo's ceiling, the action is entirely focused on the dynamism of the body and on the communicative power of gesture. The foreshort-ening of the fishermen pulling in their nets is perfect, while the solemn pose of Christ, isolated in the bow, forms a natural counterweight to the density of bodies and muscles concentrated elsewhere in the scene, whose meaning is made even more moving by the attention paid to nat-uralistic details entrusted without doubt to the exceptionally gifted hand of Giovanni da Udine. The symbolic value of these details legitimates the descriptive care with which herons, symbols of vigilant guardians of the faith, are set in the foreground, while in the background are ravens, symbols of the heresy that threatens the purity of the faith. Even the fish, almost sinking the boat in which Christ is seated, are represented in minute detail, so as to illustrate the story better. In the foreground is a large ray, a deep-water fish, which alludes to the depth mentioned by Christ when he invited Peter to cast his net into the deep water and catch the souls that are most reluctant to embrace the new faith.

This scene, together with the next one, *Christ's Charge to Peter*, speaks a language infused with and influenced by Michelangelo, above all in its striking simplification of the landscape, which ought no longer to distract from the gestures of people. The narrative in *Christ's Charge to Peter* is also focused on the innovative power of gesture and anatomical correctness. The arm with which Christ points out to Peter, who is kneeling at his feet, the keys he has just given him is bare, perfectly turned, with the musculature of a Greek god; its luminous paleness animates the scene, which is otherwise filled with an indistinct mass of classical-looking but totally inexpressive drapes.

Two more scenes seem to be strongly influenced by Michelangelo's painting: *The Stoning of Saint Stephen* and *The Conversion of Saul*. The first was intended for the altar wall; the second, hanging beside it, was intended for the start of the south wall. Both are narratives of men and bodies, where the pathos relies entirely on gestures and on physical power. The violence of the martyrdom is encapsulated in the gesture of the herculean man in the foreground, who bends to pick up stones to hurl at the saint. This is in every detail a Michelangeloesque figure, in many ways similar to the fishermen who bend to haul in their nets in the adjacent tapestry – a detail intended to give some unity to the entire wall. The man behind the saint also resembles one of Michelangelo's figures. A viewer who looked up to the vault above would have found a figure in a similar pose in the *Sacrifice* and, in the *Punishment of Haman*, a foreshortening every bit as daring as that of the other man about to throw a stone. The narrative is centred on an exaltation of the body and bodily gestures, as is that of the next tapestry, *The Conversion of Saul*, where Saul, the Roman soldier who persecuted Christians, is terrified by the vision of God. His fall, with the extremely daring foreshortening of his stretched out body and open arms, provokes the swirling movement of the startled horses and horsemen, whose flight and terror reflects the soldier's astonishment. This scene, too, owes much to Michelangelo's style and to his passion for foreshortening parts of the body, a technique experimented with here by Raphael, with results that are not entirely convincing.

Given their clear proximity to Michelangelo's painting, these four scenes may have been conceived and realized first by Raphael in marvellous cartoons. Moreover, the strongly monumentalized figures

alone testify to the consequences of the decoration of the ceiling in Raphael's style. The attention to detail in the surviving cartoons, the coherence of the anatomical drawing, the inner space of the narrative point to the fact that Raphael worked personally on these scenes and was more directly involved, while in the successive ones he relied more on his pupils. This disparity is evident in the overall conception of the narrative, which is framed by architectural detail, and above all organized in a graded arrangement of the figures that closely repeats the positioning on the Roman bas-reliefs that inspired Raphael. The figures are set out in perspective, like in the bas-reliefs, and the spatial qualities are synthetized in purely plastic qualities. Even the rhythmic, regular intervals generated by the placing of the figures and the rather simplified definition of their pleated garments reflects those of the Roman carvings.

The composition of the scenes in *The Healing of the Lame Man*, *The Death of Ananias*, *The Conversion of the Proconsul* (also known as *The Blinding of Elymas*), and *Paul Preaching at Athens* is strongly influenced by the gestural expressiveness of classical bas-reliefs. All the figures are aligned on the same plane, as in a relief, and where the space opens out, it is simplified in depth and framed by clear architectural references. This can be seen, for example, in the scene of *The Healing of the Lame Man*, where Raphael evokes the large, twisted columns of Solomon's Temple, which according to an old legend had been transported into the choir of the old basilica of Saint Peter's. The model appears to have been not only Trajan's Column but also Trajan's Arch at Benevento, which had been drawn by many Italian artists in the late fifteenth century, including Giuliano da Sangallo. The reference to the arch in Benevento in the scene of *The Sacrifice at Lystra* is too explicit to be a coincidence. Raphael's cultured play and his intention to give life and colour to the ancient stone are discovered precisely through this proximity to the Roman model. He does not even bother to alter the poses, the clothing, the decorative minutiae of the accessories; on the contrary, he delights in showing an antiquarian faithfulness to the model. He adds new meanings to an ancient framing, adapting the Christian narrative to them. It is a process of occupying and redefining an entire language, which was then fully annexed to the Christian tradition and at the same time regenerated.

The viewpoint of the spectator is from the chapel floor, never from above, so the general impression is that carved reliefs framed by pilasters decorated with symbolic and ancient-looking scenes are placed along the walls, creating an even stronger impression that one finds oneself in a classical context. The solemnity of the gestures, the hierarchy of the figures, the detailed and heavy description of the togas, and every other detail – from the seat to the scabbard of the dagger – give one the impression of being in a sculpture gallery. This decorative model was perhaps more suited to being delegated to Raphael's pupils and had the merit of creating an extremely coherent narrative from a stylistic point of view. The typically Renaissance taste for matching tones is visible only in the choice of colours, and even this is simplified to meet the needs of the special medium used for the final product. The comparison between the preparatory cartoons and the finished tapestries suggests that Raphael was completely successful in resolving the issue of the range of colours available in silken thread. Thanks to the exceptional sensibility that distinguished him among the painters of his generation, Raphael understood up to what point he could take the simplification of gestures and colours without losing the force and solemnity of the story. By introducing devices such as the red border around the tapestries, he set them visually in the architectural context defined in the middle register, where the whole was framed in mock porphyry.

The last question to consider concerns the way the commission was executed, which is a particularly important aspect of the overall theme of how each decorative cycle in the Sistine Chapel marked a progression in production methods inside the Renaissance art workshop.

38

PRODUCTION METHODS IN THE WORKSHOP

A New Relationship between Artist and Collaborators

We have already emphasized that the tapestry commission came at a time of intense professional commitment for Raphael and that the very nature of the work, which was to be made in the distant textile workshops of Flanders, imposed a radical change on the process of working.[7] On the other hand, it is worth noting that the commission was not too time-consuming in terms of the artist's own commitment. The proof is, as always, in the value of the contract. We know that Raphael was paid one hundred ducats for each of the cartoons, and this amounted to a total of one thousand ducats. If, instead of cartoons, Raphael had been given oil paintings of equal size, they would have been paid at least two thousand ducats each, considering the value of oil paintings in the Rome of Leo X, and in particular the estimate proposed by Sebastiano del Piombo for his painting of *The Raising of Lazarus*, for which the artist asked one thousand ducats. If the paintings had been frescoes, their value would not have been lower than two hundred and fifty ducats each, in view of the price of two hundred and fifty ducats paid thirty-five years earlier to the Sistine painters. So the price agreed for the cartoons tells us that this was a very limited commitment for the artist and his workshop. On the other hand, we know that the value of each tapestry – including its manufacture, the coloured silk, and the

gold – was 1,600 ducats, a value that lay halfway between that of a fresco and that of an oil painting. This is the economic context in which the papal commission should be set.

In view of the not very remunerative nature of the commission (for the cartoon of *Saint Michael* alone, now in the Louvre, Raphael will be paid twenty-five ducats by Duke Alfonso d'Este), we can imagine that Raphael would have structured the work in such a way as to eliminate wasting time wherever possible. Alongside this need, the cartoons' conception made it necessary to think about a form of checking the products already in the planning phase. This checking had to resolve a few fundamental problems: the 'mirrored' composition of the scenes, the limited chromatic range available, and the simplification of the decorative design, which was strongly conditioned by the warp and weft of the weaving process.

Raphael's genius succeeded in resolving almost all the problems that arose, including the considerable one about the stylistic and narrative continuity with the upper part of the chapel, where the greatest masters of the century had worked, and most recently his great rival, Michelangelo Buonarroti. But there is an even more interesting aspect of this affair that needs to be clarified. How did Raphael organize his workshop to deal with this commission under such conditions? And how did the reorganization of work reflect the changing role of the artist in the golden age of the Renaissance?

We have seen Michelangelo give a unique answer to this question: he chose to tackle his task alone, with superhuman commitment, because he felt that the quality of the product was a direct consequence of his exclusive commitment to execution. But this is only one possible response. Raphael's went in the opposite direction: his commitment was limited to the 'ideation' phase, after which he entrusted the execution to his collaborators, only refining the means of control. Seven of the precious preparatory cartoons for the tapestries have survived and are on display at the Victoria and Albert Museum in London, and a significant number of design drawings are held in other collections around the world.

Cartoons and drawings are the only reliable documents if one attempts to understand the creative and working process in Raphael's atelier, since the written sources are almost non-existent or unreliable.

Vasari, our main source on artistic output in the cinquecento, is contradictory and ambiguous, as usual. His *Life* of Raphael claims that the cartoons were prepared personally by the artist, but in the *Life* of Giovan Francesco Penni (1494?–1528) Vasari writes that this artist, too, played an important role in their creation, alongside Giulio Romano (1499?–1546), who is also cited by a later but highly reliable source. Both pupils are likely to have had an important role in the conception and execution of the cartoons.

Giulio Romano was an exuberant youngster, brimming with talent. He had very dark eyes and hair and a well-built but graceful body, handsome enough for him to pose frequently for his master. He was almost certainly the model for *Saint John the Baptist in the Wilderness*, now in the Uffizi in Florence. He was very interested in the invention of narratives and in portraying the human body, especially the naked female body, and a few years after working on the tapestries, he produced a series of obscene drawings to illustrate the erotic sonnets of his great friend Pietro Aretino. Not content, the two friends then turned the drawings into engravings, which were so extensively circulated that they were censored by the papal court. Together with Giovan Francesco, Giulio was designated Raphael's spiritual heir after his death; he also became one of the most famous artists of the century, a symbol of Raphael's ability to identify and cultivate the talent of his pupils.

Giovan Francesco, a Florentine by birth, was a very different character. Extremely diligent in learning his master's formal style, without too many creative flashes, he remained faithful to Raphael's lessons for the rest of his life, stiffening the naturalness of the poses and the depth of the sfumato. After Raphael's death, he and Giulio completed many of the unfinished works. These two were the real driving force behind the work on the cartoons for the tapestries, flanking Raphael as true sons and not just pupils, even though they were only a few years younger. Indeed, a close examination of the cartoons creates the immediate conviction that these were not in totality the work of Raphael. Even bearing in mind the circumstances mentioned earlier – the scarce value of the commission and the need to simplify the design, the light, and the colours – in many parts the execution is not convincing and the strong contrasts in light, the simplified chiaroscuro, and the facial and anatomical definition are reminiscent of Giulio Romano's and Giovan

Francesco Penni's paintings more than of their master's. Even those preparatory drawings that have survived seem to indicate a creative process that left considerable room for pupils, and this is the novelty that interests me most in this story.

Some drawings of a general compositional nature have survived that can be seen as models in the strict sense, where Raphael set out the definitive and precise idea of the composition, while the details were then developed by his most gifted pupils. After seeing through the master's model (which was, by definition, a sketch on a very reduced scale) and considering which poses, attitudes, and psychological expressions to use for the figures, the pupils moved independently to a life study of the individual details before enlarging them to suit the scale of the cartoon. This hypothesis about the method of work is backed up by a series of drawings by Giulio and Giovan Francesco.[8] Such a process represented a revolution in the Renaissance production system, which until then had seen the master taking charge of the entire creative process and leaving to his collaborators only the role of altering the scale of the drawings and their partial colouring on the medium used. Instead, with Raphael, the assistants took part in the entire process of creation and execution.

This new understanding of the creative value of ideation, as established through Raphael, is the opposite of the concept that underpinned the Renaissance workshops and had generated the cycle of Sistine frescoes. Michelangelo introduced a method based entirely on his own particular creative frenzy, which refused to envisage teamwork and above all did not contemplate a temporal continuity of shared work. Raphael, on the contrary, behaved like a modern master, educating his pupils to re-create his own style, passing on to them what his father had passed on to him – the selective power of the gaze, the critical capacity to assess the appropriateness of an image – and guiding them in their search for the best solutions. The reconstructed sequence of a few scenes clearly confirms this hypothesis.

Two beautiful preparatory drawings by Raphael have survived for the cartoon of *Christ's Charge to Peter*, one showing only Christ, in a pose that will later be changed in the final drawing, the other giving the layout of the entire scene. The two drawings, whose beauty and refinement leave no doubt as to Raphael's authorship and testify to

his direct intervention in the first phase of creation, are in many ways moving, on account of the documentary immediacy with which they bring the creative work before our very eyes and usher us into the heart of the workshop. The figures, especially that of Christ, are figures of real men who posed in Raphael's studio, dressed in rags or in contemporary clothes, which leave most of the body uncovered and allow the painter to study the posed anatomies. This performance was staged in the workshop with the help of assistants and perhaps a few good-looking boys pulled in from the street. It is a method of study that presupposes a passage from the real to the ideal, and it was already confirmed in Raphael's early works such as the *Coronation of Saint Nicholas of Tolentino*. The preparatory drawing (now in the Lille Palace of Fine Arts, Lille, inv. PL 474r) shows the crown, later held by God the Father in the painting, in the hands of a young apprentice whose codpiece is, perhaps ironically, well filled and in full view.[9] In this drawing, as in the cartoons for the tapestries executed twenty years later, Raphael studied the lifelike poses, the light, and the possibilities offered by different solutions. In this phase the figures were real individuals, dressed in simple everyday clothes. Once he had found the right poses and the spatial composition he had in mind, Raphael (or more probably his assistants) dressed the figures in their fictive historical garments, softened their physiognomies in conformity with those ideal traits borrowed from ancient reliefs, and these real men became – even in their appearance – suprahistorical, universal characters, close to the facial repertoire handed down through ancient images and employed by the artist as masks.

In this case (the preliminary and initial sketch of *Christ's Charge to Peter*), the creative play is particularly exciting. In fact the apprentice who posed for the figure of Christ, apparently in his early thirties and showing an incipient bald patch – recorded, almost with a chronicler's satisfaction, in Raphael's wonderfully quick hand (plate 39) – would then be replaced in the final version by Christ's face, which is based, rather remarkably, on the precious emerald cameo with the image of the True Effigy gifted to Innocent VIII by the sultan of Istanbul, Bayezid II (1481–1512). Together with the Lance of Longinus, it was a token of the sultan's gratitude to the pope for holding his dangerous younger brother Cem prisoner.[10] It must have been like walking into a

theatre before a performance and watching the company rehearse with the actors dressed in their everyday clothes.

From a certain moment onwards, the work of detailing the images was entrusted to pupils, who then updated the rough, realistic image according to the master's instructions, transforming it in line with that idealized style that had brought Raphael such success. Other traces of this process have been highlighted by modern scholars of the cartoons, for example the corrections made by the master on a model developed by a pupil and the details of studies for enlarging the poses developed by the pupils themselves – again, using real life figures. This procedure was in some respects revolutionary because the artist was aware of the phases of the work in which his contribution was fundamental – namely the overall composition of the scene, the definition of the poses, and the spatial arrangement of the figures – so that the narrative was balanced and effective. But after this phase the work was almost entirely left to assistants who worked under the master's guidance. So, while Raphaelesque physiognomies appear almost like a biological mark in the preparatory drawings at Windsor and in the Louvre, in the actual cartoon the physiognomies are much more recognizably in the style of Giulio Romano and Giovan Francesco Penni. In the latter, the contrasting chiaroscuros, the exaggerated lips, and a certain heaviness of the features all belong to the brushes of Raphael's pupils, yet this is of very little importance in a piece that had to be transposed in turn through the work of the skilled weavers of Brussels.

Even more interesting – from the point of view of creative dynamics within the group of talented young artists who collaborated with Raphael – was the collective development of the composition of *The Miraculous Draught of Fishes*. Various drawings have survived for this tapestry, documenting the various phases of the work and the contribution of individual artists. The first drawing in which Raphael established the general idea of the composition is a rapid yet very expressive sketch, today in the Graphic Art Collection at the Albertina Museum in Vienna (plate 40). It is only a light draft of the first convincing idea that Raphael had about how to illustrate the scene from the Gospels (Luke 5:3–10); and it represents his own interpretation of how that scene unfolded.

We are on the shore of a lake, and not far away from us there is a boat on the water, drawn with a few lines. It floats low in the water and

seems to be sinking, but only because it is very full. From our vantage point we can see that the hull is filled with shapes that might be fish. Christ is sitting in the bow. We see him almost in profile, raising his left hand, as if in a gesture of blessing. The index and the middle finger are drawn with clarity, while the other fingers are merely suggested. In front of him is Peter, a bearded man kneeling, hands joined in an act of thanksgiving or prayer. His pose is unbalanced but beautiful, as he pushes his bare, muscular torso forward. Behind is an even more hastily sketched upright figure, also bare-chested; he pushes the vague outline of an oar and looks across the lake, but the final pose still seems uncertain amid many confused lines. Not far away we see another boat, also low in the water; two figures are intent on pulling up a net and show their muscular shoulders, which give a very good idea of the effort required. At the back of the boat is a vague profile of another man, who is nevertheless lying back to leave a clear view of the shore opposite the one from which we look at the scene. The lake is lost in the distance, its shores filled by marks that could be trees, houses, or human figures. The sketch gives a very preliminary idea, captured on paper; but it is already full of dynamism and pathos. The surprise of the narrative comes with the figure of Christ, seated in the cramped space of the bow, with Peter, who reveres him, and with those two men pulling the nets. Raphael handed this first outline to his two most beloved and admired pupils, Giulio Romano and Giovan Francesco Penni, who were to develop it.

Giulio developed the scene in his own way, using the verso of the sheet on which Raphael made the sketch (plate 41). He left untouched the scene sketched by Raphael, but added greater detail to the figures, including to the man standing behind Peter, who was perhaps the point least worked out in his master's draft. The fishermen are still bare-chested, and the rower dips his oar in the water but turns his head towards Christ. On the bank on the viewer's side, we now see women seated, while children beside them help the fishermen. Let's imagine that they are the fishermen's wives and that their gaze follows their husbands. One of them is visibly concerned and cries, while her friend consoles her, stretching her arm around the other's neck, in an embrace. The child closest to her points at the boats, but not at the one in which Christ is seated – rather the one with the muscular fishermen

pulling in the nets. Two figures standing in the foreground give us the idea of a group of persons gathered in a meeting. The whole composition changes its subject matter, which now seems to be that assemblage of women standing in poses so dear to Giulio Romano, who lavishes on it his exaggerated virtuosity, as he had recently done in the room of the *Fire in the Borgo* in the Vatican. The richness of the composition is generated by these women, intent as they are on their own psychological drama, in which we, too, are immediately immersed. In essence, Giulio limited his intervention to a decorative editing of the scene, enriching it with figures so that they gave more weight to the narrative, but failing to focus on the theme that Raphael wanted.

Giovan Francesco Penni's interpretation of the scene in his drawing is completely different; and this is the final composition later transposed into tapestry (plate 42). Penni enlarged the boat and brought it closer to the shore on the viewer's side, concentrating the entire narrative on the two boats that are now in the foreground. As Raphael had sensed, the narrative needs to revolve entirely around the gestures of the figures, in accordance with Michelangelo's lesson. The most radical alteration concerns the other man in the boat with Christ, who now no longer pushes the oar, distracting the viewer's attention, but instead turns towards Christ, bending his knees and opening his hands, in a gesture of amazement and reverence. This serves to switch the whole focus on Christ, who no longer gives a blessing with his hand but holds it up, in a less specific but perhaps more pertinent sign of dialogue with Peter. In the boat behind, the first fisherman who pulls in the net also turns his head towards Christ, who therefore becomes the focal point of a dynamic action 'staged' through the gestures and powerful anatomies of the fishermen. The energy that sets in motion the five men in the boat originates in that gesture of the raised hand of Christ, who is isolated in the bow of a small boat in the process of sinking. Giovan Francesco's contribution developed his master's idea and helped to find the balance that would make this tapestry extraordinary. Finally, herons, symbolic guardians of the purity of faith, would be added in the definitive version, and in this way the collective effort achieved its finest goal.

INTERMEZZO

TWO MARRIAGES

Raphael's sociable and gentle character, his predilection for resolving conflicts rather than making them escalate, which came across in painting through a calm and graceful way of portraying gestures and facial expressions, did not exempt the artist from cruel competition with his masters and his competitors in the art market of the High Renaissance. In Raphael's work, however, competition was relegated exclusively to artistic creativity, without ever involving the persons with whom he was in contact in his own life (as it did in Michelangelo's and Leonardo's case). But this did not make that competition any less violent or ruthless.

Raphael had an innate ability to grasp immediately the innovations made by other artists and to make them his own, often by improving them. However, he too was unable to escape the rules of the market in which he made his debut. The first test in this competition, which exalted the surpassing of established masters, came when he was very young, around the age of twenty, when the only artist who dominated the market in Umbria and in the Marches was still Pietro Perugino. Perugino's decline would be inexorably marked by this youth who, in order to oust the old master from his position of hegemony, showed no qualms in imitating him almost slavishly, while he made his own work infinitely more praiseworthy. It was not unlike what Michelangelo had done with the first Madonnas he carved, in imitation of Donatello's.

The most striking example of Raphael's way of competing against Perugino is the execution of two paintings that shared an identical geographical context and were also chronologically very close. They were two marriages, one painted by Perugino around 1503/4 and now in the Museum of Fine Arts in Caen, the other painted by Raphael and now in the Brera collection in Milan. Although I believe that Raphael was never a pupil of Perugino but rather of his own father, Giovanni Santi, it was inevitable that, to conquer the market in central and eastern Italy, he had to measure himself against Perugino's style and to demonstrate his own superiority by making that style appear outmoded to the clients who viewed Perugino as one of the greatest Italian masters.[1] The opportunity arose when Raphael was commissioned to paint a *Marriage of the Virgin* with explicit reference to the composition of the more famous *Marriage of the Virgin* by Perugino, whom the young painter was asked to take as his model. The ambitious young artist could not have been given a more propitious opportunity to assert his talent at the expense of the old master, now in evident decline, who continued to repeat the manner and style that had enabled him to triumph twenty years earlier in the Sistine Chapel. Indeed, he had already used there the scheme of the *Marriage* in *The Delivery of the Keys*, which at the time was considered an avant-garde work on account of the sweetness of expressions and the composure of poses.

With an acumen that was to distinguish his extraordinary entrepreneurial career, Raphael arranged his own painting exactly as Perugino had done, but with improvements to the composition that immediately made clear his superior skill and future destiny. He positioned the figures in a circle, creating greater depth and naturalness where Perugino had lined them up in front of the viewer. He improved the chiaroscuro contrast within the scene in order to give the latter greater plasticity; he made the characters natural, and they acquired real consistency thanks to the perfect gradation of colours; he adjusted the posture of each figure to eliminate the rigidity shown by those of Perugino. Finally, through his mastery of anatomical foreshortening, he gave realism to the space in which the scene takes place.

Even in the architecture, which comes provocatively close to the architecture in the background of Perugino's *Marriage*, Raphael goes through the same process of adding movement. Perugino's rigid octag-

onal temple, with its elementary geometries, becomes an almost round building, on which the light breaks into infinite gradations as the inclination of the planes gradually shifts. The portico was drawn according to a more modern canon of proportions, its robust columns supporting arches framed by a relief cornice surmounted by a structure. A viewer who looks at the two altarpieces has the impression of seeing the same scene, yet staged by a more talented company in the work by the younger artist. There was little to discuss in the presence of so much similarity but also diversity, since the superiority of one over the other was immediately obvious. Afterwards Raphael was approached with a series of increasingly prestigious commissions. What was more, not content with having outclassed Perugino, he chose another artist as his master, in order to improve his style still further. This was none other than Leonardo da Vinci, who had recently returned to Florence to undertake an extraordinary series of works.

Raphael moved to Florence not only because its market held greater promise than the market in Umbria but also because there he could absorb Leonardo's research. Thanks to him, Raphael was going to supersede Perugino's rigid pyramidal structure in his Madonnas, the most frequently requested item on the market, opening them to a new, complex spatiality, as Leonardo had done in the cartoon of *The Virgin and Child with Saint Anne* (now in the National Gallery in London) – which in 1504, the year of Raphael's arrival in Florence, became the most advanced model of sacred composition in Italy. Along with the plasticity of Leonardo's structure, Raphael also looked to Michelangelo's *Doni Tondo*. This young and highly ambitious artist assimilated from Leonardo's painting that luminous sfumato that would become a feature of his painting in the years ahead.

From this time on, the competition between the two artists continued at a distance and Raphael would eventually surpass Leonardo in his composition of *Galatea*, and in doing so he drew on Leonardo's *Leda*, which he had seen and promptly sketched in Florence, studying and reproducing it in the famous drawing now at Windsor (inv. RL 12759) (plate 45). After meditating for several years on the pose of Leonardo's *Leda*, Raphael would make the original model much more dynamic in his *Galatea* (plate 44), moving the nymph's torso slightly forward and raising her left knee. This careful, almost imperceptible movement

given to the female figure is only the outward appearance of an inner dynamism, a psychological mobility that Raphael gave his model, and in doing so he opened a new horizon for the portrayal of women in Italy. In this competition between Raphael and Leonardo, the issue could not be resolved simply and definitively, in a single painting, as had been the case with Perugino. Rather, due to the exceptional talent of both artists, the competition would extend throughout their lives.

Part IV

THE LAST JUDGEMENT

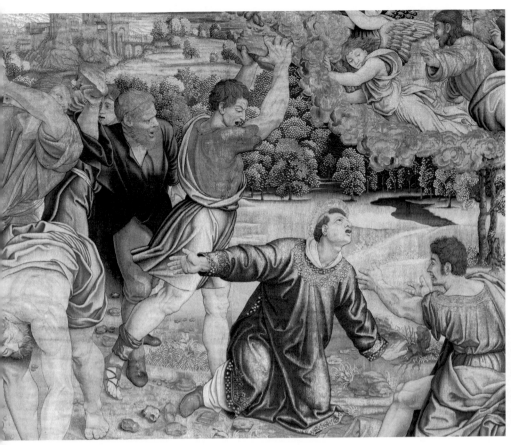

33 Raphael, *The Stoning of Saint Stephen*, tapestry. Vatican City, Pinacoteca Vaticana. Vatican City, Vatican Museum © Governatorato SCV – Direzione dei Musei

34 (Overleaf) Raphael, *The Conversion of the Proconsul*, chalk and tempera on paper. London, Victoria and Albert Museum. Royal Collection Trust/© Her Majesty Queen Elizabeth II 2022

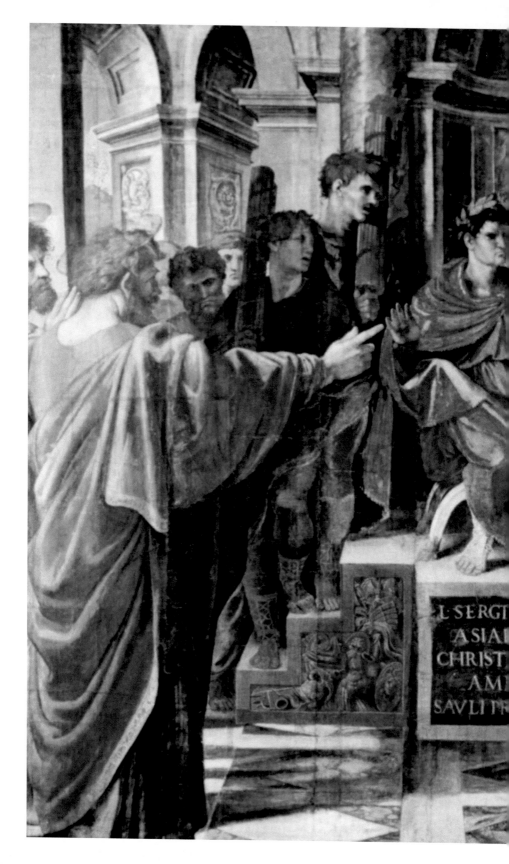

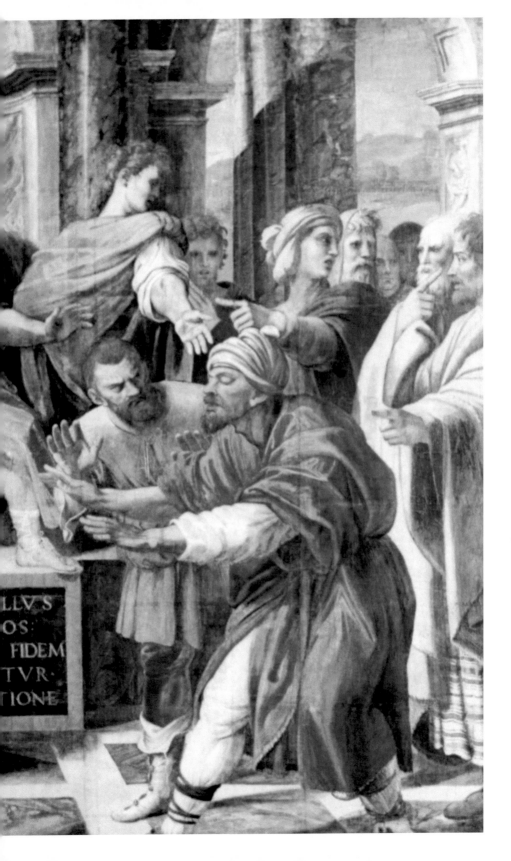

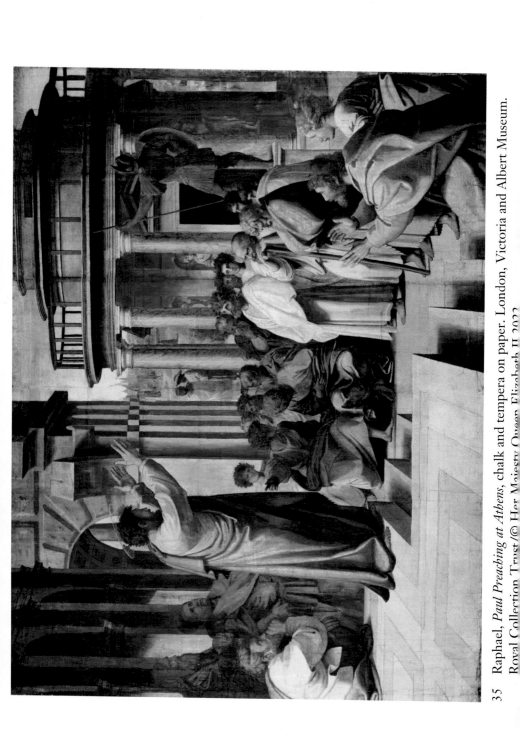

35 Raphael, *Paul Preaching at Athens*, chalk and tempera on paper. London, Victoria and Albert Museum. Royal Collection Trust /© Her Majesty Queen Elizabeth II 2022.

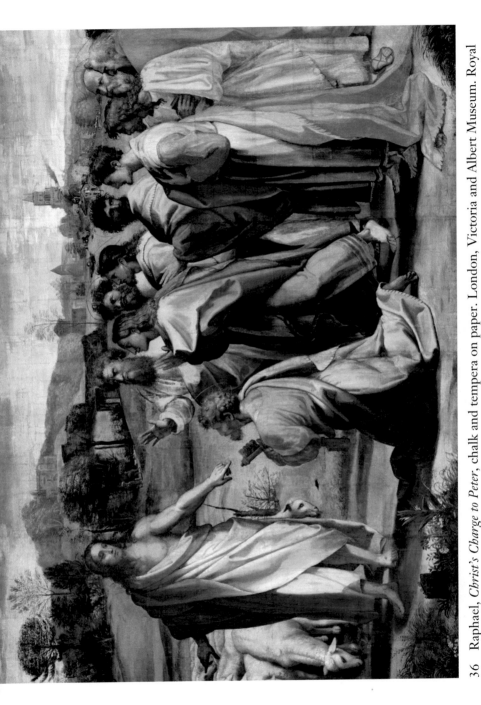

36 Raphael, *Christ's Charge to Peter*, chalk and tempera on paper. London, Victoria and Albert Museum. Royal Collection Trust/© Her Majesty Queen Elizabeth II 2022

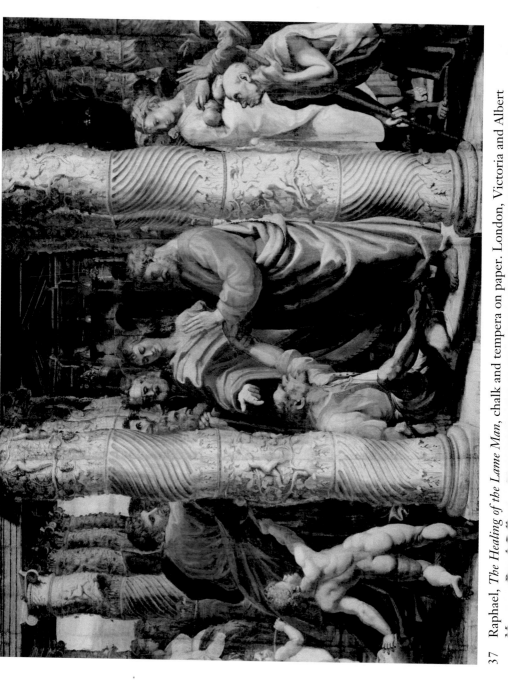

37 Raphael, *The Healing of the Lame Man*, chalk and tempera on paper. London, Victoria and Albert

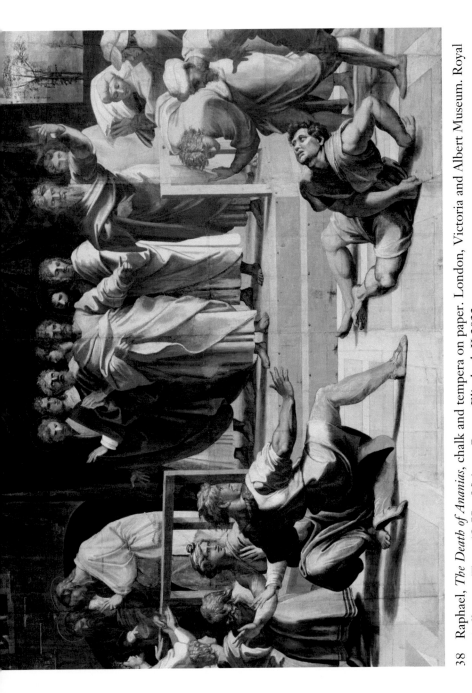

38 Raphael, *The Death of Ananias*, chalk and tempera on paper. London, Victoria and Albert Museum. Royal Collection Trust/© Her Majesty Queen Elizabeth II 2022

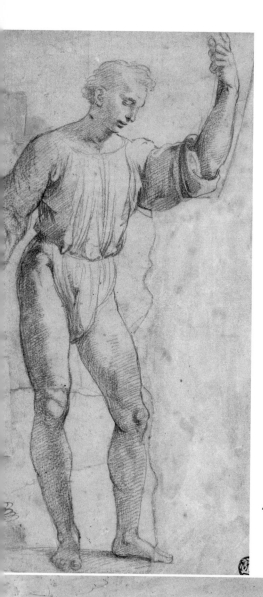

39 Raphael, *Christ's Charge to Peter*, preparatory drawing. Paris, Musée du Louvre © Musée du Louvre/Rmn Grand Palais/ Michèle Bellot/Dist. Photo SCALA, Florence

40 Raphael, *The Miraculous Draught*, first preparatory sketch. Vienna, The Albertina Museum © The Albertina Museum, Vienna

41	Giulio Romano, *The Miraculous Draught*, preparatory study. Vienna,
	The Albertina Museum © The Albertina Museum, Vienna

42	Giovan Francesco Penni, *The Miraculous Draught*, preparatory study.
	Windsor Castle, Royal Library. Royal Collection Trust/© Her Majesty
	Queen Elizabeth II 2022

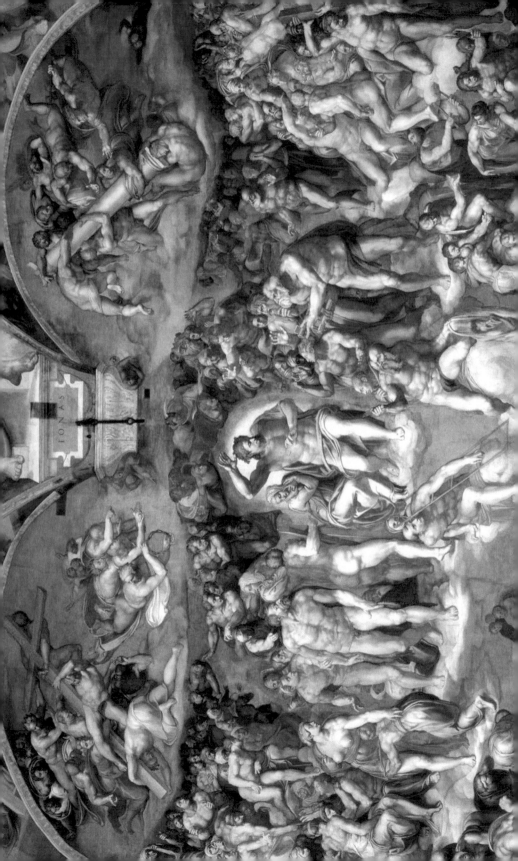

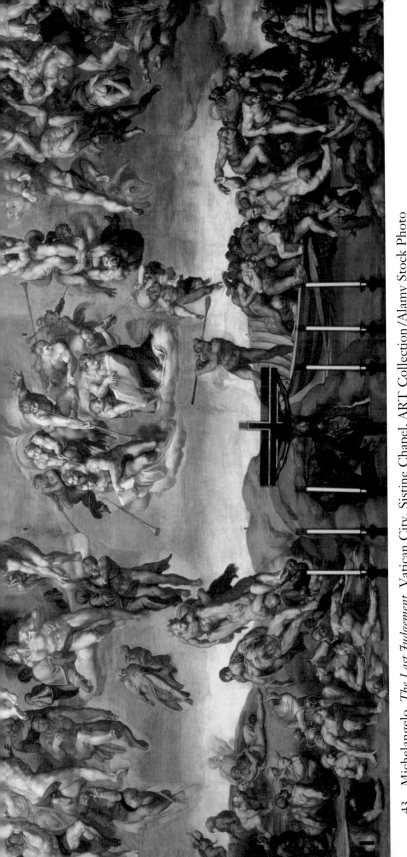

43 Michelangelo, *The Last Judgement*. Vatican City, Sistine Chapel. ART Collection/Alamy Stock Photo

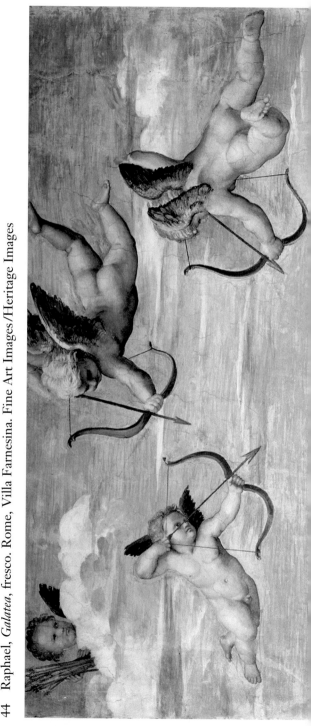

44 Raphael, *Galatea*, fresco. Rome, Villa Farnesina. Fine Art Images/Heritage Images

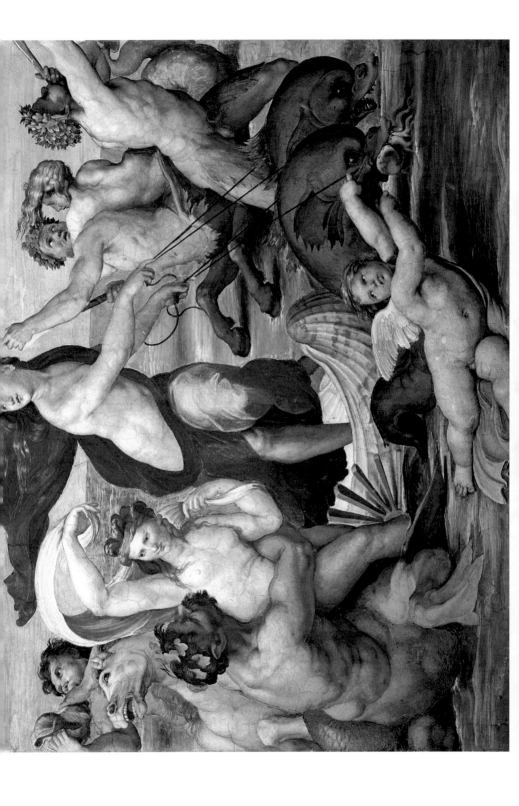

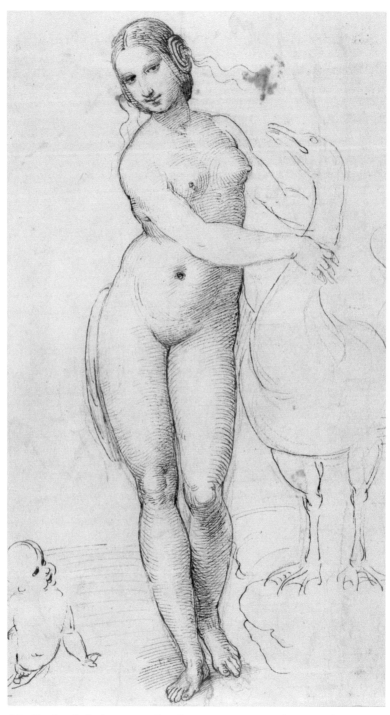

45 Raphael, *Leda*, pen and stylus on paper. Windsor Castle,
Royal Library. Royal Collection Trust/© Her Majesty Queen
Elizabeth II 2022

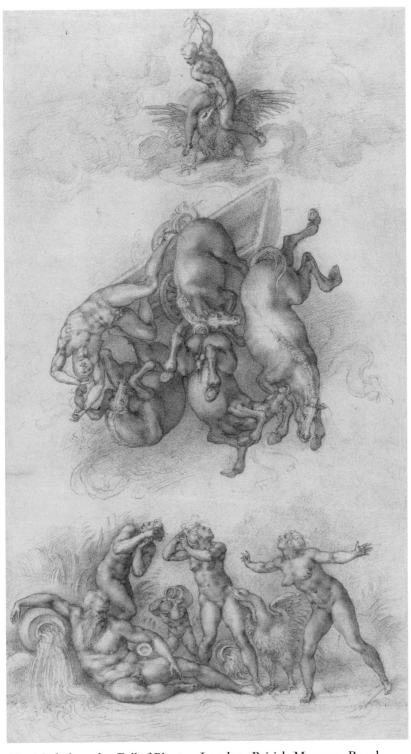

46 Michelangelo, *Fall of Phaeton*. London, British Museum, Royal
Collection Trust/© Her Majesty Queen Elizabeth II 2022

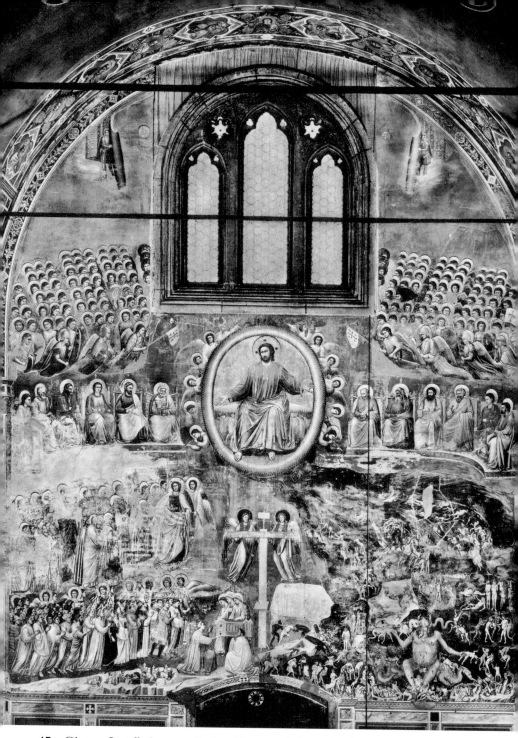

47 Giotto, *Last Judgement*. Padua, Scrovegni Chapel. The *Last Judgement*, by
Giotto, on the west wall of the Scrovegni Chapel in Padua (ADA-F-027081-0000).
Photographer: Anderson. Date of photography: 1920–1930 ca. Credit: Alinari
Archives, Florence – Collection: Alinari Archives-Anderson Archive, Florence

In spring 1535, the guards on duty at the entrance to the Sistine Chapel, the sacristans who dusted down the sacred furnishings, and the few clerics who were there to pray watched as a squad of workers led by Mastro Perino del Capitano ambled into the chapel. The workers proceeded to assemble a scaffold against the wall of the altar. Here two large frescoed panels, *Moses in the Bulrushes* and *The Birth of Christ*, had been completed fifty years earlier, together with the large altarpiece of *The Assumption*, painted by Perugino, which still showed the damage inflicted by the Landsknechts during the sack of 1527.

Then one day they heard the hammering of pickaxes coming from the poplar scaffolding and echoing under the great vault frescoed by Michelangelo. The iron tips of the double-headed picks sank into the ultramarine blue of the skies and a cascade of coloured fragments fell onto the floors of porphyry and serpentine, barely restrained by the canvases that covered the scaffolding. The first to go were the skies, with their pale clouds, then the fragments of gold glimmering in the haloes and in the highlights of the trees. Like an unstoppable leprosy, the pickaxes obliterated the reeds of the Nile and then the basket that held Moses, who had been cast onto the waters. The angels watching over the stable of the Nativity fell from the wall, shattering into pieces; they were followed by the ox and the ass that had warmed the newborn

baby, and finally by Mary and Joseph, who had stayed there for fifty years, to contemplate the miracle of that birth. When the sound of the pickaxes ceased, the wall behind the altar was nothing but bare plastered bricks, resembling the walls of German and Flemish churches, where Lutherans raged with iconoclastic fury during those same months.

Finally, they watched as a small man dressed in black arrived and gave orders with adolescent energy that belied his sixty years. At this point they understood that the new pope, Paul III Farnese, was also about to leave his mark on the place that had become the most powerful symbol of Christianity – a Bible transformed into images.

39

COMMISSIONING *THE LAST JUDGEMENT*

The idea of demolishing the frescoes behind the altar and replacing them with a huge representation of *The Last Judgement* (plate 43) had been suggested by Paul III's predecessor, Clement VII (1521–34), who had commissioned Michelangelo to do the work. It had not been an easy choice either to demolish Perugino's frescoes or to entrust the project to Michelangelo, but the events that had overwhelmed the church in the previous decade (the 1520s) had been so serious that all earlier logic, all former opinions regarding the appropriateness of making new changes to the decorative scheme of the Sistine Chapel had been set aside. A work was urgently needed that would capture and communicate the anguish of the times; and the only man who could achieve this was Michelangelo Buonarroti, even though the relationship between the pope and the artist was one of open conflict. But the pope was too tested by events and too intelligent not to put politics before pride. Art had by then become the main means of communication for rulers in Italy and personal grudges could not be allowed to hinder a patron's desire and need to link his name to that of the artist who, through his talent, guaranteed universal fame for the patron.

Clement was born as Giulio de' Medici, the illegitimate son of Giuliano de' Medici, and was miraculously legitimized by his cousin Giovanni when the latter became Pope Leo X. Clement had been a

protagonist in – and also, according to many, the person responsible for – the Sack of Rome in the spring of 1527, the most atrocious massacre carried out against the Holy City since the time of the Visigoths. But on this occasion it was the troops of the Catholic Emperor Charles V that carried out the massacre; they could not be controlled by his generals and were fired with religious hatred – the fiercest kind of hatred in human history, now fuelled through the spread of the Lutheran Reformation. Charles V had sent the army to punish the pope for his duplicity and disloyalty to alliances that he had promised, then broken for the sake of his family's dynastic aims. Clement had requested that the emperor take military action against the French, but then changed camp and allied himself with the French against the imperial forces, much to the advantage of the Medici and their ambitions. This was too much for Charles V; he decided to punish the pope for this betrayal with a military expedition whose extent was perhaps was not entirely clear to him at the start of the campaign. It may even be that the emperor did not fully understand the punishment he was about to inflict on the Holy City, but the hatred of the German armies, the squadrons of Landsknechte, had exploded with such barbarity in the city that the cruelty of the infidel Turks seemed irrelevant by comparison. The horror was described by Cardinal Salviati in a letter to Baldassarre Castiglione on 8 June 1527:

> The innocent orphans of the hospital of Santo Spirito are dead, all the patients thrown in the Tiber, the nuns attacked and raped, all the monks killed. The Great Chapel of Saint Peter and of Sixtus was burnt, the Sacred Face was burnt. The heads of the Apostles were stolen together with other relics, the silver cast into the street and crushed. The Sacrament was crushed and thrown into the mud and all possible wickedness let out, so much so that I am horrified – seeing these people, albeit heretics but yet still Christians, who have done what the Turks have never been heard to do anywhere.[1]

Never in the previous century had the infidel Turks been involved in clashes of hatred comparable to those unleashed by the reformed soldiers of Christian Germany. Nuns were raped and sold in Campo dei Fiori, citizens were taken prisoner and freed in exchange for ransom

or, if none was forthcoming, slaughtered in front of their families. More than two thousand corpses were thrown into the Tiber and 6,000 were left in the streets unburied for a long time. These are the main facts about the Catholic massacre, and one should add to them the shame of Pope Clement VII's imprisonment in Castel Sant'Angelo, itself besieged by the imperial troops. The imprisonment lasted from May 1527 until the following December.

As if all that were not enough, at the first news of the crisis in Rome, Florence rebelled against Medici control and the republicans set up a regime that lasted for three years. Then it, too, was bloodily suppressed by Clement's 'nephew', Alessandro, with the help of the imperial troops, which were pardoned for the great carnage inflicted in Rome in return for carrying out a small-scale massacre of republicans – a token offered to the pope as reparation for all the past wrongs.

On this long list of disasters Clement also had to add the shame of Michelangelo's betrayal. At the time of the republican revolt in Florence, Michelangelo was working on the tombs of the Medici dukes in the New Sacristy of San Lorenzo. The artist did not hesitate to make clear his dislike for the tyranny of the Medici, even though he had been raised by Lorenzo the Magnificent; and, as soon as the republican party overthrew the Medici government, Michelangelo laid down his chisels and mallets to offer himself to the rebels, as a supervisor of defensive fortifications. The same prodigious talent that until a few days before had been employed to glorify the Medici was then used to defend the city against them. But, once again, Michelangelo had been too rash in his choice, and when in 1530 the streets of Florence were littered with corpses, in a bloody restoration of Medici power, Michelangelo was forced to hide in an old charcoal bunker right under the floor of the New Sacristy.[2] He was rescued from this mortal danger by the pope himself, who informed his nephew Alessandro, now in charge of the bloody restoration, that he would not tolerate any physical or moral insults to Michelangelo Buonarroti. At the basis of this 'pardon' there must have been a plan, already in the pope's mind, to use the artist in the painting of *The Last Judgement*, a sort of vow to expiate the sins of which he felt guilty or was accused by many. But the project was also a warning against the arrogance of the princes who had broken the last taboo by attacking the spiritual government of Rome and by sending

troops to scatter the relics taken from the altars of churches and to trample them underfoot.

The context in which the work was conceived was therefore one strongly steeped in turmoil and spirituality, and it was these emotions that needed to be captured on the walls of the chapel that had already become the mirror of the Catholic soul. Europe was torn apart by religious struggles from which the Church of Rome was not sure of emerging victorious, and the pope was just as uncertain. The pope was deeply affected by the events he had helped to provoke and in which he had suffered personally. Sources testify to a gloomy and depressed Clement VII, who was constantly thinking about his own death, so much so that in 1533, taking the Roman court by surprise, he ordered every detail of his funeral trousseau.

In the spring of 1533 the pope, still physically handsome and well built even if broken in spirit, summoned Michelangelo to San Miniato al Tedesco, a small village between Pisa and Florence; the pope himself was on his way to Nice, where he would meet King Francis I of France. The purpose of the summons, which was very discreet, was to inform Michelangelo directly of Clement's intention to engage him in the painting of *The Last Judgement* on the altar wall of the Sistine Chapel, which until then had been occupied by the frescoes that Perugino had painted in 1481 and by Michelangelo's own paintings in the lunettes above, made in 1509. It was clear that the painting would break the narrative and formal unity of the chapel, but the pope did not want to relinquish the undertaking for any reason whatsoever. This was an urgent project, necessary and unpostponable like his need for expiation, a project for the sake of which the paintings of the previous masters could be sacrificed and the decorative unity of the chapel's walls could be broken. Testament to the urgency of the pope's wishes is a letter to the Republic of Venice sent by the Venetian ambassador one year later, in January 1534: it states that Clement returned to Rome after meeting the artist and ordered a scaffold to be assembled on the altar and that the scaffold in question was still in place a whole year later:

> The pope was so insistent for Michelangelo to paint in the chapel and for there to be the resurrection above the altar that he already ordered for the boards to be erected.[3]

But that scaffolding had to be dismantled before it was definitively reassembled in the spring of 1535.

When Michelangelo presented himself for that meeting in September 1533, he was already old and had also suffered because of the events. There was only a three-year difference in age between the two men and their lives had many parallels, the same events and the same people, although, unlike the pope, the artist could call on an inexhaustible creative tension that gave him the strength to react in these darkest moments that threatened to overwhelm him.

After the defeat of the republicans and his forced refuge in San Lorenzo, Michelangelo had a nervous breakdown that made others fear for his health, as a letter from his friend Giovan Battista Mini testifies:

> Because Michelagniolo seems very exhausted and has lost weight, the other day with Bugiardino and Antonio Mini we spoke about it, just ourselves and those who are with him all the time, and we reckoned that Michelagniolo will not live long if he does not look after himself, because he works a lot, eats little and not of good quality, and hardly sleeps, and for the past month or so he has been stuck in the church and has a headache and dizzy spells.[4]

He was worried not only about the tyranny of Alessandro de' Medici but also about the worsening litigation with the heirs of Pope Julius II, who wanted to see the completion of the funeral monument that had been paid for twenty years earlier. Michelangelo had delayed work on the tomb because he had been attracted by the new commissions assigned to him by the Medici pope (starting with the façade of San Lorenzo and the tombs in the sacristy), and he was all too aware of the scandal that his behaviour caused throughout Italy.[5] After the events that had shown how fragile even the power of the popes was, the artist grew convinced that he could not delay matters any further, and in May 1532 he travelled to Rome to conclude a new contract with the Della Rovere heirs. The trip, which had seemed at first to be a capitulation, turned into an occasion for the artist's rebirth. In Rome Michelangelo met the young Tommaso Cavalieri, with whom he fell madly in love, to the point of convincing himself that he wanted to move back to the Eternal City. The dramatic experiences he had suffered first hand in the

previous years had taught him to accept without hesitation the gift of
ardent love he felt for the boy. The letters he wrote in those months are
among the most beautiful and sincere pieces of his literary production.

> Without due consideration, Messer Tomaso, my very dear lord, I was
> prompted to write to your Lordship, not in answer to any letter I might
> have received, but taking the first step, as if believing to cross a little
> stream with dry feet, or a ford made manifest by paucity of water.[6]

These were the conditions of extreme physical and emotional hyper-
sensitivity in which the two men, the pope and the artist, met in the
small Tuscan village to talk about one of the most extraordinary under-
takings in the history of art of all time.

For different reasons and by following very different paths, the great
melancholic pope and the divine artist exhausted by his own political
and sentimental passions came to meet in a place that was inacces-
sible to others not only because of its geographical insignificance but
owing to its psychological location in the deepest recesses of the soul:
these were accessible only through the horrendous suffering that both
men had endured in the previous five years. That conversation in San
Miniato al Tedesco, where the idea of *The Last Judgement* was born,
produced a miracle of courage and sincerity that was unprecedented
and would have no continuation in Italian history.

The two men who spoke together on a radiant day in the late Tuscan
summer, amid the scent of wine vats and ripe figs, decided to create a
work that would allow no compromises, be they theological or formal,
a work that would remind the whole world of the vanity of human
ambitions and the strength of the only possible salvation, that of faith
in Christ.

During their conversation, Clement VII also gave Michelangelo per-
mission to make arrangements for other sculptors to finish the remaining
statues in the Medici family tomb in the new sacristy of San Lorenzo.
With the image of Tommaso burning in his chest, Michelangelo could
not have asked for more. And for the first time, paradoxically, at that
very distressing time, he declared his happiness in the dedication for a
drawing given to Tommaso on 1 January 1533: 'The first and for me
happy day of January.'[7] It seems entirely appropriate to stress that, in

all the artist's wealth of correspondence and autograph testimony, there is no other reference to his own happiness – which makes this naive, childlike dedication so moving.

Once he had given instructions to his assistants, Michelangelo was ready to depart for Rome, leaving Florence in the hands of the most hateful member of the Medici family, Alessandro, who was bloodthirsty and wicked, and above all – in his eyes – a usurper of the city's freedom. Instead, Michelangelo's destiny was Rome and Christianity; both were going through a process of self-questioning combined with hope, being threatened by yet withstanding a whirlwind of passions that sometimes seemed unstoppable, even miraculous, because of the depth of devotion that despite everything survived on the banks of the Tiber. In that city shone the light radiated by the young Tommaso, to whom the artist gave himself without reserve, as he had never done before. The journey must have seemed quick, but the arrival would be bitter.

As soon as he reached the city in September 1534, exactly one year after that meeting in San Miniato al Tedesco, Michelangelo learned that Pope Clement VII had died. Fate seemed to shuffle the cards of the game that had just begun. Without losing courage, the indomitable artist began to work in the Church of San Pietro in Vincoli, so that at least he could finally complete the tomb of his old protector.

40

A NEW POPE FOR AN OLD PROJECT

'I have waited an entire life to ask Michelangelo to work for me, and now that I am pope . . .' Once the solemn funeral and burial was over, the cardinals met in conclave in the Sistine Chapel, where the scaffolding that Clement had ordered, behind the altar, was dismantled, so that the Holy Spirit (and a good dose of political horse-trading) could choose a man capable of leading the church and its flock towards extraordinary goals, and above all a man who appreciated Michelangelo Buonarroti more than anyone else in the world. The man's name was Alessandro Farnese, who became Paul III. Scion of a minor noble family of Lazio, he owed his career to favours granted by his sister Giulia. In her youth she was renowned for her extraordinary beauty and, as Giulia the Beautiful, as she was known throughout Italy, became the mistress of the Borgia pope. If the scandalous affair of Alessandro Farnese's sister was the start of a sensational political career, his intelligence and acumen did the rest, so much so that at his death it was said that he held his kingdom with much more honour than he had gained it. In 1534 Alessandro Farnese had already spent fifty years at the Roman court and had been the closest advisor of Clement VII, who unfortunately had not listened to him as much as he ought to have done. Paul III's election owed much to his cunning, which afterwards became legendary in Europe: many intellectuals referred to him in their letters as the 'Farnese fox'.

As was often the case, the conclave had reached an impasse owing to the many political conflicts that proved unresolvable. Alessandro was born in 1468 and, when the conclave opened in October 1534, he was already sixty-six, with a haggard physique that suggested a weakness that was not present. Pretending to be very ill, Alessandro convinced the other cardinals that his election would save time, as he would live long enough to allow preparations for the election of a pontiff who represented a true unanimity. The ruse worked and the elderly Alexander came to the coronation ceremony invigorated by his success; so invigorated, in fact, that he held the office for fifteen years, until 1549, in one of the most enduring reigns in the history of the papacy. Because he too had experienced at first hand the horrors of the Sack of Rome alongside Clement and shared his spiritual maturity, and because he had known Michelangelo before the artist even arrived in Rome, when he was in the house of Lorenzo de' Medici, Paul III appeared even more determined to complete his predecessor's project. Indeed, in 1535 and 1536 he issued two papal briefs in which he freed Michelangelo from his ties to the Della Rovere family for the duration of the execution of *The Last Judgement* and rewarded him with an annual fixed income of 1,200 gold ducats for the years to come.[8] He wanted no impediments to what he regarded as a necessary and binding commission. On 1 September 1535 the pope decreed:

> And above us, if you were to paint the altar wall of our Chapel with the picture and story of the Last Judgment, showing [the same] work and virtue in this as in every work in our palace, we promise you will be paid for this work, as earnings and revenue, one thousand two hundred gold scudi a year for life, and this shall be paid on the strength of the presents . . . from the Po Customs close to Piacenza.[9]

He, too, had good reasons to demand that the Catholic world reflected on what had happened in the past few years and on the events that continued to take place at the time. The problems that the new pope had to confront at the very start of his pontificate were terrifying. The Ottoman Empire, led by Sultan Süleyman, was besieging Christian Europe and had already established control over a part of Eastern Europe and the Mediterranean, as well as over the African

coast. Süleyman continued to cherish the dream of bringing his horses to drink from the fountains of Saint Peter's, with the help of the ongoing alliance with the Christian King Francis I of France. The Lutheran Reformation had become firmly established on the German territories, and some of the electors were using reform as leverage to free themselves from Charles V's control. The king of England, Henry VIII, in love with a young and unscrupulous Anne Boleyn, was threatening a schism by demanding that Rome annul his marriage to Catherine of Aragon, who had given him a daughter, Mary. The pope could not grant the marriage annulment without provoking the ire of Emperor Charles V, Catherine's nephew, and without causing a universal scandal by breaking the indissolubility of the marriage bond in the presence of an heir. As if that were not enough, Paul III had to deal with a son so depraved and ambitious that he seemed to be born in hell. The determination of both father and son to create a European kingdom for the Farnese dynasty was so evident from the first days of the pontificate that Rome was inundated in violent satire and attacks in the form of Lutheran propaganda.

In this climate, Michelangelo was to portray the culminating event of Christian history, the Last Judgement, which, along with its terrifying prospects, also had the reassuring value of guaranteeing final justice for mankind. But across Europe things were far from being reassuring in those months, and the painting became a testimony of the dismay of Christian people faced with the fragmentation of a political and social universe that had remained united for at least a thousand years.

41

THE ICONOGRAPHICAL TRADITION OF
THE LAST JUDGEMENT

In the Christian tradition the Last Judgement represents the final moment in the history of the world, the end of time for humankind, which will be called to account before Christ in judgement for the good and the bad that each person has committed in life. Although this was the most important event of Christian devotion, one both feared and imagined, it did not rely on a codified literary tradition. The sources and references to the Last Judgement stem from two texts, both fundamental to the Catholic tradition: the Apocalypse of Saint John and the Gospel of Matthew. But the significance and the emotional hold of the subject of the Last Judgement mean that these sources of a fragmentary nature were replaced by an iconographical tradition that has developed since the closing years of the first Christian millennium. The earliest visual representations of the Universal Judgement are very difficult to trace, and this suggests that such representations were first attempted, developed, and codified during the Middle Ages, especially in the illuminated images of religious codices, in which learned monks used their expertise to construct a meaningful picture of the event. This monastic genesis of the iconography of the Last Judgement is also supported by the fact that the first major public representation was commissioned in the mid-eleventh century by Abbot Desiderius, the powerful rector of Montecassino, for the cathedral of Sant'Angelo in Formis. During that

century the culture and tradition of the images was kept alive, guarded, and above all transmitted by monastic centres across Europe.

The second important representation appeared shortly afterwards, in the mosaics of the Church of Santa Maria Assunta on Torcello. Both images reveal a well-structured and very homogeneous iconographical format, which did not undergo major changes until Michelangelo radically upset it. As has been widely stressed, the scheme stems from Roman monumental reliefs that celebrated the emperor in his role as omnipotent royal judge. The layout in horizontal bands and the centrality of Christ, who is depicted in the act of judging, stem from sculptural representations that have survived on the arches and temples of many Italian and Byzantine cities, as evidence of the highest imperial power. The 'story' of the last day was based on this scheme, with few variations, as Grabar explains: 'The Emperor or Christ are surrounded by other court dignitaries (or Apostles) or by lance-carrying guards (or lance-carrying Angels).'[10] From this stage on, the component elements of the representation were always the same and served to explain the theological meaning of the image to all, regardless of rank or place.

The solemn, composed figure of Christ the Judge is flanked by Mary and John, who intercede with him on behalf of mankind. The apostles flank Christ as his holy legions, consolidating his power, while the angels are delegated to execute the actions that give meaning to the event. They blow the trumpets of Judgement, hold up the fearful books in which the name of every person is inscribed with their sins and virtues, and they display the symbols of Christ's passion, the symbols of the martyrdom he faced in order to redeem the sins of humankind.

In the lower register of these parallel bands, of which the sculpted pillar in Orvieto Cathedral (c. 1280) is the most fascinating example, the elect appear to the right of Christ, while to the left the damned are condemned to Hell, which generally appears in the lowest part of the schema, populated by terrifying devils who served to remind sinners of the fate that awaited them in the afterlife. These elements were indispensable for understanding the event, but minor variations could appear, depending on the morphology of the medium or the artist's inspiration. Such variations were generally found in the depiction of Hell – an impulse for truly fantastical images invented by artists of every era – and in the definition and placement of God's people behind

Christ. In some representations (as for example in the pillar of Orvieto Cathedral) these ranks are very much simplified, while in other cases (the Scrovegni Chapel in Padua, or Santa Maria Novella in Florence) the choirs of virgins, doctors of the church, martyrs, apostles, and finally the elect are detailed and recognizable.

The fact that this representation was the display of a hierarchical canon, a law that fulfilled the destiny of people rather than the narration of an event, means that in subsequent examples the static nature of the image was reproposed throughout Europe with few changes, be they in monumental sites, panels paintings, or illuminated manuscripts. Giotto's fresco of the *Last Judgement*, painted in the first decade of the fourteenth century in the Scrovegni Chapel in Padua, is remarkable not only for the quality of its execution but also for some small but significant innovations to the narrative. Here the sense of the end of time, a concept that is almost impossible to imagine, let alone represent, is conveyed by Giotto through the depiction of two angels who roll up the sky, leaving nothing to be seen. It is a simple but moving expedient, which recalls theatrical performances at the end of which the actors roll up the backdrop because everything has been said and there is nothing more to say. Giotto's *Last Judgement* (plate 47) was almost certainly seen by Michelangelo not long before the Sistine commission. During the republican occupation of Florence, Michelangelo fled to Venice for a few months, on 12 September 1529.[11] During a stopover in Padua he would certainly have been drawn to visit the frescoes of Giotto, an artist whose work he had loved since he was young.

The Florentine images of the Last Judgement that Michelangelo had known all his life seem to have been less significant. They included those by Coppo di Marcovaldo in the Baptistery and by Nardo di Cione in the Strozzi Chapel of Santa Maria Novella. On the other hand, the *Last Judgement* in the Camposanto of Pisa, in which Christ the Judge is shown with a raised arm, has been cited as an authoritative precedent for Michelangelo.[12] To finish this brief overview of the iconographical sources that, if not directly influential, were certainly present in Michelangelo's mind as precursors of his creation, it is worth mentioning the fresco cycle by Luca Signorelli, a close friend of Michelangelo, in the San Brizio Chapel in the Cathedral of Orvieto. Signorelli made important innovations that brought dynamism to the representation

of *The Resurrection of the Flesh* and *Hell*. These were the only parts that allowed more movement in an iconography that had become so rigidly structured.

Against this background, Michelangelo faced a very difficult task. On the one hand, the theme he was about to paint had to be recognizable in relation to a very rigid, age-old iconographical tradition, but on the other his language, which had reached its fullest expression precisely on the Sistine ceiling, envisaged neither stasis nor symbolic narrative. His narration was dynamic, focused on the human body 'in action', a body that did not use characteristic symbols, as happened in most sacred art. Through posture and through the power of anatomy and expression, Michelangelo's human figures communicated the artist's feelings, which, as we have seen, were suffused with secular and spiritual anxieties that could not be suppressed by means of a static and celebratory representation of the heavenly hierarchies. In *The Last Judgement* Christ had to be, first and foremost, a man who felt the weight of history and the trials of faith (as did Michelangelo himself), just as the other protagonists of this apocalyptic event had to communicate their participation through their bodies and not simply through the place assigned to them in the rigid compartments of earlier *Judgements* painted with the precision of a ceremonial, theatrical performance.

Moreover, Michelangelo had to imagine a narrative in continuity with that of the vault, without betraying his own language. He had to renew the iconographical schema while at the same time making it recognizable and making it his own through that very specific language of bodies. In addition, the technical difficulties hinted at earlier made the task an almost hopeless one.

42

THE WORKSITE

The information we have regarding the commencement of the work is, as usual, limited to practical details. The artist was no longer the stubborn young man who, twenty-five years earlier, had tackled the decoration of the vault alone, climbing up the scaffolding suspended in the chapel. He was now very confident, despite his advanced age, and did not even try to find collaborators. Michelangelo's closest friend, the excellent painter Sebastiano del Piombo, urged him to use an oil painting technique on the walls this time. It was a process that had been developed to the highest level of excellence by Sebastiano himself, who wanted nothing better than to help his friend and master in this undertaking. Moreover, this process would have allowed Michelangelo to follow a time frame more suited to the waning energy of an older man. Fresco painting meant working at speed, since the artist had to finish the portion of plaster prepared in the morning by the workers before the end of the day. If he used oil painting instead, Michelangelo could have taken all the time he needed to finish the painting. In addition, fresco painting posed a serious problem regarding the gradation of pigments: there could be changes in tone as the weather changed. Cold or dry weather, as well as humidity, were all variables that affected the outcome, and over the years such variations were inevitable. What was more, Michelangelo had conceived of the structure of the painting without allowing for any decorative partitions: it was set

in an immense blue sky, whose completion would take years, making it very difficult to keep the tone of the colour identical. The situation was further aggravated by the morphology of the wall itself, which, unlike the ceiling, lacked architectural compartments; it presented a single continuous surface, which would make any changes in colour even more visible. Nonetheless, Michelangelo rejected Sebastiano's advice, showing disdain for what he evidently saw as a lack of confidence in his technical skills. He told Sebastiano, in characteristically straight terms, that oil painting was for lazy friars and not for an artist like himself, thus revealing that he still conceived of the work as a physical, material challenge, no less demanding than the sculptural art he undertook with marble and chisels.

Having decided to use a fresco technique, Michelangelo confined himself to making a few alterations designed to improve the durability of the painting over the centuries, for example by lining the wall – from which the previous frescoes had been removed – with a brick scarp that leant inwards at a slight angle from the top, to reduce the accumulation of dust, which would otherwise have gathered faster on a plumb surface.[13] The construction of the scaffolding began in early April 1535 and was entrusted to Perino del Capitano at a cost of twenty-five gold ducats. The scaffold was made of chestnut wood and elm boards, as was recorded in contemporary documents, but it is not certain that the painting started then. The sequence of documents suggests that the actual commencement date was much later.

In the summer of 1535 Michelangelo still appears to have been busy working on the construction of the tomb in San Pietro in Vincoli, since in December 1537 he paid the stonemason Scherano da Settignano for a roughed hewn statue of the Madonna to be placed on the monument.[14] Further confirmation that the work did not start until at least 1536 comes from a series of other documents. On 17 November 1536 Paul III issued a special decree, in which he freed Michelangelo from any other task related to the tomb, and in the first place from his binding commitment to Francesco Maria della Rovere. This is a sign that, in 1536, Michelangelo did not feel confident about abandoning his work for the Della Rovere family and that this elicited a direct, official, and authoritarian intervention from the Farnese pope.[15]

Other evidence suggests that work actually began in 1536; so does for instance a letter that Pietro Aretino wrote to Michelangelo on

15 September 1537 to propose his own iconography for the Last Judgement because he was eager to play a part in what was to be the most imposing work of the time. The fact that the well-informed poet in Venice was not *au fait* with the state of the work in 1537 suggests that it had only just started, especially since the Venetian ambassadors in Rome kept the Serenissima punctually informed of everything that happened in the Eternal City. Michelangelo's answer came promptly, stating that the work was too far advanced for him to accept Aretino's advice.[16] Lastly, the proceeds from the Po customs, with which Paul III had decided to reward Michelangelo for the work, began to be recorded in Michelangelo's ledger only in October 1537. This probably meant that the painting did indeed begin in 1536, when a new papal edict explicitly released the artist from his contractual obligation to the duke of Urbino, Francesco Maria della Rovere, and prohibited him from fulfilling all the duties related to the tomb of Julius II:

He has commissioned the said Michelangelo for a painting of this kind, according to the design of the cartoons he has made, and he has instructed the same (Michelangelo) that he should focus upon that, having put aside the aforesaid tomb [of Julius II] and any other work.[17]

The belligerent duke of Urbino did not acquiesce readily to seeing the work he had been waiting twenty years for interrupted again.

When the problems with the Della Rovere family had been resolved and the good weather signalled a favourable start to the enterprise, Michelangelo's workers began to apply plaster to the altar wall. In short, according to the evidence gathered so far, work began as spring turned into summer in 1536.

This would explain the dating of receipts for payments for the work in the following October. There is also a payment for a large supply of colours dated 6 June 1539:

On the 6th, two hundred and four scudi to Nicolo Niculuzzo [*sic*] of Ferrara for colours given for the use of painting in the Chapel of Sixtus.[18]

It is probable that there were earlier payments, but no traces have survived.

43

AN UNPRECEDENTED FEE

All the sources concur as to Pope Paul III's extraordinary esteem and boundless admiration for Michelangelo – so extraordinary and boundless that, according to Vasari, he often sent for Michelangelo to enjoy his conversation and company in intimate surroundings. Condivi's biography tells us, by way of confirming the pope's great regard for the artist and desire to commission the work from him, that when Michelangelo pointed to the difficulties of embarking on the *Judgement*, given his obligations to the Della Rovere, the pope lost patience and exclaimed in public: 'For thirty years now I have had this wish and, now that I am pope, can I not gratify it? Where is this contract? I want to tear it up!'[19]

The story was immediately repeated by Vasari in the second edition of his *Lives*. Moreover, the papal *motu proprio* ['on my own authority'] document that freed Michelangelo from any existing commitments is clear proof of the consideration he was held in and of the pope's desire to have him as his personal painter.

While such regard and friendship were unparalleled, so too was the very special type of remuneration granted to Michelangelo as compensation for his work. It leaves no doubt as to the truly extraordinary status enjoyed by the artist at the Vatican curia. The first contract regulating the decoration of the walls of the Sistine Chapel had been wholly medieval in character, because it submitted work already

done by the four Tuscan artists, the four-panel sample, to a commission that assessed the cost *a posteriori*. Instead, the allocation to Michelangelo of the revenues from the Po customs in Piacenza and the addition of other sums, which amounted to 1,200 ducats per year, closely resemble the provision of an ecclesiastical benefice, a lifetime reward generally used to remunerate the services of the great dignitaries of the court. All this shows that an artist could use his talent to scale all the social hierarchies – as Raphael had already done, being offered nothing less than a cardinal's hat, according to some contemporaries. Nonetheless, in half a century, the advances made by painters had become a triumphal march.

It is therefore easy to imagine that Paul III placed total trust in Michelangelo's ability and did not intervene at all in the definition of the narrative, as Pietro Aretino had tried to do. Aretino, it seems, had not yet understood the extent to which the artist had completely broken free from all intellectual authority, even that of people as successful as himself. But this is not to say that Michelangelo was not influenced in the creation of this work, even though any external suggestion left him unconvinced: his mind and his passion sufficed to suggest the structure of the narrative. Nonetheless, there is room to speculate that the artist's creativity may have been influenced at this moment, in 1536, by the friendship of a woman of exceptional intellectual and religious stature, the poet Vittoria Colonna, marchioness of Pescara, who was adored by literati all over Italy. Right then she was embarking on a devotional journey that would bring her to the heart of one of the most spiritual circles in Italy, a group led by the English Cardinal Reginald Pole, Henry VIII's cousin and a man who had received death threats both on account of his opposition to the king's divorce from Catherine of Aragon and on the grounds that he aspired to the throne himself.

Reginald Pole stood out for his extraordinary devotion and moral rigour and was appointed cardinal by Paul III in 1536. The English cardinal accepted some of the most important aspects of Luther's teaching, if not all, trying to graft them onto a Catholic Reformation that would not completely distort the role of the Church of Rome, as Luther wanted. Pole's bond with Vittoria was very close, as were the latter's links with Michelangelo: the latter are documented even before 1538. Whether and how Vittoria Colonna may have influenced

the conception of *The Last Judgement* is still an open question today, because the date at which the marchioness approached the artist is not certain, although it cannot have been too long after 1536: we know for certain that their relationship was already very close in 1538.[20] On the other hand, there is no doubt that this painting offered the best interpretation of the ideas of figures such as Colonna, Cardinal Pole, and the other great protagonists of the spiritual renewal in Europe during those years. It is well documented that it was thanks to this painting that Michelangelo, in the years after its completion, became an organic part of the group known as the Spirituali (Spirituals) and that in some way, perhaps through his small paintings and drawings, or through the frescoes in the Pauline Chapel, he was the channel through which the group's ideas were transformed into images.

In Michelangelo's creation the Spirituali saw a reflection of the anxieties, fears, and hopes that the most dramatic time in the history of Catholicism was producing. Like the artist, they, too, felt anxious about the destiny of Christianity, and this restlessness made the ceremonial and static representation of the Last Judgement distant and impractical, given that it was the event to which Christians had looked with serene certainty for centuries.

44

THE WHIRLWIND OF HISTORY

Only remnants of the preparatory drawings for the fresco of *The Last Judgement* have survived but, albeit few, they do confirm that, from the outset, Michelangelo shattered the horizontal schema of iconography in order to develop a concentric composition, a vortex of forces that places the movement of Christ at its centre. No longer showing the regal restraint of the Roman emperors, Christ's passionate gesture exerts a physical effect on the surrounding atmosphere. The power of that gesture is such that the air becomes solid and condenses into a whirlwind that originates precisely from Christ's raised arm, which is emphasized by the dazzling light around it. With that gesture the poetics of physical expression reaches its highest possible level.

The marvellous Christ, beardless and as beautiful as Apollo, as powerful as Hercules, sets in motion the mass of humanity around him with one single gesture. This fearful gesture that announces the moment of judgement, the destiny of the saved and the destiny of the sinners, has a consequence for and an effect on all the protagonists in the image, making no distinction between the elect, the saints, the virgins, the fathers of the church, and the damned who are dragged by the devils, for perpetuity, into the fire of hell. They are all helpless and dismayed. The choirs of the blessed and of the virgins, of the saints and of the apostles, seen in the other *Last Judgement* paintings, motionless and ecstatic,

have disappeared forever. No one feels truly safe in the presence of that gesture. Everyone is frightened, their fate is uncertain, just as the fate of Michelangelo and his contemporaries seemed uncertain. The artist at work in the most iconic site of the Roman Catholic Apostolic Church refused to give a reassurance that those who commissioned the painting had perhaps intended to offer; instead he sent Luther, Henry VIII, Süleyman the Magnificent, and all those who questioned the legitimacy of Rome a message to the effect that the destiny that rewarded those who remained faithful to Christ could be fulfilled only in Rome, in the heart of the Vatican.

Yet in Michelangelo's painting and in the fervent devotion of Vittoria Colonna and Reginald Pole this destiny remained uncertain, even on that last day of judgement. Michelangelo challenged the church right at its heart, and started a debate that was to continue in later years, fortunately with results that were less disastrous than they might have been. A part of the church considered that image intolerable, and not because of the element of nudity, as was claimed; the ceiling was already full of nudes, and far more disturbing ones, where beautiful young men recalled those who frequented the 'baths' and Eve herself did not hide any part of her body. The criticism had started to arrive while the painting was still in progress. Biagio da Cesena, the master of ceremonies, feeling that his sense of decorum was offended, criticized the painting when a third of it was still unfinished and Michelangelo took revenge on him by portraying him in the lower register with a diabolical serpent biting into his genitals. This lively, even crude depiction was justified by the medieval tradition of the torments inflicted on sinners, a tradition that ignored the rules of decorum imposed on all public representations. The Flemish *Last Judgement* paintings of the previous century contained a disconcerting series of bloody scenes involving the torture of sinners. This anecdote, commemorated by Vasari, highlights an atmosphere at the curia that was not exactly one of unanimous consent around the work of the divine artist – who, besides, was spiteful and unmanageable.

What the cardinals and other members of the curia who flocked to the chapel saw on the day of the painting's inauguration in the autumn of 1541 was a disturbing vision that caused many to cry out in scandal. However, despite the suspicions of heresy and Lutheranism levied at

the artist, the power of the painting's beauty justified the admiration of the pope and of most of the curia. It took their breath away – and, with it, the desire to judge such a courageous man, who had confronted the whole contemporary world with the weight of its own destiny and behaviour. The most vivid testimony of the astonishment and dismay that the unveiling of *The Last Judgement* aroused appears in the letter that Niccolò Sernini, ambassador of the cardinal of Mantua, sent to his patron as soon as he saw the painting.

> Your Illustrious Lordship, there is no lack of those who condemn it in every way, the Theatines are the first who say that it is not good to have naked people in such a place showing their parts, even though they have had such great consideration for this, that hardly ten of that number are seen to be dishonest. Others say that he has made Christ beardless and too young and that Christ does not convey that majesty that befits him and so, in short, there is no lack of those who say so, but the Most Reverend Cornaro, who gazed at it at length, put it well by saying that if Michelangelo wants to give him a painting that has just one of those figures painted in it, he will pay him whatever he asks and he is right that these are things, in my opinion, that cannot be seen elsewhere.[21]

The final comment holds the key to yet another success for Michelangelo, who this time openly challenged tradition and iconographical custom and won, because he invented things that could not be seen elsewhere. The debate on the painting would continue throughout the century, albeit this aspect was prudently settled by Vasari's criticism, whose verdict on *The Last Judgement* has passed on to posterity.

> When *The Last Judgement* was uncovered, Michelangelo proved not only that he had triumphed over the first artisans who had worked in the chapel but that he also wished to triumph over himself in the vault he had made so famous, and since the Last Judgement was by far superior to that, Michelangelo surpassed even himself, having imagined the terror of those days, in which he depicted, for the greater punishment of those who have not lived good lives, all of Christ's Passion; he has various naked figures in the air carrying the cross, the column,

the lance, the sponge, the nails, and the crown in different and varied poses with a grace that can be executed only with great difficulty. There is the figure of Christ who, seated with a stern and terrible face, turns to the damned to curse them, while in great fear Our Lady, wrapping herself in her cloak, hears and sees great devastation. Countless figures of the prophets and apostles are there surrounding Christ, especially Adam and Saint Peter, who are thought to have been included because one was the first parent of those brought to judgement, while the other was the first foundation of the Christian religion. . . . Nor in the depiction of the resurrection of the dead did Michelangelo hesitate to demonstrate to the world how these bodies take on their bones and flesh anew from the very earth, or how, assisted by others who are alive, they go flying towards Heaven . . . Thus, any person who has good judgement and an understanding of painting will see in this work the awesome power of the art of painting, for Michelangelo's figures reveal thoughts and emotions which were never depicted by anyone else; such a person will also see how he varied with diverse and strange gestures the many poses of the young and old, male and female: to whom do these figures not display the awesome power of his art along with the sense of grace with which Nature endowed him?[22]

Vasari clearly grasped the central point of the painting, although he tried to condition the viewer's gaze by emphasizing a determination in the condemnation of the damned that, in fact, cannot be seen in the almost suffering face of Christ, who is not seated but rather suspended in the fury of his gesture (it was this lack of majesty that provoked the criticisms voiced by Sernini). That central point was Michelangelo's ability to show the full range of the 'affections', feelings, and emotions conveyed without resorting to any symbolism, but only through the body. This ability to express all the nuances of feeling through the poses of the body is at the heart of Michelangelo's artistic language and is achieved with such virtuosity that it verges on exaggeration but never crosses that border, leaving the observer stunned and overshadowing the very meaning of the painting.

The meaning that Michelangelo revealed was the peerless skill with which he represented the body, the hallmark of his painting since that

cartoon of *The Battle of Cascina*, in which he conveyed the surprise and dismay of the impending battle only through poses of the bodies.

The artist had also prepared a theological legitimation for this obsession with the body. Accused of wanting to show off the nude too brazenly in sacred places, he replied that the nude is the surest image of the glory of God that can be seen in the world.

> To imitate each of these things perfectly is merely the wish to imitate the art of God Everlasting, therefore the noblest and most courageous painting will imitate the most beautiful beings, created with the greatest knowledge and delicacy. What judgement is so barbarous as to not understand that the foot of a man is nobler than his boot? His skin nobler than that of the sheep with which he is clothed? And does not find in this the merit and greatness of each thing?[23]

But beyond this rather weak theological legitimization, his interest was exclusively focused on his own creative research. Michelangelo's coherence with his own research, his ability to alter a representation, even when its symbolic value and the setting in which it was placed demanded respect for a very rigid structure, is the most interesting feature of his *Last Judgement*, particularly in the context of the argument I have developed throughout this book. Here Michelangelo achieved such a degree of iconographical freedom that he moulded the representation to his creative urges. The fact that his creative needs overrode the need to respect the codes and expectations of his patrons can be seen first of all by taking a closer look at the artist's production of those years, by juxtaposing the structure of *The Last Judgement* with that of a series of compositions that the artist had tackled; albeit completely different in nature and motivation, they are structurally very close to the new Sistine painting. We could even say that, for the artist, form was decidedly more important than content. This axiom is generally used to evaluate contemporary art and, although it was unthinkable in the context of Renaissance art, it lends itself perfectly to explaining Buonarroti's creative processes in the composition of the *The Last Judgement*.

<center>45</center>

THE DRAWINGS FOR TOMMASO
A MODEL FOR *THE LAST JUDGEMENT*

From the moment he met Tommaso Cavalieri, Michelangelo used drawing to seduce the young Roman nobleman, who was sensitive to art. He offered him a series of compositions that immediately enchanted the young man with their extraordinary beauty and conveyed the message of the old artist's yearning love.

The most famous composition in this series, described by critics as 'presentation drawings', is the *Fall of Phaeton* (plate 46). Three versions are known, all of which can be dated to the eve of the composition of *The Last Judgement*. They are respectively in the Gallerie dell'Accademia in Venice (charcoal, 394 × 255 mm, inv. 1771), in Windsor Castle (charcoal, 413 × 234 mm, inv. RL12766r) and in the British Museum (charcoal, 313 × 217 mm, inv. 1895-9-15-5171). Their meaning is one of complacent self-harm: the old artist, who defied custom by declaring his love for the young Thomas, compares himself to Phaeton, who defied Jupiter's laws by driving the chariot of the sun and therefore deserved his severe punishment. Jupiter is shown above, hurling his lightning bolt at Phaeton's chariot, which plummets to the ground, horses and all. Here too, the expressive key to the scene lies in Jupiter's powerful gesture, which causes the chariot to fall as a result of the astonishing loss of gravity of the horses. As has already been noted by critics, Jupiter is almost exactly in the same position as Christ in *The*

Last Judgement; and the closeness of the two compositions is definitively proven by a number of sketches on the verso of the Venetian sheet that can be traced back to the Sistine painting.[24] The other two versions of the composition, in Windsor and in London, repeat the motif of the Venetian composition with variations in the fall of the horses but an almost identical repetition of the gesture of Jupiter shooting the bolt. Even though the dating is not precise and the sequencing of the drawings is not unanimously accepted, it is of utmost importance that in this composition, produced between 1533 and 1535, Michelangelo defined a motif that obsessed him, or at least interested him to the point of making him return to it with force in the structure of the *Judgement*. The motif is in the figure of the God who, with his gesture, causes the whirlwind that in one instance leads to the fall of Phaeton's chariot and in the other sets in motion the angelic hosts and the resurrection and fall of souls. The theme is the energy communicated by the movement of the powerful body to the world around it. It is the quintessence of the expressive capacity of human anatomy, which in this powerful explosion of energy testifies to its divine origin. The breaking of the rigid horizontal schema of the ranks that had appeared in earlier *Last Judgement* paintings originates in this visual obsession; and, although we will never know its precise source, it is entirely coherent with Michelangelo's expressive gestural and anatomical research, begun forty years earlier with the cartoon of the *Battle of Cascina*. The fact that, around the mid-1530s, he became obsessed with the gesture that provoked the motion of the air has no possible explanation; we cannot guess its cause any more than the reasons that had led him twenty years earlier to the calm brushing of the fingertips of God the Father and of Adam, and to his construction of the miracle of the Creation. While it is possible to identify the driving force of expressive language, which remained constant over time, there is no explanation for the force of imagination that inspired the perfect gesture we see in Adam's *Creation* and then in Christ's *Judgement*.

Once the generative centre of the story was fixed, all the other details of *The Last Judgement* – the bodies that show every possible human emotion, fear, terror, hope, and even the miraculous transformation of the resurrecting flesh, or the fierce greed of the devils, which literally recall Dante's passage, as Vasari does not fail to point out – were executed.

What makes the composition even more astonishing is the different scale of the figures represented, which broke the pattern followed by Renaissance painters almost for a century.

The figure of Christ, although far away from viewers, is larger than the figures situated in closer proximity to them. This breaks an infallible canon, the coherence of perspective, which had guided artists for almost a century. This variation in scale, which could easily have produced grotesque results, is perfectly calibrated in that the larger dimensions of Christ are not taken to the point of looking unnatural. Michelangelo replaces the orderly structure of parallel bands with a dynamic structure of turbulent movement. The parallels between the movement of the figures and the movement of history expressed the artist's restlessness and would also have been felt by contemporaries. For many, the effect was unbearable. The criticism directed at the nudes was symptomatic of people's discomfort with the painting. The fact that the Theatines, the most conservative and orthodox faction of the church, immediately embarked on a relentless battle against the artist and his painting and that this battle came very close to destroying the masterpiece gives a measure of the profound repulsion that Michelangelo's great fresco provoked in certain sectors of Italian society. There was nothing reassuring in the painting of *The Last Judgement*, nor was it even clear where to turn for salvation because not even the blessed express any tranquillity there.

The concentric structure – the dynamic vortex of the plasticity of massed bodies surrounding Christ – eliminates the previous narrative, structured as it was by rank and disposed in bands. The centre of the narrative, which is no longer a static representation but an overwhelming event that takes place before our eyes, is Christ the Judge, shown in a pose that is anything but regal and proclaims his emotional participation in the action he is generating. Christ raises his right arm as if to stir the air and rises from his seated position as the drape slides over his legs. He is the centre to which our eye continually returns after exploring the various actions around him depicted on the wall, which has become a blue sky crossed by a dynamic current; and this current is in turn emphasized by the poses of hundreds of figures. Such a dynamic mise en scène forces us to look for the peripheral actions around the central event, since they animate the story as never before. The large

female figure to the left of Christ is the church, stripping itself of all its wealth on the last day; the saints displaying the emblems of their martyrdom seem to cry out their conviction with a pathos verging on violence. Violence also seems to agitate the group of angels who display the symbols of Christ's Passion high up in the lunettes, a display that looks more like a battle than like a regal ostentation, as it had been treated until then. This passage in particular serves to measure the transformations that Michelangelo brought to the story. The angels, who in the other *Judgements* displayed the symbols of the Passion statically, are here unleashed in a physical battle, like Titans in flight. They are the Ignudi of the vault, who have descended to the wall with the same divine beauty, to compete for the symbols of Christ's Passion, which they exalt with their physical passion. The pillar to which he was tied, the cross to which he was nailed, and the crown of thorns that was placed on his head, the lance that pierced him, and the sponge that burnt his wounds are carried in flight and exhibited with such realism that we feel the tangible effort of the angels to lift and keep airborne that pillar that would otherwise plummet to the ground.

The static exhibition is transformed into an event, into a dynamic story; and in the lower part, where the devils battle with the angels for the souls of the damned, that story becomes an epic tale, with the timely reference to Charon's boat ferrying the dead, as Dante had described. The poet was admired and almost venerated by the painter, who becomes miraculously humble, as he had never been, to the point of literally illustrating the verses of his great fellow countryman:

> The devil, Charon, with eyes of glowing coals,
> summons them all together with a signal,
> and with an oar he strikes the laggard sinner.[25]

There are, starting with Signorelli's suggestions in the Chapel of San Brizio in Orvieto, thousands of fantastic details on the devils' bodies that turned them into fascinating creatures, and despite their monstrosity they lost none of the powerful muscular beauty that alone could express Michelangelo's emotions. Even the figure of Minos, who allegedly represents Biagio da Cesena, the Vatican's master of ceremonies, has a regal majesty.

The violent passion that animates the story is the first to strike the viewer; and it was this feature that struck contemporaries. Christ appears in the resplendent form of an Apollo, as he appeared in the Byzantine mosaics of Ravenna, on which Michelangelo drew in his search for an original spirituality. To those who criticized the depiction of Christ without a beard and therefore without majesty, Michelangelo responded with a beauty that is a divine manifestation and with a power that is human power taken to the extreme.

If in the upper part of the painting the angels engage in violent battle with the symbols of his passion, the feeling of battle – or at least of terrified astonishment at what is happening – spreads to the people of God, to the saints, whom we recognize by the emblems that some of them carry in their hands, to the patriarchs, and to the virgins, who no longer look motionlessly at the spectator but look in fear at Christ the Judge, as if they, too, await his verdict. Christ is painted on a larger scale together with the figures that flank him – Adam, Saint Lawrence, and Saint Bartholomew, who carries a skin with the likeness of Michelangelo in his hand. Then, immediately below this immense vortex of the saints and the elect, another battle is taking place between the damned and the blessed. It as if their destiny depended not on the judgement written in the great book held open by two angels under Christ's feet, but on the outcome of the struggle in progress, because even on the last day it seems that mankind must fight for salvation.

The angels, hanging in the air in poses that make their physical presence concrete, strive to lift the bodies of the chosen ones, who are rising from the earth, thereby giving tangible evidence of that 'resurrection of the flesh' announced by the gospels. There are bodies at every stage of resurrection, from skeletons to pure shadows to miraculously rediscovered anatomies.

The saved rise from the green earth on Christ's right, while on his left the fighting angels, with visible physical effort, shove the damned towards hell, where the devils seize them and drag them into the fiery cavern, to make them suffer eternal punishment.

Salvation and eternal perdition become a living drama that captures and engages the viewer and transforms the scene into a narrative, abandoning the static rigour of celebration forever. With astonishing intuition, Michelangelo gives consistency to flight and to this suspen-

sion in the air, while preserving the heaviness of the bodies' gestures. For the first time, humans who have defeated gravity but not physicality are shown in flight. That moralistic anecdotal approach already present in previous Italian and Flemish paintings of the Last Judgement is reduced to mere citation, because it holds no interest for the artist. Among the individuals pushed by scornful angels towards hell, almost with their fists, we find a pope who is immediately seized by greedy devils and, falling, shows the golden purse with which he desecrated Saint Peter's throne, symbolized by the two keys hanging next to the bag. It was a brazen warning against that carnal greed – a warning that was almost unthinkable here, at the heart of the Vatican, and echoed the accusations of the Protestant Reformation against Rome and one of its most blatant incarnations: the reigning pope, Paul III Farnese. But this same pope was also aware that the force of Michelangelo's message could in no way be diminished.

46

THE POWER OF COLOUR

The figure painting adopted by Michelangelo, which rejects all organ-
izing elements such as architectural frames, was a manifestation of his
desire to make a clean break even at the cost of disrupting the spatial
and architectural order of the entire chapel, as a great scholar has per-
spicaciously noted.

This particular conception of the *Judgement*, painted by Michelangelo
as an event that unfolds directly and dramatically before the specta-
tor's eyes, transforming an essentially timeless image projected onto
eternity into 'history' and into an image 'in action', could be translated
formally only into a dynamic structure that is focused entirely on the
'eloquence' of the bodies and on their peremptory gestures in certain
key points, as in the figure of Christ the Judge (but also, for example, in
that of Saint Peter or Charon). Above all, it relies on the infinite variety
of poses, their connections and oppositions, on the contrasts between
movements on the surface and those in the depths, on the impression
of an immediate thickening and thinning, as in a sky crossed by stormy
clouds, on the groups of the saved, who gather around Christ and
the Virgin, on the wingless angels struggling to lift the instruments
of passion, as if resisting the pull of a whirling force that threatens
to overwhelm them, and again on the bodies that break free, heavily,

from clods and the bodies that ascend, carried by air, into the void, or that struggle wildly or fall towards the chasm of fire. And their nudity, which can certainly be read as a symbol of the redemption of the body on the glorious day of the resurrection of the flesh, must have appeared to the artist as an irreplaceable instrument for the formal organization and expressive enhancement of the image.[26]

The new visual order created by Michelangelo is based on a refined perspective of the foreshortening of the body in space, and above all on an accentuated technique of chromatic perspective that we could even label 'photographic', in the sense that his brushes define the figures in the foreground as perfectly in focus, while blurring those in the background in an increasingly radical way. This painterly skill, which relied on an extraordinary visual sensitivity, was needed to introduce order into a narrative, into a representation that had rejected any other form of organization designed to make it intelligible.

A very clear example of this 'chromatic perspective' is in the middle register around the figure of Christ, where the compact glazed surfaces radiate light and cast shadows, as in a marble relief that has acquired living colour. Next to Christ, the figure of Peter holding the keys has the same luminous density and compact and crystalline chromatic saturation as the figures on the ceiling. This chromatic, light-filled density identifies the advanced plane of these figures, as well as accentuating their narrative value. But just behind the saint, the figures begin to fade away, rapidly losing consistency. Adam, with his long beard, is already less defined, and the two faces behind him are barely sketched through a chromatic texture that becomes evanescent, just a touch of light and shadow in the farther one, to give a perceptible depth to the space around the figures, making it congruous and realistic. In this way Michelangelo creates a three-dimensional order solely by using a different density of colour on the brush.

Another sensational piece of this powerful painting technique can be found in the lower part of the painting, in a scene in which, in a sort of animated sequence, four figures are shown resurrecting, taking shape in their own flesh. The man who wakes up, lying on the crest of the hill, is already in possession of his own flesh, although he is not defined with the clarity of the figures in the foreground. Behind him is a skeleton

covered in a shroud that slips over the skull and ribs, clearly showing the bones that wait to be filled in; here the chromatic and chiaroscuro contrast is very subdued. In the far distance, a silhouette raises its arms to the sky, while in the far space against the clear sky a transparent stain, painted with rapid strokes of umber, suggests, as in a photographic background, the features of a human figure, yet without defining its fleshy consistency. All this depth is accomplished only through the gradation of colour and the rapidity of brushstrokes, as is correctly explained by Gianluigi Colalucci, a restorer who worked for twenty years, first on the ceiling and then on *The Last Judgement*:

> The brushstrokes are freer, less tied to the fifteenth-century canon, whose hallmark was an almost mathematical order and crystalline purity of tone. In *The Last Judgement*, the liquid, transparent colours, fluid brushstrokes and glazes disappear almost completely, and in their place appear areas of coloured *impasto* and broad, fast, scratching and apparently disconnected brushstrokes.[27]

Of course, it was not Michelangelo who first used this impressionistic technique; he had already turned to it in the last part of the painting on the vault (the angels who hold up God the Father in the scene of the *Creation of Adam*), and Raphael had given it an extraordinary interpretation, in the Sibyls he painted around 1514 in the Church of Santa Maria della Pace in Rome, by blurring the angel behind the Old Sibyl in order to give credibility and distance to the space that separates the two figures. In this painting Raphael, too, had used a full-bodied brushstroke that incorporated different pigments in the colour. But Michelangelo carried it to an extreme, by using a free gestural expressiveness that anticipated a certain style of painting in later centuries – as in the figures depicted inside the cavern of hell, barely tinged in transparency by the glow of the fire, to create a striking visual impact. What is surprising about this small technical revolution is the fact that the artist completed it at the age of sixty, a very advanced age by sixteenth-century standards and a marker of his extraordinary creative vitality. Ever since the *Doni Tondo*, Michelangelo's painting had been 'constructed' with subtle, precise brushstrokes, almost mechanical in their regularity, reminiscent of the stepped texture of the surfaces of

his sculptures. Such rigorous, clear, confident brushstrokes are still to be found in *The Last Judgement* (and, again, in the Pauline Chapel), but here they serve only to give depth to the anatomical reliefs by combining dark strokes with very light ones, in a sort of graphic correction to the use of rapidly mixed paint with broad, full-bodied brushstrokes. Just as, in his sculpture of the same period, the old artist showed an astonishing ability to chisel the marble with such even marks, impossible for a young sculptor to achieve, so in *The Last Judgement*, the ability to define the image by combining clear, regular brushstrokes, almost like coloured pencil marks, with impasto surfaces applied with very broad brushes, almost as if applying whitewash, is surprising.

The development of his painting technique served in a functional way, to reinstate that order erased from the wall with the disappearance of any architectural partitioning. Even the plasterwork changed slightly in composition. For the ceiling, he had used plaster made from just lime and pozzolana, but on the wall of *The Last Judgement* we find these same compressed plasters, resembling marble, over which there is often a layer of white lime designed to give added brightness to the transparency of the painting. The iconographical revolution progressed on a par with the technological revolution and the freedom of gesture.

The effect is surprising and can still be appreciated today. Although it lacks architectural order and spatial references, the immense crowd of *The Last Judgement* tells a story with exemplary precision and the eye is continually drawn back to that centre, which would become suspect in the years that followed. Michelangelo's Christ is exalted by the yellow light applied through a dry technique – an extremely rare transgression of the technical rigour he observed throughout the four hundred and fifty days it took him to paint the entire surface, some two hundred square metres. The iconographical risk was, as always, supported by the technical risk, and although the break in the visual unity of the chapel is immediately apparent to visitors as they enter it, the magnetic attraction exerted by that crowd of giants remains the most exciting experience that a work of art can offer humanity.

EPILOGUE
A New World

By using the procedure illustrated earlier, which was prompted by the special need to 'translate' colour into silk tapestry threads, Raphael was able to experiment freely with new forms of creative collaboration that would radically change the workshop system and increase the intervention of assistants, even in oil paintings, to a point where identifying the master's hand will become decidedly problematic in many cases. An example of this type of composition is *The Holy Family of François I*, now in the Louvre, where the work of Raphael's pupils is almost predominant. Proof of the effectiveness of this creative process, which gave responsibility to the assistants, can be seen in the exceptional careers they will have after Raphael's death. Giulio Romano will be a painter of major importance and will be to Mantua what Raphael had been to Rome; Giovan Francesco Penni, on the other hand, will successfully produce Madonnas and sacred images of the highest quality from his own studio.

The creation of the tapestries also opened a new chapter in European art, that of the production of 'multiples', artefacts made in different copies from a single model invented by an exceptionally talented artist. The cartoons, paid for with one hundred scudi, remained in the Flemish workshops for at least a century and continued to be used by weavers in new series that were to end up in princely collections all across Europe,

as well as in some cathedrals, such as the one in Toulouse.¹ At the same
time, the cartoon generated copies that were as 'original' as the first
series produced for Pope Leo X, in that they never betrayed the process
of execution for which they were conceived. Only the borders were
changed through the insertion of the owners' coats of arms, or other
ornamental motifs dear to the patron. For the rest, Raphael's *Acts of the
Apostles* were faithfully reproduced in the same precious materials that
had been used for the Sistine Chapel, and they secured for the master a
secular fame that no other Renaissance artist has experienced between
the sixteenth and nineteenth century.

This commission can be said to have definitively concluded the tran-
sition of the painter's trade to being a primarily intellectual activity,
whose value lay in conception and less and less in execution, and which
brought painting closer to architecture. The extreme consequences of
this state of affairs would be drawn two centuries later by Canova, who
applied to sculpture – an art closely linked to physical effort and manual
skill – the same principles as Raphael, by limiting himself to creating
the model and leaving to others the material execution of the work. But
by that time the workplace of the great fifteenth-century craftsmen was
only a distant memory, obscured by Raphael himself, who was regarded
as marking the true beginning of modern painting.

What is extraordinary and needs to be emphasized is that this pro-
cess took place over a short period of time, without any break, and for
the most part in one of the foremost sites of European culture, namely
in the Sistine Chapel, a place that acquired this status and still retains it
today, perhaps precisely as a result of this process.

When Sixtus IV embarked on his project to decorate the renovated
Cappella Magna, he probably did not foresee any of this. His aim was
to reaffirm the centrality of Rome and of the papacy at a time of very
serious crisis, when that centrality was called into question both mili-
tarily and culturally. Was it perhaps the ensuing competition among
the artists that produced such an extraordinary result? It is not possible
to draw clear-cut conclusions in this respect, not least because Julius II's
intervention already had universalist ambitions. But, without doubt, the
fact that Michelangelo was called upon to continue the decoration con-
tributed to the stratification of increasingly complex outcomes within
those solid walls, which evoked the ancient Temple of Solomon.

Michelangelo's intervention played an enormous part in deciding the future of this place since, as we have seen, the artist wanted the commission at all costs: he had sensed that this would be the ideal site for him to show the world his revolution in art. The same is true of Raphael's intervention, which added further creative value to the Sistine Chapel by defining it as a place of direct confrontation within the most advanced formal research of the Renaissance. We could say, without fear of being contradicted, that here, in the Sistine Chapel, there was a much fuller demonstration of that synthesis and 'comparison' promised in the Palazzo Vecchio in Florence in 1504, when the two large frescoes of the *Battle of Anghiari* and the *Battle of Cascina* were entrusted to Leonardo da Vinci and Michelangelo respectively.

The final consecration of the chapel as the ultimate place of art and spirit (a resounding coincidence that undoubtedly owed much to the sensibility of the popes, the first ones to choose to manifest Catholic spirituality through art) occurred in 1534, when the execution of *The Last Judgement* was assigned to Michelangelo, a commission that continued the long process begun in 1480. Once again, there was a pope (first Clement VII, then Paul III) who wanted to mark his own pontificate – in Clement's case, almost as an expiation for the crisis of the Sack of Rome; and, once again, Clement's background convinced him that the only way to do so was to call upon the greatest artist of the time. The competition stimulated Michelangelo to achieve extraordinary results, developed in perfect continuity with his own expressive language.

From that moment on, even though a part of Christianity, embracing the Lutheran Reformation, rebelled against that identification, so Italian, and hence degenerate, of spirituality with visual art, the Sistine Chapel became the centre of the powerful Catholic propaganda machine. It has survived for five hundred years and enhanced its own emotional value, despite all the changes that have occurred in the history of Europe, then of the world, then of the planet.

Today the Sistine Chapel has asserted its presence in the new media and, although these rely on technologies that were inconceivable at the time of its creation, they nonetheless pay tribute to the immense and primordial force of the talent of the Renaissance artists whose technology was nothing but brushes and coloured powders, accompanied of course by their brilliant minds. It is not only at conclaves that we see

powerful images played on screens all over the world. Also in television series and films, which have enjoyed global success (*The Young Pope* is only the most famous title), the Sistine Chapel is used to symbolize Roman Catholicism and the torments that the church faces in the current phase of its history, even though these are quite different from the troubles faced by Sixtus IV, Julius II, Leo X, Clement VII, and Paul III.

These same media simply amplify the emotional power of the building, almost as if, in the intervening five hundred years, nothing new has been built that is capable of standing up to it. In my opinion, this is because that unique place brought together ambitions that were excessive and heroic in the same measure, those of the popes and those of the artists who fought for their own reputation and for the affirmation of a new social standing. Such a conjunction has never occurred in western history again, and it is for this reason that the Sistine Chapel continues to thrive as the dual centre of secular and religious spirituality, attracting millions of visitors of different religions from all over the world.

Notes

The English translations of Italian primary sources not cited from published English editions are by Lucinda Byatt.

Note to Prologue: Turks in the Port

1 On the siege of Otranto, see V. Bianchi, *Otranto 1480: Il sultano, la strage, la conquista*, Bari: Laterza, 2016. The book offers a balanced and unbiased retelling of the events of those years. On the universal claims of Mehmed II advanced after the conquest of Constantinople, see G. Ricci, *Appello al Turco: I confini infranti del Rinascimento*, Rome: Viella, 2011.

Notes to Part I: Affirming Papal Primacy

1 On the history of rebuilding the Sistine Chapel, see F. Buranelli and A. Duston, eds, *The Fifteenth Century Frescoes in the Sistine Chapel*, Vatican City: Edizioni Musei Vaticani, 2003, with two chapters: P. N. Pagliara, 'The Sistine Chapel: Its Medieval Precedents and Reconstruction', pp. 77–86, and A. Nesselrath, 'The Painters of Lorenzo the Magnificent in the Chapel of Pope Sixtus IV in Rome', pp. 39–75. For the complex ceremonial function of the chapel, see the fundamental study by E. Steinmann, *Die Sixtinische Kapelle*, vol. 1, Munich: Bruckmann, 1901 and that by J. Shearman, 'La storia della Cappella Sistina', in *Michelangelo e la Sistina: La tecnica, il restauro e il mito*, ed. by G. Morello and F. Mancinelli, Rome: Palombi, 1990, pp. 19–28.

NOTES TO PAGES 11–49

2 *Nicolaus P. III fieri fecit palatia et aulam maiorem et cappellam et alias domus antiquas amplificavit pontificates sui anno primo*; Steinmann, *Die Sixtinische Kapelle*, vol. 1, p. 13.

3 Pagliara, 'The Sistine Chapel', p. 77.

4 On the fresco, see the essential documentary study by J. Ruysschaert, 'Sixte IV fondateur de la Bibliothèque Vaticane et la fresque restaurée de Melozzo da Forlì (1471–1481)', in *Sisto IV e Giulio II mecenati e promotori di cultura: Atti del convegno internazionale di studi. Savona 1985*, ed. by S. Bottaro, A. Dagnino, and G. Rotondi Terminiello, Savona: Soprintendenza per i beni artistici e storici della Liguria, 1989, pp. 27–44.

5 The contracts are in Nesselrath, 'The Painters of Lorenzo the Magnificent', pp. 69–70.

6 The drawing is in the Gabinetto dei Disegni e Stampe degli Uffizi in Florence. Many scholars have questioned Pier Matteo d'Amelia's part in the decoration of the ceiling but, as Shearman, 'La storia della Cappella Sistina' (p. 26) has stressed, there can be no doubt about his role because documents exist to prove it. Moreover, it is frankly hard to see how anyone could claim that a vault in such an important chapel was left for thirty years, simply covered in coarse plaster, while the walls below were covered with the richest decorations and filled with gold leaf and lapis lazuli.

7 The document is in G. E. Creighton, *Italian Art, 1400–1500: Sources and Documents*, Evanston, IL: Northwestern University Press, 1992, p. 217. On the documentary sources that offer evidence regarding the actual methods used in Italian art during the century, see also D. S. Chambers, *Patrons and Artists in the Italian Renaissance*, Columbia, SC: University of South Carolina Press, 1971, and R. Klein and H. Zerner, *Italian Art, 1500–1600: Sources and Documents*, Englewood Cliffs, NJ: Prentice Hall, 1966.

8 I refer here to my direct experience of the restoration of the Scrovegni Chapel between 2001 and 2002 and of the frescoes in the choir of Sant'Andrea della Valle, Rome. In both cases, the work was undertaken by several 'workshops' that acted as a consortium, a procedure identical to the one used in the Sistine Chapel in 1480.

9 Giorgio Vasari, *Lives of the Most Eminent Painters, Sculptors, and Architects*, vol. 3, trans. by Gaston du C. De Vere, London: Macmillan, 1912–14, pp. 188–9.

10 See M. Cavina, *Maometto papa e imperatore*, Bari: Laterza, 2018, p. 105.

11 T. Verdon, *La Cappella Sistina: Cuore e simbolo della chiesa*, vol. 2, Vatican City: Edizioni Musei Vaticani, 2017, p. 5.

12 Ibid., p. 7.

13 Leonardo, *Trattato della pittura*, ed. by E. Camesasca, Milan: Tea, 1995, p. 102: 'That no reflected colour is single but rather mixed with the species of other colours. No colour reflected on the surface of another body colours its surface with its own colour, but it will be mixed together with the other reflected colours that are evident in the same place.'

14 Letter from Leonardo and Ambrogio de Predis to Ludovico il Moro in 1491, in E. Villata, *Leonardo da Vinci: I documenti e le testimonianze contemporanee*, Milan: Ente Raccolta Vinciana, 1999, p. 72. On these events, see also A. Forcellino, *Leonardo: A Restless Genius*, trans. by Lucinda Byatt, Cambridge: Polity, 2018, pp. 114–15.

Notes to Intermezzo: Leonardo's Impossible Project

1 In E. Villata, *Leonardo da Vinci: I documenti e le testimonianze contemporanee*, Milan: Ente Raccolta Vinciana, 1999, p. 17.

2 Ibid., p. 44.

3 '*Antiquarie Prospettiche Romane composte per prospettivo Melanese Depictore*, 1496–1498 ca.', in Villata, *Leonardo da Vinci*, p. 96: 'Non fer le antiqui mai si gran scultura, / né ymaginosse come 'l so medello / che devorasse il cel, i'n'ho paura / per thema l'ayer scura / Tenendo il Vince ch'habbia immortal alma / perché de Iove tien la invita palma. / Victoria vince, et Vinci tu victore / vinci colle parole un proprio Cato / e col disegno di sculpir si grato che honor ti porti col ferro pictore.'

4 The episode is described in K. Frey, *Il Codice Magliabechiano, cl. XVII. 17. contenente notizie sopra l'arte degli antichi e quella de' fiorentini da Cimabue a Michelagnolo Buonarroti, scritte da Anonimo Fiorentino*, Berlin: Grote, 1892, p. 115.

Notes to Part II: The Giant Climbs Skywards

1 News of the damage caused in the chapel by the crack in spring 1504 is given in the diaries of the two papal masters of ceremonies, Johann Burchard and Paris de Grassis: *quia capella palatii reparabatur per cathenas super voltum superiorem et in voltis inferioribus propter eius rupturam per medium* ('because the palace chapel was being repaired with chains above the higher vault and in the lower vaults, on account of its split down the middle'; J. Burchard, *Liber notarum*, ed. by Enrico Celani, in L. A. Muratori, *Rerum italicarum scriptores: raccolta degli storici italiani dal*

cinquecento al millecinquecento, vol. 32, pt. 1.2, Cittè di Castello, Perugia: S. Lapi, 1911, p. 451); *quum ipsa cappella ruinosa erat et tota conquassata, ita ut ibi stare non posset papa* ('because the chapel itself was dilapidated, and so completely broken that the pope could not stay inside it'; Steinmann, *Die Sixtinische Kapelle*, vol. 1, Munich: Bruckmann, 1901, p. 134, n. 4).

2 On the first projects for the Sistine ceiling, see the chapter by C. L. Frommel, 'Michelangelo e il sistema architettonico della volta della Cappella Sistina', in *Michelangelo: La Cappella Sistina: documentazione e interpretazioni: Atti del convegno internazionale di studi, Roma, marzo 1990*, vol. 3, ed. K. Weil Garris Brandt, Novara: De Agostini, 1994, p. 135.

3 The passage is cited from I. Cloulas, *Giulio II*, Rome: Salerno editrice, 1993, p. 152.

4 A. Condivi, *The Life of Michelangelo*, trans. by Alice Sedgwick Wohl, ed. by Hellmut Wohl, 2nd edn, University Park: Pennsylvania State University Press, 1976, pp. 99–101.

5 Giorgio Vasari, *The Lives of the Artists*, trans. by Julia Conaway Bondanella and Peter Bondanella, Oxford: Oxford University Press, 1991, pp. 439–40.

6 On the question of the scaffolding, see A. Forcellino, 'Sul ponteggio michelangiolesco per la decorazione della volta sistina', in *Michelangelo: La Cappella Sistina: documentazione e interpretazioni: Atti del convegno internazionale di studi, Roma, marzo 1990*, vol. 3, ed. K. Weil Garris Brandt, Novara: De Agostini, 1994, p. 57.

7 Condivi, *The Life of Michelangelo*, p. 39.

8 Letter from Pietro Rosselli, from Rome, to Michelangelo in Florence, in *Il Carteggio di Michelangelo* (posthumous edition by G. Poggi), 5 vols, Florence: Sansoni, 1965–1983, vol. 1 (1965), ed. by P. Barocchi and R. Ristori (hereafter *Carteggio 1*), p. 16.

9 Quoted from A. Forcellino, *Michelangelo: A Tormented Life*, trans. by Allan Cameron, Cambridge: Polity, 2009, p. 85 (which gives more context for this document, together with an extensive commentary).

10 This sonnet, with its strong homoerotic overtones, almost a solitary release of these urges, appeared in a letter of 24 December 1507 and can therefore be dated to around that period: 'How a pleasant garland enjoys / being worn on golden hair, its flowers, well woven, / each before the other leans / as if to be the first to kiss that head; / and all day long that dress / delights in tightly enveloping the breast, then widening out; / and that net of spun gold rests / lightly on the cheeks and neck; / but more

pleasantly still that ribbon, tipped with gold / seems to enjoy pressing against such finely formed temples / and clasping the bosom that it entwines. / When the plain knotted belt / says to me / "Here, I will always clasp" / I ask, What would my arms do in its place?' (*Carteggio* 1, p. 59). The sonnet was published by C. Guasti, *Le Rime di Michelangelo Buonarroti pittore scultore e architetto cavate dagli autografi e pubblicate da Cesare Guasti*, Florence: Le Monnier, 1863, p. 178. Guasti arbitrarily placed it among those dedicated to Vittoria Colonna, although it can be dated to 1507, when Colonna was just seven years old. Moreover, in his comments, Guasti alleged the presence of sexual orientation by forcing a reference to a woman who is completely absent from the sonnet: 'How pleased the joyful garland of carefully woven flowers worn by a woman with hair as fair as gold.' He evidently intended to censor the text by manipulating it. The reference to a man's clothing is quite clear in the conclusion, which emphasizes the plain belt – an article from the male rather than female wardrobe.

11 *Carteggio* 1, p. 40. Things did not go as Michelangelo predicted in this letter. In the correspondence of the following days and months we can follow the progress of the work, which proved to be extremely difficult, confirming once again that casting was the most arduous undertaking an artist could embark on at the time. Although it is difficult to avoid the temptation of a mythical reading of the feat in Bologna, it is true that Michelangelo managed to overcome considerable difficulties, which would have been insurmountable for most other artists of the time. The fact that he completed the casting is even more surprising if we consider that he had no specific expertise (ten years earlier, a *Hercules* he had sculpted was cast and sent to France). Michelangelo's ability to deal with this crisis with tenacity and competence undoubtedly encouraged the pope to trust him with the ceiling project.

12 Letter of 1 July 1507, in *Carteggio* 1, p. 40.

13 Note dated 1 April 1508, in *I Ricordi di Michelangelo*, ed. by L. Bardeschi Ciulich and P. Barocchi, Florence: Sansoni, 1970, p. 1.

14 Michelangelo, from Rome, to Friar Jacopo di Francesco in Florence, 13 May 1508, in *Carteggio* 1, p. 66.

15 'I remember that today, the 10th May 1508, I Michelangelo, sculptor, have received from the Holiness Our Lord Pope Julius II five hundred cameral ducats, which were paid by Messer Carlo degli Albizzi for the painting of the ceiling of the chapel of Pope Sixtus, on which I have started work today subject to the conditions and agreements set down

in a document written by the Most Reverend Cardinal of Pavia and signed in my hand' (*I Ricordi*, p. 1). We learn from this note that an agreement had been signed between the pope and Michelangelo that unfortunately has not survived, yet the note does not allow us to form an idea of what exactly Michelangelo was contracted for at that date. Nonetheless, the form and timing of this agreement appear to be very different from those of the earlier agreements with the Sistine painters. It is also worth noting that, in the agreements for the fifteenth-century cycle, the contract was signed by the superintendent of the works for the apostolic palace, the architect Giovannino de' Dolci, but in this case it was a cardinal who was responsible for drawing up the agreement between the pope and his painter. Finally, one should point out that the sum paid as an advance to Michelangelo, 500 gold ducats, was perhaps the highest ever paid to a painter for a decorative work.

16 *Carteggio* 1, p. 68.

17 The letter mentioning the request of a salary equal to that paid to Pier Matteo d'Amelia is in *Carteggio* 1, p. 73.

18 Shearman, 'La storia della Cappella Sistina', p. 28, n. 31.

19 Michelangelo, from Rome, to his father Ludovico in Florence, on 27 January 1509, in *Carteggio* 1, p. 88.

20 Michelangelo, from Rome, to his father Ludovico in Florence, 30 April 1509, in *Carteggio* 1, p. 91.

21 On the reasons for believing that this scene was the starting point for the decoration of the ceiling, see *Michelangelo: La Cappella Sistina: documentazione e interpretazioni: Atti del convegno internazionale di studi, Roma, marzo 1990*, vol. 2: *Rapporto sul restauro degli affreschi della Volta*, ed. F. Mancinelli, Novara: De Agostini, 1994, p. 235.

22 Michelangelo, from Rome, to his father Ludovico in Florence, 7 September 1510; *Carteggio* 1, p. 108. The letter is interesting for several reasons. It mentions 500 ducats for work done, in addition to the sum received in advance. These 1,000 ducats, together with the 2,000 ducats that Michelangelo received in February 1513 (*I Ricordi*, p. 3), amounted to 3,000 ducats, a figure that gives a credible idea of the value of the contract. At the same time, to dismantle the old scaffolding and rebuild the new one, Michelangelo asked for a further 500 ducats; but from the payments made to Rosselli it appears that the first scaffolding had cost 95 ducats, and presumably the second one would have cost the same amount, taking into account the depreciation of the timber and the ropes. So Michelangelo managed to make an extraordinary profit

from this contract. A precise reckoning of the work on the vault is not possible, because Michelangelo himself would later declare that much of the money paid by Julius II was intended for the tomb, even though those figures appear in separate accounts. In any case, on the basis of the figures at our disposal, a realistic estimate of the value of the decoration of the ceiling amounts to at least 3,500 ducats. The estimate allows us to compare this figure with the undertaking of the fifteenth-century painters, who were paid 250 ducats each for a much larger decorative cycle (fourteen panels); moreover, of that earlier sum, at least 20 per cent was spent on gold leaf and lapis lazuli, which Michelangelo did not use for the ceiling.

23 Giovanni Michi, from Rome, to Michelangelo in Florence, 27 October 1510, in *Carteggio* 1, p. 110: 'Here your orders are being carried out and Gismondo and Bernardino are busy portraying, and I believe they do you honour and a favour.' Michelangelo's two assistants were busy 'portraying', or rather enlarging the drawings left by Michelangelo and turning them into preparatory cartoons for the fresco. This is a sign that it was only at this stage that Michelangelo had finalized drawings and sketches for the continuation of the vault.

24 Michelangelo, from Rome, to his brother Giovan Simone in Florence, July 1509, in *Carteggio* 1, p. 72.

25 Guasti, *Le Rime*, p. 159.

26 The episode is cited in Cloulas, *Giulio II*, p. 233.

27 Quoted from Forcellino, *Michelangelo: A Tormented Life*, p. 108. The Italian source comes from E. Steinmann, *Die Sixtinische Kapelle*, vol. 2, Munich: Bruckmann, 1905, p. 729. The visit of Alfonso d'Este, duke of Ferrara, is reported here.

Notes to Intermezzo: The Crucifix of Santo Spirito

1 Vasari, *Lives of the Artists*, pp. 420–1.

2 For a recent discussion of the question of *The Crucifix of Santo Spirito*, see A. Forcellino, 'Maestri e allievi nella competizione rinascimentale', in *Götterhimmel und Künstlerwerkstatt: Perspektiven auf die Kunst der italienischen Renaissance*, ed. by J. Dellith, N. Horsch, and D. Roberts, Leipzig: Leipziger Universitätsverlag, 2019, p. 109. I refer to this study for all the scientific documentation relating to Michelangelo's crucifix for Santo Spirito.

Notes to Part III: The Golden Age

1 On the papacy of Leo X, see P. Giovio, *Le vite di Leon decimo et d'Adriano VI sommi pontefici, et del cardinal Pompeo Colonna, scritte per mons. Paolo Giovio vescovo di Nocera, e tradotte da m. Lodovico Domenichi*, Florence: Lorenzo Torrentino, 1551; for the pomp of the papal coronation, see M. Sanudo, *I diarii*, vol. 16, Venice: Stamperia di Visentini Cav. Federico Editore, 1886, p. 158.

2 The most complete and detailed study of the tapestries for the Sistine Chapel is still that of J. Shearman, *Raphael's Cartoons in the Collection of Her Majesty the Queen and the Tapestries for the Sistine Chapel*, London: Phaidon, 1972; see also J. Shearman, 'Gli arazzi di Raffaello nella Cappella Sistina', in *La Cappella Sistina: I primi restauri*, ed. by M. Boroli, Novara: De Agostini, 1986, pp. 88–91. On the question of the cartoons after they were transferred to the tapestries, see J. White, *The Raphael Cartoons*, London: Her Majesty's Stationery Office, 1972.

3 I owe this view to a conversation with my teacher and mentor Christoph Luitpold Frommel during a trip to Lake Bracciano in August 2019.

4 This excerpt from Bembo's letter is, in my opinion, the most lucid and extraordinary literary synthesis of Raphael's gift of recreating a humanized nature in his painting. The same cannot be said of any other portrait painter in the sixteenth century. The letter, dated 19 April 1516, is published in Italian and commented by J. Shearman, *Raphael in Early Modern Sources, 1483–1602*, 2 vols, New Haven, CT: Yale University Press, 2003, vol. 1, pp. 240–1.

5 On the festivities held in the Campidoglio in September 1513 and the strongly classicist climate in the city during the period, see F. Cruciani, *Il teatro del Campidoglio e le feste romane del 1513*, Rome: Il Polifilo, 1968.

6 On the important monument that also inspired Raphael, see P. Zander, 'Il quattrocentesco ciborio per l'altare maggiore della Basilica di San Pietro in Vaticano', in *Il Ciborio degli apostoli*, ed. by P. Zander and A. Gauvain, Città del Vaticano: Edizioni Capitolo Vaticano, 2010, pp. 4–33.

7 From the documents in our possession, it is not clear exactly when Raphael was commissioned to provide the cartoons for the tapestries, but it is more than likely that the date was sometime between 1514 and 1515, because two payments, of 300 and 134 ducats, totalling 434 ducats, are recorded respectively on 15 June 1516 and on 20 December 1516 in Shearman, *Raphael in Early Modern Sources*, vol. 1, p. 271. Another document published by Shearman – the diary of Marcantonio Michiel,

at the date of 27 December 1519, on the occasion of the exhibition of tapestries in the Sistine Chapel – states that Raphael was paid 1,000 ducats for the tapestry cartoons: 'The drawing of the pope's tapestries was made by Raphael of Urbino, an excellent painter; for these he received from the pope 100 ducats for each, and the silk and gold, which are both very abundant, and the workmanship cost of 1,500 ducats for each piece, so that in all, as the pope himself said, each piece cost 1,600 ducats, although they were judged and said to be worth 2,000 ducats' (ibid., p. 491). The document is the most detailed and reliable source on the matter. The cost of 100 ducats per cartoon reflects the very limited amount of work involved by comparison with an actual painting. Considering the prices of painted panels of the period and taking as a comparison the 1,000 ducats paid by the pope to Sebastiano del Piombo for his *Raising of Lazarus* at about the same time, we can surmise that, if the scenes had been painted, they would have cost at least 2,000 ducats each. The talent of the most celebrated artists was equal to the silk, gold, and expensive and laborious workmanship of the Flemish tapestry workshops.

8 The question of the distribution of work within the workshop for the preparation of cartons is addressed in Shearman, *Raphael's Cartoons*, pp. 141 ff., although not in a fully convincing manner. Shearman concentrates on searching for the author of the various drawings through a survey of the cartoons scattered in museums around the world, rather than attempting a meaningful analysis of the distribution of the work inside the creative group. Shearman attributes to Raphael both drawings for *Christ's Charge to Peter*, the one in the Louvre (cat. 512, 257 × 133 mm) and the one in Windsor Castle (RL 12751, 257 × 375 mm); but they cannot both be by Raphael because the Windsor one faithfully reproduces the Louvre one, simply in reverse. To think that, during this phase of study, Raphael could reproduce an identical copy of a figure he had already defined is, in my opinion, untenable from a practical and creative point of view. It is more likely that Raphael drew the drawing now in the Louvre (which is, moreover, stylistically consistent with other drawings by the master), then his pupils (Giovan Francesco Penni?) traced the drawing on another sheet of identical height, cutting it in exactly the same way, in order to develop an overall composition.

9 On this question and on the transition from a life study to an idealized representation, see A. Forcellino, *Raphael: A Passionate Life*, trans. by Lucinda Byatt, Cambridge: Polity, 2012, pp. 36–7.

10 On the emerald carved with an image of Christ that was presented by Bayezid II to Pope Innocent VIII in exchange for the custody of his younger brother Zizim, or Cem as he is also known, see P. Helas, 'Lo "smeraldo" smarrito, ossia il "vero profilo" di Cristo', in *Il Volto di Cristo*, ed. by G. Morello and G. Wolf, Rome: Biblioteca Apostolica Vaticana, 2000, p. 217.

Note to Intermezzo: Two Marriages
1 On these events, see Forcellino, *Raphael: A Passionate Life*, pp. 47–50.

Notes to Part IV: The Last Judgement
1 Letter from Cardinal Salviati to Baldassarre Castiglione in Paris, 8 June 1527, in Ludwig von Pastor, *Storia dei papi*, 20 vols, vol. 4.2: *Adriano VI e Clemente VII*, Rome: Desclée, 1956, p. 725.
2 On Michelangelo's betrayal of the Medici, for whom he was working in the New Sacristy, see G. Spini, *Michelangelo politico e altri studi sul Rinascimento fiorentino*, Milan: Edizioni Unicopli, 1999 (reprint 2017).
3 Extract from a letter from Agnello written in Venice, quoted in von Pastor, *Storia dei papi*, p. 532.
4 Letter from Giovan Battista Mini to Bartolomeo Valori, 29 September 1531, in *Il Carteggio di Michelangelo* (posthumous edition by Giovanni Poggi), 5 vols, Florence: Sansoni, 1965–1983, vol. 3 (1973), ed. by Paola Barocchi (hereafter *Carteggio* 3), p. 329.
5 The history of Julius II's tomb and of its consequences, including social ones, on Michelangelo's image are discussed in A. Forcellino, *Michelangelo Buonarroti: Storia di una passione eretica*, Turin: Einaudi, 2002.
6 Michelangelo, from Rome, to Tommaso Cavalieri in Rome, late December 1532, in *Carteggio* 3, p. 443.
7 [Michelangelo, from Rome, to Tommaso Cavalieri in Rome, 1 January 1533, in Michelangelo, *Carteggio*, vol. IV, 1979, pp. 1–2. The English translation appears in Forcellino, *Michelangelo: A Tormented Life*, p. 188, but no source is given there.]
8 For the background of Paul III's *motu proprio* (papal bull) of 17 November 1536, which takes Michelangelo's part regarding the complex story of Julius II's tomb, see M. Forcellino, document 5, in Forcellino, *Michelangelo Buonarroti*, pp. 233–8 and, more recently, C. L. Frommel and M. Forcellino, *Michelangelo: Il marmo e la mente*, Milan: Jaca Book, 2014, Doc. 370, p. 338.
9 The document is published in F. Mancinelli, *Michelangelo e la Sistina: la*

tecnica, il restauro, il mito, Rome: Palombi, 1990, p. 274.

10 A. Grabar, *L'Empereur dans l'art byzantin*, Paris: Les Belles Lettres, 1936, p. 254.

11 On these events in Michelangelo's life, see Forcellino, *Michelangelo: A Tormented Life*, pp. 170–1.

12 F. Zöllner, C. Thoenes, and T. Pöpper, *Michelangelo, 1475–1564: l'opera completa*, Cologne: Taschen, 2008, p. 462; Zoellner also points to the existence of a bronze medal – chiselled by Bertoldo, a sculptor who had played an important role in Michelangelo's training in the sculpture garden of San Marco, Florence – as an inspiration for Michelangelo's Christ. However, I do not believe that the medal had a significant effect on Michelangelo's creative process, particularly because it was an extremely private object, whereas the Sistine *Judgement* had an extraordinary public value.

13 Vasari, *Lives of the Artists*, p. 461.

14 Frommel and Forcellino, *Michelangelo*, Doc. 371, p. 338.

15 See n. 7 in this chapter.

16 Letter from Michelangelo to Pietro Aretino, in *Carteggio* 4, pp. 87–8.

17 Frommel and Forcellino, *Michelangelo*, Doc. 370, p. 338; see also Steinmann, vol. 2, pp. 748–51.

18 The document is published in Mancinelli, *Michelangelo e la Sistina*, p. 275.

19 A. Condivi, *The Life of Michelangelo Buonarroti*, trans. by Alice Sedgwick Wohl, ed. by Hellmut Wohl, 2nd edn, University Park: Pennsylvania State University Press, 1976, p. 75; on this episode, see M. Forcellino, 'La Tomba di Giulio II: la gloria negata', *Incontri*, 29.1 (2014): 104–14, here 111.

20 For a discussion of the origins of the relations between Michelangelo and Vittoria Colonna, see M. Forcellino, 'Vittoria Colonna and Michelangelo: Drawings and Paintings', in *A Companion to Vittoria Colonna*, ed. by Abigail Brundin, Tatiana Crivelli, and Maria Serena Sapegno, Leiden: Brill, 2016, pp. 270–313.

21 Letter from Niccolò Sernini to Ercole Gonzaga, cardinal of Mantua, quoted in Forcellino, *Michelangelo Buonarroti*, p. 26 (see also the commentary there).

22 Vasari, *Lives of the Artists*, pp. 462–4.

23 Michelangelo's words were reported by Francisco de Hollanda; see A. M. Bessone Aurelj, *I dialoghi michelangioleschi di Francisco D'Olanda*, Rome: Loescher, 1926, p. 64.

24 The presence of the first sketches for the *Judgement* on the retro of one of the drawings for Tommaso is commented in *Michelangelo's Dream*, illustrated by Stephanie Buck, London: Courtauld Gallery, 2010, p. 130.
25 Dante Alighieri, *The Divine Comedy*, vol. 1: *Inferno*, trans. by Mark Musa, London: Penguin Classics, 1971, p. 92 (Canto iii).
26 P. De Vecchi, 'Sintassi dei corpi e modi delle attitudini dalla Volta al Giudizio', in *Michelangelo: la Cappella Sistina, documentazione e interpretazioni: Atti del convegno internazionale di studi. Roma, marzo 1990*, vol. 3, Novara: Istituto Geografico De Agostini, 1994, p. 87.
27 G. Colalucci, 'Test ed informazioni disponibili sul Giudizio: lo stato di Conservazione e la Tecnica esecutiva', in *Michelangelo: la Cappella Sistina, documentazione e interpretazioni: Atti del convegno internazionale di studi. Roma, marzo 1990*, vol. 3, Novara: Istituto Geografico De Agostini, 1994, p. 229.

Note to Epilogue: A New World
1 The history of the sixteenth- and seventeenth-century reproductions of the cartoons can be found in J. White, *The Raphael Cartoons*, London: Her Majesty's Stationery Office, 1972.

INDEX